Humanity

ISBN 978-1-7323025-1-8

Library of Congress Control Number: 2018942963

Cover design by Aileen Cassinetto

Interior design by C. Sophia Ibardaloza

ALSO FROM PALOMA PRESS:

Blue by Wesley St. Jo & Remé Grefalda
Manhattan: An Archaeology by Eileen R. Tabios
Anne with an E & Me by Wesley St. Jo
Humors by Joel Chace
My Beauty is an Occupiable Space by Anne Gorrick & John Bloomberg-Rissman
peminology by Melinda Luisa de Jesús
Close Apart by Robert Cowan
One, Two, Three: Selected Hay(na)ku Poems by Eileen R. Tabios, Trans. into Spanish by Rebeka Lembo (Bilingual Edition)
HAY(NA)KU 15 Edited by Eileen R. Tabios

PALOMA PRESS
Publishing Poetry+Prose since 2016
www.palomapress.net

HUMANITY

An Anthology
VOLUME 1

Edited by Eileen R. Tabios

PALOMA PRESS
San Mateo & Morgan Hill, California, 2018

Contents

Introduction

REACHING FOR "A MOUNTAIN-LIKE LOVE"

When I was asked to be the editor of *HUMANITY*, I felt I was being asked to do the impossible. Since I'm a poet, I thus said Yes.

HUMANITY was conceived by Aileen Cassinetto (poet and publisher of Paloma Press). She says she was inspired by Annie Dillard's *For the Time Being* which, "in large part, contemplates humanity 'in a world of almost 7 billion individuals.'" Aileen chose the first contributors and she chose some based on being "experts in their field" as their work ultimately relates to their worldviews. Aileen emphasizes that she believes "any one person can change the world" but "opted for some experts' views as [she] thinks each one represents an aggregate of what makes the world move at a certain direction." When I later solicited other writers to add to the book, it was from a point of view of perceiving gaps these contributors could flesh out or further expand.

As such, *HUMANITY* is the 15th anthology I've either edited or conceptualized but is the first anthology where the concept was someone else's and I just stepped into place as editor. I did not object to this structure specifically because of its theme: humanity. I felt that any group collected in an anthology is not going to be fully representative. But I did want diversity in views. Ultimately, I wished there to be sufficient content to make a wide variety of readers pause, think, then think again, and perhaps engage in some positive action as a result of reading.

Despite their differences, all of the writers in this book share something in common: thoughtfulness, as facilitated by traits like attentiveness and curiosity, among others. For the older writers, such traits clearly affected the decisions they've made about how to live in the world—resulting in a strong activist orientation among several, whether it's working for both

human and animal rights, the natural environment as well as cities, war victims, socio-cultural policies as well as a deeper aesthetics. Other writers present a variety of coming-of-age experiences. Together they present an overall picture of both strength and fragility.

In *HUMANITY*, we are presented with humanity's explorations, often struggles, with itself in a variety of contexts. One take-away certainly would be the importance of persistence in searching for a better way to do things—a better way to live. Another would be the fragility of children and young humans— how so much of what they become are significantly affected by what happens to them at young ages; as writer Jonathan Carroll once said, "Our youth is where the only gods we ever created live." These are elements that don't surprise me. But it's hopefully telling that I learned new lessons—or new emphases— about humanity as I read through the anthology's essays. I'm optimistic readers, too, will learn something from various writers in the anthology. The following are just a few of the points that resonated with me and do not at all come close to revealing the complexity of the contributors' writings, the book's gems of wisdom or notable sources of grief. The latter is worth stressing—grief so often forms us as much as perhaps the more quoted source of love.

From Daniel Atkinson's discussion on narrative, we are reminded that a narrative for change might first occasion the personal revolution of changing one's inherited (thus often taken for granted to be true) narrative—something difficult to do when "the status quo lends itself to the idea that difference in narrative often means deficient in value." This matter resonates as Atkinson's discourse relates to "Placelessness for Afro- in the American Narrative." Indeed, Atkinson's words also offer another and useful way to consider, to understand, why Colin Kaepernick kneels.

S. Lily Mendoza addresses narrative in another way: "[O]ne most prevalent narrative ... is that which says that the awful conditions we find ourselves living in today (the violent hierarchies, wars, selfishness, greed, cutthroat competition, domination of the weak by the strong, etc.) are just 'human

nature;' that this is a 'dog-eat-dog' world and will always be because 'that's just the way we are as human beings.'" Mendoza disputes this by referencing indigenous beliefs: "Our Cree brothers and sisters have identified our modern civilization as suffering from a serious disease of the soul or spirit they call 'wetiko' ... and whose grief we must now learn to understand and find ways to metabolize if we are to heal ourselves and the earth from its long reach and shadow."

Mendoza emphasizes that what needs to be done is "spiritual work.... To do this kind of work is to come face to face with immeasurable grief and sorrow. We cannot do this work alone. It is work that requires community (both of the human and the more-than- human kind), deep love, and, most especially the capacity to compost grief into life-giving beauty. Anymore, mere anger and denunciation of wrong will not suffice. We must dig deep, beyond our hatred and despair. In the words of indigenous writer Martin Prechtel, we need a 'mountain-like love for something [that] is bigger than [our] righteous hatred over the unfairness of others'."

From Jeannine Pfeiffer, we learn partly about the allure of heroism—"saviorhood for the otherwise powerless." While, in Pfeiffer's case, she is relating to helping animals (her epigraph is Anatole France's statement, "Until one has loved an animal, part of one's soul remains unawakened"), as soon as I read the word "saviorhood" I couldn't help but be reminded of this force's many manifestations. Saviorhood is complicated: e.g., Robert Cowan's contribution is *also* a warning on do-good tourism. Those sponsoring "missions" to volunteer at orphanages, for example, have not always addressed well the effect on children when the visitors return to their more privileged homes. It's a graying effect I personally witnessed during the process of adopting my son out of an orphanage in Colombia.

From Rodrigo Toscano and Aaron Beasley's conversation, we see poets who don't abide by norms as they search for a more effective way to practice poetry. Toscano's timely suggestion for poets "to resist becoming professional virtue signalers" is just one of many deeply-considered notes in his contribution.

Melinda Luisa de Jesus's poem, "Hay(na)ku: For the white feminist professor who told me I was 'ghettoizing' myself by studying Asian American Literature," resonates for me, in part because another Filipino poet once told me, "you're too good to be just a Filipino-American or Asian-American poet." I ignored him and continued my work back then volunteering at New York's Asian American Writers Workshop or AAWW (partly as editor of its now-defunct *The Asian Pacific American Journal*). The irony is that since those AAWW days, I've moved on to write poems that would be irrelevant to some in my ethnic community precisely because my poetry is open to other cultures, including "white" cultures. Some readers don't go beneath my poems' surface narratives to discern that what knits it all together is actually an indigenous Filipino trait called Kapwa, which can be defined as interconnectedness with all beings. I was introduced to Kapwa by Leny M. Strobel whose essay offers "an integral/wholistic understanding of the interconnection of All. It is all Sacred."

De Jesus' poem also shows the reach of history when it incorporates the term "little brown sister" to hearken "Little Brown Brother," a term once used by U.S.-Americans to refer to Filipinos. The phrase was coined by William Howard Taft, the first American Governor-General of the Philippines (1901-1904) and later the 27th President of the United States.

Murzban F. Shroff echoes Toscano's (and others') search for a deeper understanding of one's (required) role. For Shroff, when he transitioned from advertising to fiction writing as "a career switch [that] wasn't about self-indulgence but about making a meaningful contribution," he discovered that he had "not even attempted to understand the holistic picture that was India. As an advertising man, the really poor never mattered, for they did not have the buying power. But as a writer [he] had to understand the motivations of the less privileged." Shroff would come to realize that there were "three kinds of people: the haves, the have-nots, and the know-nots. The know-nots were people like me, who did not know how the other half lived. It would be my duty to sensitize the know-nots to the have-nots,

to bridge this seemingly wide divide and create understanding where there was none."

§

From high school student Rio Constantino, we see courage: "The vast territory of the unknown stretches before you. Dark shapes flit across the sun above. It is a sign to curl up into your shell—or break from it. To crane your neck out and see. There are dangers, there are risks, but there is no such thing as complete safety. Moving or not, prey is still prey. In which case, I'd rather take my chances, look around, and know whether the best option is to fight or flee."

It must be no coincidence that from Rio's father, Renato Redentor Constantino, we see the type of parental influence that succeeds in positively developing a child's outlook: "When faced with a choice between the unknown and probable stability, consider choosing the greater challenge. It may not be the wisest counsel, but if you do encounter job options, why not invest in your capacity to grow."

In a way, I see the father-son Constantinos as exemplifying what Audrey Ward says is needed: "The young need someone to look up to." Ward, noting that "we are accountable for children whether we have young ones in our own home or not," states that "if we pay attention to creating a world that's fit for children we will also enjoy living there. It requires, first, building a home that practices ethics, talks about and requires respect, honesty, faithful kindness (even when angry), and forgiveness. Then, learning to live by this moral compass in our families, neighborhoods, and schools."

Relatedly, J. A. Bernstein notes the importance of family as well as the strength of place, especially if the latter is one's homeland. When he visited the Baqa'a Refugee Camp, he observed: "This is a roughly one-and-a-half-square-kilometer, poured cement warren sprawling north of Amman. It encompassed some sixty-thousand Palestinians, all refugees and their descendants. ... one elder invited me to his home for tea, whereupon I inquired of his political thoughts. We sat along his plush sofa, inside the dark cell, and he regaled me with pictures

of relatives. Little kids came and went, and veiled women served us mint tea. He said he remembered Deir al-Dubban, his village, southwest of Jerusalem, in present-day Israel, from which the family was expelled in '48. They still had the keys to his home, he explained, and someday they would go back."

From Cynthia Buiza, we learn one contemporary way to define "Home" in the anthropocene: "... you can't claim to be a Manila girl if you can't describe in a few words how the city's legendary traffic chewed you up and spat you out like thoroughly masticated Chiclet." Zeitgeist means taking out the specific reference to Manila and replacing with any large urban setting.

From John Bloomberg-Rissman, we see hard-earned self-awareness. Discussing (his) "White privilege," he notes, "Justice will be intersectional or not at all." He also reminds that, significantly, "the coiner of the term 'intersectionality' is Kimberlé Crenshaw, a black woman and an expert on race and the law." He stresses, "It is improbable that a white person, however thoughtful and educated, would have come up with the concept. That improbability is white privilege in a nutshell."

From Karen Bryant Shipp, we learn about the trickster Coyote's circular way of moving through life: "Nothing with Coyote is a straight line," befitting how life is indeed more varied than that straight line. Her meditations on the Coyote lead her to question monotheism: "What is lost when we make God all one thing? What is lost with monotheism, the belief in an Omnipotent God who is all Creator, and no destruction? ... We become the creators of a dualistic world, where Right and Wrong, Good and Bad are separated in our minds and therefore in our experience. In this either/or universe we are left impoverished. Monotheism is fertile ground for intolerance and fundamentalism and exclusion, because if my 'One God' is the only Way, then you must either convert or be damned."

Shipp, adds, "How different a world mine might have been if I had grown up with Coyote! If the religious tradition in which I was raised had told me stories about the Trickster and his antics, perhaps the world's snafus would not be as likely to throw me

off course or into deep depression. The trap inherent in the belief that there is One God who is All-Powerful is that, when things go horribly wrong, there is no way to grasp what is happening without accusing the One whom we believe to be 'in charge.' If God is Omnipotent, how can we not blame God? Without a world view that includes the Trickster, we cannot help being forever confused by the uncertainty and ambiguity of our world as it is."

Finally, from poets Marthe Reed and Laura Mullen, we learn "in service to the #MeToo Movement ... something we need" to know: "A) access to the mind of the abuser in the instant of planning abuse and B) access to the mind of the victim, where the abuse resonates long long after the event." We learn this by reading of Reed's account of herself as a student and young writer hoping to "be seen as a real writer"—a hope so large her sister considered it "dangerous." And it was a hope betrayed by the all-too-familiar abuse by a man made more "powerful" for being established and lauded (including lauded by those who turned blind eyes to his actions). Movements are not formed from one-off moments. Reed mentions other abusers as well and I repeat them here for emphasis: Galway Kinnell, Yevgeny Yevtushenko, Rabbi Baruch Korff, and (one I wish she'd named) "the colleague, who invited Yevtushenko...who I will later understand used the women graduate students as his personal stable from which to select lovers." Of such "bullshit," too are humanity made—which does prevent any of us from agreeing (with actions and not just words) that, to quote Mullen, "That bullshit has to stop."

If adult warnings are present throughout the anthology, it makes sense—albeit sadly—that teen poet Gabriela Igloria contributes "Catastrophizing." The poem is her sole response to *HUMANITY*'s theme when she was solicited for works in any form (e.g. essay or poem). But is that the effect we want to impose on our young? To be young can be to have a thinner skin between one's psyche and one's environment—from such can emanate a truth specific to its more innocent roots. We should ponder why, in her poem, it's a child—not a parent or adult or a security guard walking their beat—who's referenced in this line:

"A child cries out, the sky is falling." Why does the young poet write it will be "the children [who] will see it first"?

§

But while *HUMANITY's* writers show that living is challenging, they also are able to offer sagacious coping devices, including but not limited to:

From Mary Pan: "camaraderie is therapeutic."

From Renato Constantino: "There's always mischief to make. / There's always ice cream to enjoy. / ... The dog eats everyone's homework.

"/ Punch back.

"/ ... "Rain is awesome, 'rain that comes like passion and leaves like redemption,' as Rebecca Solnit once wrote.

"/ ... the world will attempt to beat [kids] into conformity and submission, because things are really not going well. / It's important to pay attention and to learn how things work. To learn how to build and create. To read. To befriend disruption. To finish your drink. Life can be hard."

From Robert Cowan: "being deeply loved by someone gives you strength, while loving someone deeply gives you courage."

From Jeanine Pfeiffer, the importance of not becoming jaded: though her patient Bitty the bat died, she "accept[s] that our interventions into the lives of others, no matter how well-intentioned or well-crafted they may be, are quixotic and ephemeral. ... *But* we must offer what we offer with palms open, fingers splayed." (The italics is mine for emphasis.)

From Christine Amour-Levar, that positive human relations can create warmth despite adverse circumstances. Christine's context in her contribution is the tundra: "Despite the harshness of the environment, we adapt surprisingly well to our new way of life, but it's also because the Nenets are so hospitable, treating us like their daughters, making sure we are warm and well fed at all times. Yuri's pregnant wife Elena sees that I was about to step out of the chum to go herding with the men I can't find my balaclava—essential to avoid frostbite when riding on the snowmobiles to reach the herd. Elena quickly pulls off her own embroidered scarf and ties it tightly across my face to make sure

the skin is protected, while whispering words of motherly concern in the Nenets language..."

A last but not least example from Leny Mendoza Strobel: "Joanna Macy, a Buddhist elder, reminds us that in this sixth extinction phase we are facing, we can create Beauty as we disappear. I, too, intend to disappear and disintegrate elegantly."

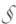

My own contribution—read some years from when the conversation was written—leads me to question poetry's sufficiency. I chose at the last minute of forming the anthology to include a conversation with John Bloomberg-Rissman (JBR) because it synchronistically touches on issues raised by other participants. Looking at it now, I wonder whether I've taken the easy way out in considering these topics raised by JBR as interviewer and by other writers in this anthology. The interview focuses on the "arduity" of writing poetry (including whether one should write poetry) given the prevalence of "an aesthetic regime that is at its very heart racist, misogynist, etc etc." I see now that by ultimately focusing on poetry—so that I can muster "I write in poetry, not English" to elide the colonial history of English—I was able to avoid addressing some harder layers of the question. And so I end this Introduction as an introduction to what I, too, must continue to explore, question, engage with, and contribute. If I have relied too much on poetry-as-language to preserve my own sense of my humanity, there are other ways that may be more meaningful to others—it's time I expand my definitions and my own efforts.

It's my hope that readers of *HUMANITY* also are led to consider new notions about humanity, our shared humanity. I believe in the merits of knowledge—if we learn more about each other, we hopefully can live better with each other and the environment we all share. The strength and beauty of our humanity is how it moves us to not remain human beings but be one being with each other and all others.

EILEEN R. TABIOS

MARY PAN

Dust

I SLEPT IN MY SCRUBS. It was a restless sleep, an on-call sleep. The kind of half sleep where your mind won't turn off, skimming on the surface, bobbing just below consciousness, ready to pounce. Mothers of newborns know this kind of non-sleep too. I was the lone physician in charge of a rural Kenyan intensive care unit. The phone call summoning me to the ICU awakened me at 5 a.m., ringing shrill through my drafty one bedroom apartment.

It was winter in Africa. The air was cool as I shuffled out the door in the just-morning light. As I ran across the dusty copper road, the dirt rising into the air under my feet, the weary world was already awakening. Others seemed to move in slow motion, not understanding the urgency of my summons. I trotted, then ran, self-conscious and conspicuous, fueled by anxiety.

I hurried across the dirt road, tearing through the empty corridors of the now-familiar hospital, flinging wide the doors to the tiny medical intensive care unit, six beds in all, for adults and children alike. I was in charge. My patient in duress, a young woman with post-operative complications, was in the corner bed. The nurses looked up as I entered but they were not moving, not hurried and harried as I expected them to be. I asked what was going on. Silence. They were bagging the patient: forcing oxygen into her lungs by compressing a bag, in her case through a tube in her throat—a tracheostomy.

I had participated in many "full codes" during my medical training in the States. Teams of people would fill the tiny room of the dead or dying patient, each with a role and purpose—a coordinated attempt to bring a person back to life. Here, there was no rhythm of intravenous medications and chest compressions. There were no rules of resuscitation or options for chronic mechanical ventilation. I asked if she had a pulse. No one had checked. She didn't.

The surgeon showed up at that point and replaced her tracheostomy tube. I started chest compressions and gave her epinephrine and she began breathing on her own and regained a pulse. The surgeon and I discussed the fact that she had probably suffered brain damage since she was without oxygen for some time. Her pupils were fixed and dilated: a telltale and ominous sign. If she coded again she was unlikely to recover. Twenty minutes later she stopped breathing. All we could do was watch her die.

§

When they asked me to bring a roll of electrocardiogram paper, I said yes. It was just paper, but paper that was hard to come by in rural Kenya. It seemed like something I could do. Just like working in the small hospital for a month, learning and teaching. It felt like I was helping; contributing my time and that ream of EKG paper.

Only it didn't arrive as expected. My luggage was lost, somewhere en route to Nairobi. Most likely it was snatched from the Nairobi airport, targeted as a westerner's luggage, walked right out the dirty sliding doors of baggage claim without question. Maybe just a sideways glance.

Missionaries at the Kenyan hospital prayed for my bag and the precious EKG paper contained within. Many times during those first few weeks, working in the unfortunately termed "Casualty" (Emergency Room) or managing patients in the intensive care unit, I coveted that specially lined paper, so prevalent at home.

In rural East Africa, I was without so many diagnostic tools; I had to rely on my fund of knowledge or suffer the lack thereof. It was an entirely different way of practicing medicine, simultaneously terrifying and freeing. There was no CT scanner, no radiologist to read the x-rays. Even the one staff pediatrician was out of town when I arrived. Although I was a novice physician, early in training, I was considered the expert in neonatal intensive care issues. We thought long and hard about what labs and studies to order because patients paid out of pocket for each test. Sometimes they ended up

just staying at the hospital after they were discharged, loitering in the murky hallways or sienna-stained grounds, until they'd procured sufficient funds to pay for their stay.

Under-resourced, we relied on the vanishing skills of the physical exam, hoping touch would reveal clues to the diagnosis. It was a blind medicine by today's standards, but somehow more exhilarating, more satisfying, more full.

It took seventeen days, but that day I came home from my shift to find the lost bag sitting outside my apartment door. Where it had been and how it managed to finally make its way to the small town of Kijabe 50 kilometers northwest of Nairobi will forever be a mystery. I hurried the precious ream of electrocardiogram paper over to the hospital, proudly presenting it to the physician on call. He was ecstatic. It wasn't until days later that I learned that the EKG machine itself was, in fact, broken.

I lodged myself in the tiny spearmint bathroom and stuffed half of a peanut butter and jelly sandwich in my mouth. It was my first day on call at Kijabe Hospital and I was overwhelmed and jittery. The smell and taste of the peanut butter, comfort food literally brought in a jar from home, gave me a moment's reprieve. No time to digest, I stepped back out into the Emergency Room, or "Casualty."

A Kenyan Clinical Officer—a physician in training—hurried up to me, donning a short white coat and clipboard. It was early afternoon and a 22-year-old man had been transferred to us from another hospital because he was deteriorating. Our staff had already ordered some basic blood tests and performed a lumbar puncture to examine the patient's spinal fluid. We were looking for signs of infection. The young patient had presented to the outside hospital five days prior with a headache and fevers. They were concerned about malaria or meningitis, but had not performed a lumbar puncture, which can be diagnostic for meningitis. One of the staff physicians had warned me earlier: "Here, they think everything is malaria." The other hospital did treat the

patient for malaria, but it was unclear whether or not any definitive studies were performed to make that diagnosis.

Upon arrival at our hospital, the patient became unresponsive and began to have generalized tonic-clonic seizures—rigid and violent jerking of the limbs. The Clinical Officers had given him the anti-seizure medications diazepam and phenobarbital.

As I approached the patient, his right arm was seizing, his left pupil was blown (a sign of serious and permanent brain damage) and he was unresponsive to painful stimuli. He was thin and lanky and so young. My mind raced. The only intubation equipment—a way of maintaining his airway so his lungs could receive oxygen—was at the other end of the hospital. He had been seizing and unresponsive for the past 24 to 48 hours. The nearest CT scanner, which could give us valuable insight into damage to his brain, was 50 kilometers away in Nairobi. Suddenly the patient's family appeared. They said they couldn't get the money required to pay for the CT scan until the following day at the earliest.

There were several possible scenarios: intubate the patient myself, pool money to pay for the CT, drill a "burr hole" to relieve pressure on the brain. I wanted to hide in the spearmint-colored bathroom, barred off from the chaos of the situation. I wanted to savor my peanut butter and remind myself it's not always, not everywhere, so hard. I eventually decided to seek counsel.

I found the surgeon in his outpatient clinic. As I explained the situation, I felt an instant release: camaraderie is therapeutic. The surgeon suggested the burr hole; he's a surgeon, after all. He took the patient to the operating theatre and drilled a hole in his head which produced frank pus; thick greenish-yellow fluid poured forth from the opening. Pressure relieved. The patient had a brain abscess. This was my first hospital admission of the day.

Walking through the wards sometimes felt like avoiding land mines—scattered bedpans, people washing themselves

with soapy water, buckets of vomit, trays of chai, plates of yesterday's food. Often labs ordered the day before were not actually performed or recorded accurately in the patient's chart. So they needed to be reordered, or checked on by traipsing down the hall to the lab where all of the results were kept, written in pencil, in a ledger book. If I needed a consult I could page the desired physician, but if it was a surgeon usually I would just look for them in one of the operating theatres.

I entered the hallway adjoining the operating theatre, flustered from my morning rounds on the inpatient wards. I was looking to consult the one surgeon we had on staff. It was mid morning and the hallway was cluttered with people in surgical scrubs and caps, sitting on stools. A Kenyan surgical tech smiled at me and lifted his cup of hot liquid. It was tea time.

So much to do, always so much to do. But twice a day, mid morning and mid afternoon, carts of stainless steel cups and plastic pitchers full of hot chai were doled out. Everyone stopped. Staff, patients, maintenance crew and physicians. Everyone stopped for a cup of tea.

It took me weeks to get used to this custom. Seemed odd, but also strangely dignifying, to wheel carts of chai twice daily among rows of suffering patients, many with end-stage cancer, advanced AIDS, or severe complications from tuberculosis. I was always rushed, wanted to get things done, but grew to respect and emulate the universal taking of time for a reprieve.

Everyone kept asking her if she was pregnant. She kept assuring us she was not. She was young and thin and short, even by Kenyan standards. Her cappuccino skin was creamy smooth and she was pretty. She wore flowered fabric dresses and smiled shyly, but never showed her teeth. Her belly swelled under her shirt: gravid, protruding. Three months of worsening abdominal distension. I wasn't sure if I believed her, this denial of being with child, with a progression and

physique so classic for pregnancy. I'm skeptical by nature. But there was no ultrasound to prove her assurances wrong.

We took the patient to the operating theatre one humid afternoon. An exploratory laparotomy, the poor man's imaging modality: cutting into the abdominal cavity to determine what this massive bulge might be. It was the most impressive surgery I'd seen. The mass took up her entire peritoneal cavity, the bulk of her abdomen.

The obstetrician, experienced in all gynecologic surgeries, couldn't even get around the massive growth. He had to call in the general surgeon. I heard him mutter under his sterile mask, "I don't usually work above the uterus."

They eventually had to drain it. Six liters of pus. Six. Liters. Milky greenish-gray. Draining, draining. It felt like we were draining the life from her, stealing the bulk of her tiny girth away.

We sent the murky fluid straight to pathology, but the results were all inconclusive. Clear answers were lacking, other than the patient was right, telling the truth all along. She never seemed upset at the fact that no one had believed her. But her story served as a reminder to listen to the patient, even when all logic may point in a different direction.

\int

I was searching for the death certificate when her husband arrived. The patient had died ten minutes earlier. I had tried to save her but failed.

It was a fluke that he showed up to the hospital at that moment. We hadn't had a chance to call him to tell him: she's dead. It's no small task to tell someone their loved one has died. The hesitancy, the awkwardness, the feeling that these are momentous words you're stumbling over. Never sufficient eloquence. Never adequate empathy. All the more challenging using an interpreter across cultures.

The husband was gracious and thanked me and the nurse profusely for trying to save his wife. He wanted to convey his appreciation. This was his initial reaction. I was puzzled and touched. I had witnessed several deaths, coded many patients,

and informed family members of a patient's death before. Yet, this situation was different; I felt responsible. Maybe he picked up on that. Maybe it was the Kenyan way. Maybe he was particularly kind. Maybe he wasn't so surprised that she could die unexpectedly in this land where untimely death is all around. He shook my hand and walked out the double doors. I'd never see him again. I'd never forget him. I turned around, searching for the death certificate as another patient was wheeled into the ICU.

DANIEL ATKINSON

Give Me Your Freedom or I'll Give You Death: Placelessness for Afro- in the American Narrative

LOOSELY DEFINED, narrative is a collection of related events, ideas, or patterns that form a story and/or identity. It is an essential component of what makes us human and it helps us to define who we are as individuals in the context of the world in which we live.

In the United States, narrative plays a most powerful role in determining our values, morals, aesthetics, and status. While not the deciding factor, the narrative we assign to ourselves and others when coupled with an individual's character can often decide the kind of life that a person may lead and, ultimately, their worldview. Hence, a person born into a life of privilege and abundance is less likely to understand the struggles of someone who was born into a life of struggle, chaos, and inconsistency. This is particularly true if the chaos of the latter empowers the former, destroying the legitimacy of merit within the American narrative.

The power lies in the fact that those of privilege explicitly or implicitly form the default to which everyone else is expected to aspire and accept, regardless of merit. This is further complicated by the insistence that the narrative of the less privileged is to be ignored, undervalued, and even erased, with little to no consequence if it is not readily available for conspicuous consumption.

For example, the sovereignty that chattel slavery and Jim Crow institutionally forced onto Africans and their descendants in the U.S. was, at the time, acceptable. However, that same sovereignty is unacceptable now, when asserted on a cultural level via protest, boycott, insistence of privacy and reciprocity, or simply a wish to self-seed culture without caveat as the basis for sovereignty. This allows powerfully privileged people to treat the Afro-American narrative as a salad bar where one can pick and choose what they like or

what is most convenient for conspicuous consumption, then leave the rest to obscurity. The result is a monolithic myth in place of a genuine, living Afro-American narrative.

Therein lies the fundamental hypocrisy of the standard American narrative of bootstrap, upward mobility in which anyone can become anything, so long as they have the talent and work ethic to will their dreams into existence. At the same time, that omission highlights the importance of people who choose to engage with the Afro-American narrative beyond what is acceptable or convenient. It is a labor of love, and in most cases, a thankless way to demonstrate the wealth of our collective potential as Americans. Further, it is important to note that one does not have to be of African descent to recognize this, to participate, or to facilitate. Simply put, one must be willing to submit to the possibility beyond their own personal narrative so their sense of liberty does not stem from another person's lack of liberty. After all, before there was government, there was Circle, a pre-governmental ideology of communal governance in which "different" does not automatically mean "deficient," so long as the individuals in the Circle are willing to extend the same principles of humanity to others as they seek for themselves. In this atmosphere, difference can serve as groundwork for greater, mutual understanding of complex issues of narrative.

If narrative plays such a powerful role in the worldview of a person, then the art as expressed by ANY individual can provide a wealth of contextual information about the attributes and shortcomings of the American social order, especially if they are among the disenfranchised or disinherited. On one hand, the examples in this essay are just like any other. On the other hand, they are unique in that they contain the inconvenient truths that have always been present, but rarely included in the greater American narrative. This is vitally important because the status quo lends itself to the idea that difference in narrative often means deficient in value—and the effects can be catastrophic for those labeled as different. Nevertheless, it is through our differences that we can discover grounds for mutual understanding of narrative in a metacognitive sense.

Consequently, embracing the discomfort of the learning process is the only way for us to recognize our potential to fully give and receive love equally. If not, we will continue to sell our inequities down the road for future generations to deal with, despite the fact that they are hidden in plain sight all around us. And much like cancer, if it is left unaddressed, it is only a matter of time until it addresses us collectively.

It is my hope that the few examples that I provide will shed light upon the situation with potency so that they may compel the reader to seek their own personal truth rather than ignite a sense of entitlement that demands an explanation to preserve the sanctity of an inalienable right to comfort and convenience.

Foreign Trade: Context for American Hypocrisy

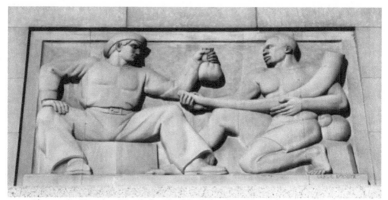

Figure 1—*Foreign Trade* by Carl L. Schmitz (Photo by Daniel Atkinson)

While working for Smithsonian Folkways Recordings and the National Museum of African American History and Culture in Washington DC in 2007, I regularly passed by this limestone, bas-relief sculpture (Figure 1) while on my way to and from my photo processor. It sits atop one of the south-facing doorways of the Federal Trade Commission, just steps away from the National Mall and the White House where the American narrative is celebrated and affirmed for people of all walks of life.

This celebrated sculpture known as *Foreign Trade* by Carl L. Schmitz (1900-1967) was commissioned in 1937 and shows a

pair of men in the act of exchange. The man on the left, of European descent is in the foreground, seated high and fully clothed with legs spread in a show of dominance, handing a bag containing something unknown to the man on the right and the viewer alike. It could be a bag of coins, beads, malaria, infected rags, or anything the imagination can produce. Only the European knows for sure, leaving the man of African descent on the right, to take what is given. The semi-nude African is in the background, kneeling below the European and offering to him an elephant tusk, a very difficult, dangerous and destructive thing to obtain, especially without the aid of guns, germs or steel.

Ostensibly, the ivory tusk, a phallic symbol from the natural world is to be converted into objects that symbolize European material wealth and dominance of the exotic parts of the globe via colonialism, resulting in the decimation of wildlife throughout the tropical world. Regardless of the final product: billiard balls, piano keys, broaches, dominoes, knife handles, or pistol stocks, these objects continue to be a marker of success and excess in the postcolonial world. Further, objects like tusks provide a hegemonic barrier between cultures of *hands on skin* or *wood* versus *hands on ivory* or *pearl*.

For the African, the effort to bring his wares to market is far more dangerous and labor intensive, hence his use of two caressing hands to offer it to the man on the left who, in turn, only uses one. Presumably, the weight that the European carries is the burden of reason, established in autodidactic fashion, providing all of the necessary narrative elitism to justify such practices. Hence, it is safe to assume that this is one of the acceptable times for a man of African descent to take a knee, free from grief.

Herein lies the fundamental hypocrisy and power ascribed to America's birth defect of White supremacy. Within this construct, one can easily see who is "Foreign" and who is not, thereby, indicating who is getting the better end of the trade and who is subject to whom. Further, this encoded message functions as a forewarning of the kind of experience a person of color will have when they attempt to operate within

our American institutions with the expectation of equal treatment as granted in the bill of rights and impotently reinforced via the 13th, 14th and 15th Amendments to the Constitution. And though it is not an image of a confederate general, glorifying days long gone behind, it conveys the same harsh, pervasive reality of the American narrative, and demonstrates why Africa is considered by some the home of "shithole countries," and precisely how they became so.

Essentially, Black humanity is to be begged, borrowed and negotiated into passive impotence. It is the willingness of Afro-Americans to accept and even promote this dynamic as natural that is the source of the term "Uncle Tom." As eloquently stated by James Baldwin:

> Tom allowed himself to be murdered for refusing to disclose the road taken by a runaway slave. Because Uncle Tom would not take vengeance into his own hands, he was not a hero for me. Heroes, as far as I could then see, were white, and not merely because of the movies, but because of the land in which I lived, of which movies were simply a reflection: I despised and feared those heroes because they *did* take vengeance into their own hands. They thought vengeance was theirs to take, and yes, I understood that. My countrymen were my enemy (Baldwin and Peck 2017, 22).

Each year, this sculpture and many, many other iconic symbols of institutionalized oppression are viewed by millions of people, most of whom I fear have not critically engaged with their role within the power dynamic that is abundantly clear. Therefore, it makes a very poignant statement about the willful, collective ignorance of our American history and culture, especially, with regard to public policy and the unequal treatment of its people. Consequently, it begs a question; if this is taking place at the seat of our national identity, then what else is taking place in full view of a conveniently blind and critically unengaged public? That question is especially poignant when one compares *Foreign Trade* to its companion atop the other south facing entrance on the Federal Trade Commission building called *Construction* by Chaim Gross (1904-1991), which clearly

shows America's industrial might and reciprocity between working men as long as they share a narrative. (See Figure 2)

The characteristics of these two sculptures are the basis of the capitalist system where there is presumably infinite growth, as well as winners who are confirmed by the very necessary presence of losers. This inalienable right to privilege, stemming from the desires of bereft people, is the foundation of many of the social problems we face today, in that, certain segments of our society have grown so accustomed to knowing that they are tall because an Other is on their knees, so long as they are there by force and not by choice. As a result, any erosion of their privilege toward equality seems unfair. For this reason, more than two hundred years after the creation of the United States, the principles they symbolize continue to manifest themselves in mainstream American culture. Our schools, churches, popular culture, hospitals and criminal justice system are all products of this philosophy. Accordingly, we have facilitated an inherent contradiction between what America says it is and what it is in reality.

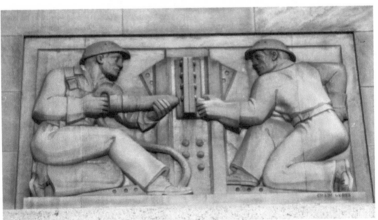

Figure 2—*Construction* by Chaim Gross (Photo by Daniel Atkinson)

The fundamental truth(s) expressed in these two sculptures state that Black people and all others deemed undesirable in one way or another are only useful, so long as they are deemed necessary and know their place. This is a fundamental norm order of the American narrative and dates

back to the first enslaved Africans brought to the continent. Hence, Black sovereignty is only acceptable when institutionally forced in ways that are advantageous to White supremacy and not when culturally asserted in ways that erode White supremacy toward equity where merit wins out over privilege.

By this reasoning, it is perfectly fine for a Black man to kneel as long as it is in reverence to White Supremacy, but completely unthinkable if done so in an attempt to bring light to a fixable problem that is centuries old, hidden in plain sight and designed to destroy our contradictory nature of saying one thing in the Constitution, while doing another in practice. This is what allows certain people to behave as though they have no ancestors watching them and without a crisis of conscience when they act without equity while professing the opposite. This is a bit of the knowledge that I picked up from my elders who understood what was lost via assimilation disguised as integration, which allowed the implementation of the philosophy that continues to encourage non-Black people treat Afro-American culture like a salad bar, as if to say with impunity, Jackie Robinson only, everyone else is unnecessary....

From the Quasi-opportunity of Race Music to exclusion of Rock and Roll

To give context to the earlier description of integration in the U.S., I'd like to present a crash course on the history of one of the most "American" cultural exports, Rock and Roll. In the early days of recorded music, the products that emerged from Black artists were collectively called "Race Music," which served to differentiate White cultural products from Black, in a way that maintained the existing power dynamic. This afforded enough legitimacy to Black music to allow access to the buying public, resulting in profits for White record labels.

In essence, this was Black music for Black people. In 1949, a man named Ralph Peer rebranded it "Rhythm and Blues" to reflect the White public's desire to buy Race Music without dithering their White status. This model worked well, until the

privileged demanded more. The final and most insidious part of the process came when it was rebranded yet again as "Rock and Roll" in the early 1950s by Alan Freed, a New York based disc jockey. This was, actually, Race Music that was then being played by White people and sold to White people, despite the fact that Rock and Roll is a Black vernacular term for sex. As indicated by the inimitable Wynonie Harris (1915-1969) in his 1949 R&B hit, *All She Wants to do is Rock*:

> My baby don't go for fancy clothes
> High-class denim and picture shows
> All she wants to do is stay at home
> And hucklebuck with daddy all night long
> All she wants to do is rock (x3)
> Rock and roll all night long (Harris 2004)

Then, it was only a matter of time before there was an appropriate, White manifestation with the Black sound to be crowned "King." Be it Benny Goodman, the so-called King of Swing; Elvis Presley, the King of Rock and Roll; Sam Smith, the King of R&B, or Macklemore, the King of hip hop, the process has remained the same, to be repeated every generation since the advent of minstrelsy in the 1830s (America's first form of popular culture), so long as the Black cultural aquifer remains underground, waiting to be tapped and conspicuously devoured by the entire world without regard to consequence.

This process of assimilation disguised as integration allows Whites to exercise their liberty while exorcizing the liberty of Blacks, facilitating a rising tide that only raises some ships. Resultantly, we are coming to a close on the second century of White exposure to Afro-American cultural expression *en masse* and for whatever reason, they still don't get it, while insisting that their out of step, mediocre at best renditions of the vernacular are as good or better than the Afro-American original. In the end, this practice has ensured that guilty feet have got no rhythm whether they recognize it or not.

Despite the fact that it literally takes a nation of millions to hold us back, when I was a child, in the 1980s, there was an

abundance of elders, practitioners and devotees who all played a role in the development and care of our vernacular culture. They understood the beauty of the sovereignty that was facilitated by the institutionalized hate of Jim Crow segregation, chattel slavery, and the fact that we are among the few in the U.S. who cannot point to a specific place of origin or a language. Unfortunately, these elders were among the last who understood the philosophy of the before mentioned Circle, a nonwestern ideology of communal governance that predates institutions upon which the basic principles of jazz, blues, gospel, hip hop and every other genre that falls under the banner of Black American Music was founded.

Within this framework, a community of practitioners collectively negotiate their way through an agreed upon process of communal expression that contains restraining aspects; chord changes, song form, tempo and key, like in Western classical music. However, there is space for an infinite variation of expression, provided the practitioner is able to submit to the idea that individuals make the Circle, but no individual is greater than the Circle.

This reality, coupled with the idea that life is short, painful and unfair, compels one to be present in the moment and to project one's best self as a soulful conduit of culture when the opportunity for expression beyond the restraining aspects of life presents itself. That is precisely why I loved jazz as a child and wanted nothing more than to be part of the long line of practitioners who added to the language and cultural legacy in the twentieth century. Alas, by the time I was of age, jazz was in the closing stages of transformation from the peak of Afro-American cultural expression to an institutionalized facsimile equivalent to Western classical music in which convenience of consumption and parroting took the place of the kind of diligent, dedicated, self-reflexive process of the past. Traditionally, this provided a practitioner and experiencer the opportunity to liberate oneself from that which pains them through the act of expression and/or validation of a shared narrative. When asked about this philosophical conundrum, New Orleans-born jazz musician

Branford Marsalis had this to say when he was interviewed for the documentary *Before the Music Dies*:

> What I have learned from my [university] students is that students today are completely full of shit! That is what I have learned from my students…Is that, much like the generation before them, the only thing they're really interested in is you telling them how right they are and how good they are. That is the same mentality that basically forces Harvard to give out "Bs" to people that don't deserve them out of the fear that they'll go to other schools that will give them "Bs" and those schools will make the money. We live in a country that seems to be in this massive state of delusion where the idea of what you are is more important than you actually being that. And it actually works as long as everybody is winking at the same time. And then if one person stops winking, you just beat the crap out of that person and they either start winking or they go somewhere else. But it's like, yeah, my students just uh… All they want to hear is how good they are and how talented they are. And they're not really…Most of them aren't really willing to work to the degree to live up to that (Shaper 2006, 1:15:52-1:17:01).

Marsalis described a scenario where his students seek validation rather than knowledge in the spirit of divination. An exchange? Yes, but not a reciprocating one because they use him only to facilitate what they think they already know about a cultural expression from an Other. In doing so, they expose their institutionalized narcissism, or at the very least, an uncompromising and unconscious selfishness. It's as if to say that the Other is used only to maintain one's sense of self, a demonstration of bereavement that goes unnoticed by all, except those on the losing end of the binary as demonstrated in Carl Schmitz's *Foreign Trade*.

The statement is especially important because Marsalis is speaking in lightly coded language about mainstream America in a way that enslaved Africans and their descendants have spoken and sang about mainstream America to the Christian God from the antebellum period to the present day. To understand the deeper meaning of the message means that one carries an extra burden supplied by the power one is trying to subvert with the coded message. Without this code-making and

breaking, there would have been no underground railroad to speak of and the vernacular music of Afro-American people would be drastically different.

In Marsalis' case, he is speaking of America's young elite who can afford to go to prestigious colleges and believe they can learn from a master in a matter of moments what has taken him and many others like him years to attain in a very different environment that predates emancipation. Marsalis' observation, "the idea of what you are is more important than you actually being that," is very telling of our current state of this country where equality is the order of the day, but inequality is the mode of operation.

Our prisons, schools, hospitals and all other public institutions are no exception and are not free of the "massive state of delusion," he referred to. However, Marsalis is not immune to the American political climate and norms of retribution. After all he is a Black male and earns his living as an entertainer in post-integration America. This may explain his use of coded language that to the unaware can apply to anyone who just so happens to go to an elite university where he teaches. Anyone who cares to engage such a statement head on can deduce what he is getting at, but for most, including the people he spoke about in his statement the message may be encrypted just enough to fall upon deaf ears, very much like the ring shouts and spirituals prior to the popularization of Fisk style Jubilee music that is far more preoccupied with White acceptance than authenticity. This is by design and occurs simply because of the lack of reflexivity in contemporary US culture where racism is defined by old, incomplete definitions (KKK members on horseback, lynchings, church bombings, etc.).

With that caveat in mind, no one fancies themselves as part of the problem if they don't want to, especially if one has the power to omit what one doesn't want to hear. There are plenty of cultural mechanisms in place to verify the wholesomeness and holiness of this mode of operation. As a result, anyone who is not among the elite or social majority in this country and wants to succeed beyond what the "wink" allows must negotiate this very, very carefully as the writers of the slave narratives did

so eloquently in the 19th century. This goes for any musician in the US that operates within the Afro-American vernacular tradition. Otherwise, neutralization of the nonconformist, non-winker is in order.

As stated by Marsalis, "If one person stops winking, you just beat the crap out of that person and they either start winking or they go somewhere else." More often than not, the "somewhere else" Marsalis refers to is the prison industrial complex, social obscurity, or even death. This has been the fate of many potent civil rights activists in this country, from those who professed nonviolence to those who advocated violence only in self-defense.

With this in mind, one can easily see how the "wink" extends to the beginning of our collective, institutional, national identity: our Constitution. The majority of its signers and contributors who, at least on paper, subscribed to the idea that, "All men are created equal," in fact, owned slaves from Africa and in some cases fathered illegitimate children with them.

Even when an enslaved woman named Phillis Wheatley (1753-1784) who composed Greek prose and demonstrated a mastery of Latin after the teachings of her owner, proving to the Boston elite that enslaved people were as capable as anyone if given access to education, was silenced. Though she proved her point, Thomas Jefferson, John Hancock and others neutralized her for the sake of preserving their way of life and reduced her effort to that of an anomaly, continuing the "wink" because the fragility of the greater American narrative had to be protected, which ultimately snuffed out Wheatley's merit. Essentially, they needed her to be on her knees so that they could feel tall, a precedent that has held true to the present day and a testament to the fact that the U.S. will never meet its full potential unless it is addressed.

More than two hundred years later, despite being born in the birthplace of jazz, a cultural practitioner and a leader in the field, Marsalis is still expected to accommodate squares in the Circle, giving credence to his final statement that, "Most of them aren't really willing to work to the degree to live up to that [idea of what they are]."

As for the majority of us who aren't on the national stage, we are fragmented between those of us who have been deemed unfit for conspicuous consumption and, therefore, are neutralized via prison, addiction or death, and those of us who have found a way to be a fly in the ointment even at our own peril and that of our comrades; and other folks who are completely on the outside who, after years of trying to be acceptable while having a speck of personal integrity, who feel as though they have no other option but to make an extreme example.

Back in the day and when I was a child, if you couldn't answer the call at a jam session and play, you had to sit down, regardless of status. That was the essence of be-bop and why it was such a powerful tool to demonstrate the merit of Black intellectual thought at a time when a Black person couldn't do so in any other context, save a boxing ring without terminal consequences.

Now that more master musicians have passed on than remain, the more overt the oppression has become more overt because they are being replaced by Whites and Blacks who act in "acceptable" ways, thus destroying the fundamental meritocracy of the music. This could be the case, partially, because pro-Whiteness is rooted in anti-Blackness, so by default, pro-Blackness must be rooted in anti-Whiteness, despite the fact that when conceived, jazz was, by all definitions, Black or "Foreign" and no one of status would touch it. Nowadays, Americans can insist on having their Race Music and remain White without the pretense of changing the name as in the past.

A case that demonstrates Marsalis' idea of the delusion at the base of the American narrative was when jazz vocalist Rene Marie sang the melody of *The Star Spangled Banner* with the Lyrics of *Lift Ev'ry Voice and Sing* (The Black National Anthem) before the State of the City address by the Mayor of Denver, Colorado in the summer of 2008 (See Marie 2011). Because of the Afro-inclusiveness of her rendition of the National Anthem, Marie herself was designated a national pariah and received death threats for her perceived dishonesty and, as in James Baldwin's example, taking her

vengeance. Understandably, she later felt forced to explain her actions to a public that still remains largely ignorant to the feelings of injustice still harbored by those forced to live and grow under Jim Crow laws in America.

In order to address the nearly overwhelming volume of questions, attacks and threats, she posted a series of questions and answers on her personal website. Among them was the question, "Weren't you promoting racism by singing the 'Black National Anthem' instead of the National Anthem?" Her response:

> Nothing could be further from the truth. The song you are referring to as the Black National Anthem is correctly titled "Lift Ev'ry Voice and Sing." As a kid living in a segregated, southern town I grew up singing both songs. It seemed apparent to me early on that the sentiments expressed in each song are diametrically opposed to one another. The "Star Spangled Banner" spoke of "proudly hailing the flag" in "the land of the free and the home of the brave." I could see how some folks could have pride for the flag and feel free and brave and at home. But that sentiment was not a reality for black folks living in a town with Jim Crow laws, where the flag often hung from buildings they could not enter. It was not a reality for Black soldiers (among them my own father) returning home and being denied their civil rights after having fought for the nation the flag represented. On the other hand, nobody but Black folks found comfort in "Lift Ev'ry Voice and Sing," even though the lyrics focused on "ev'ry voice singing" the "harmony of liberty." Why was that? I loved singing both songs but each one seemed to have their own aspects of exclusivity and segregation, not by design, no. But still the separation was palpable. Could I find a way to marry the two ideologies musically by melding the two songs into one harmonic thought? That would be a helluva thing. The fear of alienating both blacks and whites by blending these two sacrosanct songs was very real. But through the door I went, not heedless of the offense that might be taken. And to complete the effort, I re-wrote the melodies to "America the Beautiful" and "My Country Tis of Thee" but retained the lyrics. I combined all these songs in a suite and named it "Voice of My Beautiful Country." The song I sang at the Mayor's State of the City speech is the third movement of that suite. It is a love song to my country.

During my conversation with Marie, she was very adamant in saying that she felt that if she had substituted *America the Beautiful* instead, no one would have called her a "racist" or "dishonest" despite the fact that she was old enough to remember a time when she had no access to the square, so she had to make her home in the Circle. Regardless, because certain people could not easily access the reality of her uniquely Afro-American narrative, she had to be punished. Adding insult to injury, some felt that she had to be punished rather than be inspired to embrace the discomfort of the learning process in order to divine their own, personal truth on the matter. The truth is, like Langston Hughes, she too, sings America, a more complete America as expressed in the redacted third verse of the Star-Spangled Banner (See Hughes, Rampersad, Arnold, & Roessel 1994, 46):

> No refuge could save the hireling and slave
> From the terror of flight or the gloom of the grave,
> And the star-spangled banner in triumph doth wave
> O'er the land of the free and the home of the brave.

As a much younger man, I wanted nothing more than to contribute to the richness of Afro-American culture, and like Marie, because of my insistence of cultural sovereignty, I have been deemed undesirable, despite my terminal degree and a lifetime of service to my nation beyond the accepted definition of carrying a rifle in a foreign land to promote the dogma of *Foreign Trade*. As so eloquently stated by James Baldwin more than half a century ago:

> I have always been struck, in America, by an emotional poverty so bottomless, and a terror of human life, of human touch, so deep that virtually no American appears able to achieve any viable, organic connection between his public stance and his private life. This failure of the private life has always had the most devastating effect on American public conduct, and on black-white relations. If Americans were not so terrified of their private selves, they would never have become so dependent on what they call the "Negro problem." This problem, which they invented in order to safeguard their purity, has made of them

criminals and monsters, and it is destroying them. And this, not from anything blacks may or may not be doing but because of the role of a guilty and constricted white imagination as assigned to the blacks (Baldwin and Peck 2017, 58).

With this in mind, I must ask my fellow countrymen, would you rather continue the mass delusion affirmed by *Foreign Trade* or embrace the discomfort of the learning process as presented by Colin Kaepernick and many others who not only believe in their own potential, but that of their fellow citizens if all had equal access to liberty? After all, both men are kneeling, but only one by choice, despite the price for his constitutionally guaranteed right to seek his vengeance as an American.

This is especially true when one realizes that no one is paying him to take a knee, nor is he running for office, or have anything to sell. His motivation is purely altruistic, because he knew more than anyone that it would declare career suicide. Ironically, he stands to make more money now than if he had been allowed to stay in the league because of the illegal, institutional backlash that has occurred in which he has been blacklisted by the league.

Only time will tell if I will become a full citizen before the end of my life as I am, but one thing is certain to this writer. That is, if the greater American narrative is a coal mine, then the Afro-American narrative is a canary.

Therefore, I would like to close with a message inspired by Paul Hudson a.k.a. H.R. of Bad Brains—If you should close the gates of liberty to me, thereby condemning me to the bottom of an institutional pit, that is the saddest day of *my* life. But if you should know the difference and still chose not to wake from your sleep, then every day is the saddest day of *your* life.

WORKS CITED

Baldwin, J., & Raoul Peck. *I am not your Negro: A Major Motion Picture Directed by Raoul Peck*. New York: Vintage International, 2017.

Harris, W. *"Drinkin' wine spo-dee-o-dee* (American song)." *Wynonie Harris: Greatest Hits*, King Records, 2004.

H.R. *Charge,* SST Records, 1990.

Hughes, L., et al. *The Collected Poems of Langston Hughes*. Knopf, 1994.

Marie, R., Bales, Kevin, Jordan, Rodney, & Baxter, Quentin. *Voice of My Beautiful Country,* Motéma Music, 2011.

Rasmussen, J., Shapter, Andrew, Badu, Erykah, Bramhall, Doyle, Clapton, Eric, Costello, Elvis, XM Radio. *Before the Music Dies,* BSIDE Entertainment, 2006.

JEANINE PFEIFFER

Until We Have Loved

"Tant qu'on a pas aimé un animal, une partie de son âme reste non-réveillé"
(Until one has loved an animal, part of one's soul remains unawakened.)
—Anatole France, poet and Nobel laureate (1844-1924)

BITTY. I NAME THE CREATURE BITTY.

The bat is so itty-bitty-teeny-tiny her body embraces only half my thumb, to which she clings during our first moments. Clings to with eyes shut: either because she naturally re-immersed herself in torpor, or from exhaustion. Exhaustion due to merciless battering from an overindulged, overweight cat.

I gaze at Bitty, turning my hand this way and that, trying to examine who and how she is. When Bitty repositions herself, I gently tease apart her velveteen wings, double layers of skin stretched across bones so finely etched they are calligraphic. On the left side her skin is tattered, the flight membranes slashed into quiescence.

Perhaps her wing could be repaired, the elastic skin super-glued and allowed to heal. I have a choice: unhook her from my thumb and place her outside, and death is certain; an upside-down version of the natural order, as Bat is endemic and Cat is non-native, invasive. But then again, maybe Cat obeyed ancient instincts and preyed upon the weaker one, the sick one.

I am pondering the options when Bitty's translucent ears twitch softly, like minute sonic beacons, and my insides coalesce into such earnest desire there is no choice. As long as she lives and eats, I must try a homegrown bat rescue, rabies scares be damned.

§

Bitty is not the first wild fur ball to charm me. In the manicured hinterlands of coastal Florida I fed my carefully hoarded, only-after-church-on-Sundays candy to wild

squirrels: their noses and tails twitching in syncopation, their haunches propelling tawny bodies towards mine. Paw-fingers outstretched to grasp and gnaw every last one of my chemically enhanced peppermint Tic-Tacs. A juvenile case of dope peddling.

The squirrels were a side act. A hypersensitive child navigating an abusive household, I constantly searched for things to care for: the more exotic, the better. Incapable of *not*, I clumsily attempted to rehabilitate baby rabbits, scrub jays, and anole lizards, while lacking rudimentary training in bio-physiology or thermodynamics. Despite patient efforts to craft the perfect faunal refuge or coax homemade recipes down pursed beaks, my charges expired in less than a week. Dead from internal injuries, from stress and trauma, from malnutrition and heat loss.

Yet heroism remained alluring. Saviorhood for the otherwise powerless.

I joined the ranks of lifelong experimental critter-savers, stubbornly recalibrating our fumblings after each failure. We popularized the spaying and declawing of kitties. Developed better detergents for removing crude gunked onto waterfowl feathers. Bankrolled advanced veterinary surgery. Designed more elaborate band-aids to extend innocent lives.

And native biota kept disappearing, their home territories shrinking like raindrops on hot asphalt. As we two-leggeds forged into biomes previously left untouched, clearing old growth forests for our first, second, and third homes; draining and paving wetlands to shave ten minutes off our commute time, we expanded our "humane" shelters to treat a wider variety of fin, fur, feather, and scale.

Career rescuers became combat physicians, perpetually patching up and exporting casualties from the middle of a war zone. Channeling our anthropomorphic distress into doable acts, we stuck our compassionate, bitten, and chewed fingers into ever-increasing holes in the dams. Refused to yield to the inevitable floods.

§

"I taut I taw a puddy tat!" declares rotund, yolk-yellow Tweety Bird, swinging on his perch. Eyelashes fluttering saucily, he announces the incursion of sly, svelte Sylvester the Cat and the beginning of another animated predator-prey romp during Saturday morning cartoons. Even with Sylvester's claws glinting and feathers flying, the scenes are comical because we know that Sylvester, despite test-driving an endless gamut of ingenious get-Tweety schemes, is a bumbling fool. Doomed. Try as he might, he will never eat Bird.

Turn the television off and switch our focus to feline pets and we enter the dark side of the looking glass. In contrast to Sylvester, and in concert with their feral cousins, domesticated kitties are awesome killing machines. What appears to be a random selection of minor executions: bird-batting on the back porch, mouse entrails in the living room corner, adds up. To a whopping twenty billion bird and mammal deaths each year.

I don't know when I became inured, or perhaps the right word is *habituated*, to the predictable outcomes of critter-unfriendly choices. Such as domestic cats, who are nature-bound to hunt; and petroleum-fueled everything, oil being nature-bound to spill, somewhere, somehow.

Was it growing up on a steady diet of Bugs Bunny, Woody Woodpecker, Wile E. Coyote, and Road Runner: oddly displaced critters trying to survive in a world of Acme trucks, canneries, and [sub]urbanization? I thought their strangers-in-a-strange-land antics and accents hilarious. Did The Looney Tunes teach me to consider habitat destruction as just another game of chase-me?

Belatedly, begrudgingly, I acknowledge my starring role in a zero-sum interspecies competition. A match where belonging to the winning species means losing out. I own these conundrums not just because I am a scientist, keenly aware of harmful trends long before they are featured in the media, but because I am a pet-owning, car-driving, house-occupying human who enjoys cartoons. I am a card-carrying, typically hypocritical member of the human race.

I pretend I can eat my cake and have it, too.

\int

Bitty stretches, yawns, falls back to sleep.

The clock is ticking and I have a still-breathing somebody in my hand. It has taken less than fifteen minutes for my heart to melt into a puddle, a condition my pragmatic-optimistic brain recognizes as unhelpful.

We need data to save Bitty.

I try a digital taxonomic search to confirm Bitty's identity. She weighs less than an ounce, but so do another twenty-odd species of Californian bats. She's uniformly brown with a snub nose, which eliminates half the contenders. Sleuthing through a swamp of densely worded scientific monographs—replete with details crucial to zoologists but maddeningly obscure to everyone else—I try to cut to the chase, ticking off distinguishing characteristics. If she has a *keeled calcar*, that particular feature can narrow the search substantially, but first I have to suss out what a "calcar" is, and what it means to be "keeled." Darn. Should have taken a mammalian anatomy class back in graduate school.

After much page-flipping, I discover the calcar to be a faintly defined spur. On humans, it would be the *calcaneus*, the rounded heel bone of our foot. On bats, the calcar extends from the underside of the bat's foot; but because bat-wing is seamlessly attached to bat-foot which curves into bat-tail, the calcar is actually an extra edge of cartilage running between foot and tail along the bottom hem of the wing. If it is "keeled," a tiny flap of skin extends from the spur. In other words, I need to determine if Bitty has extra fancy flying boots.

More crosschecking.

Finally all of the above, plus Bitty-bat's ear size and shape— especially the length and position of her *tragus*, or ear lobe, her almost-not-there tail, and the habitat range where I found her, narrow the categories down to two. She is either *Myotis lucifugus*, the Little Brown Bat, a hairy-toed, relentless mosquito-gobbling machine, or *Myotis yumanensis*, another tiny brown bat native to the Pacific Northwest. The two species are virtually indistinguishable from each other, due to morphological

overlaps in body parts, fur coloring, forearm length, and sonar frequencies. Most biologists have to run DNA tests to be sure.

M. lucifugus is more common to our area, so I go with it.

A Little Bitty Brown Bat.

\mathcal{S}

To call such exquisite life forms "bat," a shortened conflation of the early 14th century, Middle English word *bakke* for flapper, and the Latin term *blatta* for nocturnal insect, common words invented when we humans were even more ignorant of non-humans than we are now, seems wickedly inadequate.

The poetry of Bitty's scientific name better evokes the poetry of her existence: *Myotis* (Greek) for her mouse-like ears, *lucifugus*—"fleeing from light"—for her vespertilionid habit (most active at dusk). *Myotis* bats begin their lives in hibernacula—female-only nursing colonies spanning most of North America—and can live to be over thirty years old. But given the realities of indiscriminate, broad-spectrum pesticides and power lines, most only make it to their seventh birthday.

Peering into a scrunched up face, and lightly stroking chocolate-grey bat fur that is softer and finer than satin, I try to assess her physiological maturity. I can't tell if Bitty is a juvenile, middler, or elder.

The average age of insectivorous bats throughout the eastern United States is declining precipitously. White nose syndrome, an unprecedentedly lethal disease, is rampaging through bat caves, killing millions. In its initial phases, it spread so widely and quickly the United States Fish & Wildlife Service launched a national response plan with a slew of other agencies. For years, as bat colonies collapsed like shattered glass, we were in the dark: we didn't know what caused the syndrome. We still don't know the whole story, but we've identified the main cause: a previously unknown, possibly invasive fungus, *Pseudogymnoascus destructans,* that scientists discovered after test-driving and eliminating related fungal lineages.

Infected cave-dwelling bats, who depend on hibernation to make it through winter, exhibit masses of white fungal mycelium frosting their muzzles, arms, elbows, wings, feet. They behave strangely: flying during the day and clustering near the entrances of hibernacula, perhaps in an effort to dry out the fungus. All this movement when they should be in torpor depletes the bats' fat reserves, while the fungal infections handicap wing-dependent functions. Unable to maintain their water balance or body temperature, bats grow dehydrated, chilled, and paralyzed. In many areas, white nose syndrome eliminates 90 to 100 percent of infected colonies; yet in some localities up to fifty percent of infected individuals survive from one winter to the next.

Perhaps there is reason to hope.

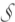

Bats slay me. They tease me with their biological phylogeny: cross-dressers fusing the mammalian and avian worlds, their delicate features rendered in sharp relief by a provocative Creator. Bats live insouciant, daring lifestyles, flaunting crepuscular and nocturnal aerodynamics, and occupying powerful ecological roles. Without bats, many of our natural treasures would crumble: no forests, no orchards. No mangoes, no bananas, no peaches. No tequila, no mezcal. Instead: infinite reliance on chemical treadmills to protect our farms and gardens from insect pests. Far more incidents of nasty mosquito-borne and zoonotic diseases.

Bats entice me emotionally with their toes-up resting stance and their proclivity for constant cuddling. I have slept with bats-in-rehabilitation on three continents: their softly pulsating bodies attached to my clothing like tiny furry extensions of my heart, snugged next to my skin to keep warm.

I pray I can help Bitty.

I delve back into the scientific literature: according to observational studies, Bitty-bat's favorite foods, beyond mosquitoes, are gnats, beetles, and moths. Then I stumble upon a novel fact. I knew that bats echolocate, but I never thought about the mechanics of how insectivorous bats,

especially the more dietary picky ones or "specialists," who go for a select number of species (as opposed to the less discriminatory "generalists"), capture and consume their prey. If the bat buffet consists of flying insects roaming through a several-kilometer slice of the troposphere, that's a huge area to cover for one's dinner. How do bats optimize their hunting strategies?

Turns out my little Bitty bat is preconfigured with a personal fishing net: *Myotis* bats can "hawk" prey in the air by scooping up flying insects with a flexible portion of the skin called the *uropatagium* (or interfemoral membrane). Stretched between the lower part of their leg bones and tail (around the same spot where the calcar is located), and looking like a skirty-bat diaper, the uropatagium is flexible enough to curve up completely around and over the bat's frontside.

If we hominids had an uropatagium, it would be much easier to politely eat with our feet—cramming our webbed toes into our mouths—or play volleyball with our soles uplifted, whopping punts into the air with our butts on the ground.

To care for Bitty-bat, much as I cared for an injured acorn woodpecker (*Melanerpes formicivorus*, the species name referring to their favored prey, ants) by capturing thousands of native ants from our backyard oaks and tweezing them one-by-one onto watermelon slices, I needed to secure wild bat food. Yet when Bitty-bat's life intersected with mine, I was overnighting in an off-grid house, so I couldn't use a high-intensity nightlight to create an outdoor insect trap. I tried a candle inside a basin of water, but came up empty.

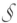

The next morning, anxious to locate something edible on the bat menu, and assuming the bat's avian side of the family endowed them with a hyper-metabolism requiring constant feeding, I searched fruitlessly for bat snacks at agricultural feed stores, natural foods cooperatives, supermarkets. No dice.

I cast my line further into the grocery ecosystem. Rural counties like ours with fishable bodies of water inspire charming oddities: fishermen vying for artificially introduced, not-

terribly-good-tasting species like bass and carp, Native festivals featuring boats made of edible water reeds, and convenience stores offering live bait next to the beer and Gatorade.

Bitty scores a sawdust-packed Styrofoam container of night crawlers, bought enroute to my science lab at a Buddhist academy. Bringing a wild creature into the classroom can be an excellent teaching moment: we can cover food webs—the interrelationships between who eats whom; or ecosystem services—the crucial role bats play in pollination and transmittable disease suppression. When I introduce Bitty to the kids, my biology students have mixed reactions: discomfort due to erroneous bat stereotypes vying with curiosity and instant fondness for something small, silky-furry, alive, and helpless.

I crack open the bait. The recently purchased wrigglers are still wriggling; juicy larval morsels for breakfast. With Bitty gently grasped in my left hand and a pair of tweezers in my right, I realize I've never tried to corral food into such an exquisitely tiny mouth. Even the smallest insect segments are too large; I must secure slices mere millimeters square, an involved, gooey dissection.

I am not accustomed to this: I eat my insects whole.

But I keep at it, and once I achieve the optimal size, Bitty accepts my offering, daintily devouring the segment with miniscule, razor-sharp teeth. I hold a spoonful of water up to her face, and she drinks. The students watch the proceedings, ambiguously alternating between inquisitiveness and repulsion. Ultimately the feeding leaves us mildly thrilled; pleased with the successful bridging of human and other-mammalian worlds.

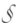

Class ends, and I carry Bitty back to my abode. We make it through our first day, Bitty grasping a branch inside the portable terrarium, alternately dozing and feasting. That evening, in my largely wild and densely wooded homestead, I leave the stairwell light on and the outside door wide open. With the flush of winter-into-spring, our oak forests are rife with insect life. Dozens of moths flitter in. Over the next few

nights I trek up and down the stairs with a mesh-capped jar, wildly successful with moth wrangling, supplying as many dusty-winged, juicy prey as Bitty can consume.

The more I hang with Bitty, the more I see how useful a bat's uropatagium can be. Bitty encircles struggling moths, some as long as her torso is wide, with her extended flap of tail skin, wrapping them in an intimate embrace. Having never witnessed bats feeding on such large insects, I always assumed the mouth-to-prey size ratio to be 3:1, not 1:3.

Apparently not.

Bitty-bat is a raunchy eater. She tears into moth flesh, masticates with her mouth open, makes smacking sounds. Bitty's technique resembles a miniature Sumo wrestler immersed face-first into the depths of his fighting *mawashi* diaper-and-thong loincloth, voraciously consuming jawfuls of meat engulfed in the folds.

I observe her ferocious munching with relieved fascination. I desperately want to be successful in this rehabilitation. If I can save Bitty in a world of absent forests and desecrated mountaintops and endangered species and toxic bioaccumulations and overflowing landfills and catastrophic oil spills and acidified oceans and nuclear meltdowns and a changing climate, then I have moved one step closer towards avoiding complete and utter failure as an environmental scientist.

Restoring Bitty's health would, in the topography of my mind comprised of depressive ruminations on All I Cannot Save, coax me one step back from the ever-looming precipice.

§

I check on Bitty-bat frequently over the next few days, maintaining a warming lamp over her terrarium and keeping a jar lid filled with water that she wing-waddles over to and drinks with micro-tongue laps. Bitty continues to work her voodoo on me. She never stops being anything but exquisite. She makes visible a formerly invisible branch of my extended family.

Yet my bat recovery ward turns into a bat hospice. On the morning of Day Four she is no longer moving. When I pick her up, her body is unbearably light, a wisp of a puff of a being.

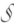

I don't know how or why Bitty-bat died. I don't know what was wrong, or if she (he?) died in peace. All I know is Bitty expired with attentive room service, a moth smorgasbord, and a full tummy. Yet what I know pales in comparison with all I do not know. The true scientist is a humble scientist, prostrate before the infinite realms of not-quite-knowing; of unknowing. The chits of hard-earned knowledge we clutch in our sweaty hands are barely legal tender, unredeemable in most instances.

Gently lifting Bitty out of the terrarium, I take her outside and offer her back to the elements. My heart cracks open but does not break. I accept that our interventions into the lives of others, no matter how well-intentioned or well-crafted they may be, are quixotic and ephemeral.

We can offer a hand, some food for the soul.

But we must offer what we offer with palms open, fingers splayed.

No grasping.

RIO CONSTANTINO

A Place Beyond the Horizon

MY PARENTS TRAVEL A LOT. For the sake of a meeting, they will board a plane, fly to Bangkok, Cape Town, or Delhi, and be back the following week. They have visited every continent except Antarctica, although my father came close once onboard a ship.

For a child, the places they went to were wonderfully foreign. I pestered my parents upon their return. What did they see? Who did they meet? Do the people there eat rice like we do?

After a round of stories they would inevitably turn to work. Some gibberish about the latest news from a conference. Policies, strategies, papers. The details shed were often serious, occasionally grim. Ice caps melting. People dying. Thieves and murderers close to home. I didn't mind. I was still up to my ears in toys and play.

Now I am older. The grim reality of my parent's stories has turned out to be mine. The warming globe will be my generation's to inherit. The tyrants of yesterday, succeeded by the dictators of today, will be ours to face tomorrow. The future is tenuous and uncertain.

An open mind is a remnant of childhood. It comes from a time when everything was seen as startling and strange. The reverse happens as we grow older. The world seems to shrink. Encounters with the new age prematurely. "'I've seen this before," mutters the bitter cynic. A dam halts the flow of time. The continuity between past, present, and future is broken. Only the past seems to remain.

We wean kids off toys. I weaned myself off video games. Play is stopped to give way for study and work. Both tasks require our full attention, often to the exclusion of all else. Life is not always fun and games, especially when the monsters of childhood are translated into adult fears. Ghosts may not be real, but hunger, illness, and lost jobs are.

Yet play exists for a reason. Studies have linked it to increased cognitive activity and improved sociability. Lion cubs play in preparation for their hard life as a predator. We think it wasteful, but play lets our minds engage in open exercise, thinking, enjoying, exploring, leaving the imagination free to stretch and wander. Silliness wakes a foggy soul like a shock of cold water.

Thankfully, I never learned to let go of silly things. While the toy soldiers are kept beneath my bed, a toy robot guards the sanctum of my desk. Posters pepper the walls of my room. Led Zeppelin on the west wall, Lord of the Rings on the east, and Katipunan Beer to the north. Just one window to look out of, but a very nice view of the sky south. When I am tired I lie down on my bed, let the grey light wash my face, and watch the clouds slowly roll down the horizon.

Bruce Chatwin's *Songlines* makes the case that we are hardwired wanderers. Restlessness forms the root of all sin. Rooms are a cage. In attempting to escape the prison of sedentary life, we shake the surrounding order, damaging it.

He might have a point. Our ancestors were extremely successful migratory animals. They settled several distant continents in a very short evolutionary span of time. They walked, swam, and invented boats. Ecosystems were dominated and destroyed by the coming of this great primate.

The Aboriginal Songlines, as Chatwin describes it, are the remembered paths of each Ancestor, totemic beings who sang Creation into being on their travels. Every object they encountered, they named, and so began existence. Their odysseys are passed down from generation to generation, forming the basis of Aboriginal religion, culture, and society.

One passage of the book speculates on the history of the Aboriginals before arriving in Australia. From the Aboriginals' first landing point on the northern coast, a dense thicket of Songlines reaches across sands, seas, and time, eventually reaching an ancestral ape deep in African forest.

Feet allowed Homo sapiens to settle the Earth. From our species' birth we have never stopped moving. Perhaps

restlessness lies behind our capacity to wonder. Far horizons may be the mother of curiosity.

Or it might be something else. Humans have a limited range of sensory experience. It's a consequence of our cognitive abilities, which take up a lot of space. Compared to other animals, we are deaf, blind, and utterly lacking a sense of smell. Ask your dog. Ask your cat. Migratory birds have organs letting them sense the magnetic fields of the earth. We remain on a macroscopic scale, here. What about insects, bacteria, viruses? We can only perceive a very narrow region between the impossibly large and the extremely small.

Our brain has another limitation. It cannot focus on more than a few things at a time. Otherwise, the rest of the body would starve trying to feed this greedy organ in our head. Priorities might cease to exist. If our ancestors could not realize the urgency of the tiger to their left, compared to the clump of grass on their right, they would have never survived.

We tend to notice only what stands out from our surroundings. This can be deadly rather than helpful. What if the clump of grass contained a snake? The most evident threats may be the least important. Unknowns can be as tantalizing as they are dangerous.

The world is a big place. It hides many secrets. The mystery expands into roaring immensity when we consider the abysses of time and space. How did life begin? How did existence begin? Matters we have pondered over the millennia, giving birth to many philosophies, beliefs, and faiths.

Ancient humans were animists. Meaning the first nomadic hunter-gatherers believed each rock, each tree, and each stream, along with all the animals that could be seen, contained spirits. The smallest pebble could have feelings, make requests, and be talked to. The universe was a full place. We shared the world with many other beings, large and small.

Theists came later. Gods and goddesses arrived with the advent of agriculture and a sedentary lifestyle. In some places the gods further coalesced into a singular God. The rocks, trees, and streams emptied out. Their spirits were consumed

or took on new forms. The skies became the sole dominion of a supreme being.

For a traveling nomad, what lay beyond the horizon was a great unknown. For a sedentary farmer, the climate, soil, and seasonal fate of their crop was an even greater unknown. A question mark hung on top of both their heads. Its resolution could mean the difference between life and death.

Questions have the ability to grow and grow. It's funny until you realize how big they can get. Take for example a cloud. What is it made of? Water vapor. What is water made of? Two atoms of hydrogen and one of oxygen. Well, what are they made of? Protons, neutrons, and electrons. And then? Um. Quarks? Inevitably, it ends in another question.

This is both terrifying and exhilarating. The vast territory of the unknown stretches before you. Dark shapes flit across the sun above. It is a sign to curl up into your shell—or break from it. To crane your neck out and see. There are dangers, there are risks, but there is no such thing as complete safety. Moving or not, prey is still prey. In which case, I'd rather take my chances, look around, and know whether the best option is to fight or flee.

People make mistakes. We choose wrong answers frequently. It's how we learn, develop, grow. The problem is when wrong answers are considered right, and no one is allowed to debate them. A situation even more dangerous than ignorance. A gap in knowledge provokes consternation, but an overlooked fault easily solidifies into permanence.

Recent centuries have seen the growth of a movement obsessed with human error. Reality became independent of belief and thought. Tools were made to address human fallibility. Statistics. Error bars. Evidence as a requirement for belief. These are meant to smash aside any false claims to knowledge or superiority. Today the movement is called science.

Its practitioners are given a bad rap. In popular culture they are depicted as cold and sterile. They use too many numbers. They rely entirely on logic like computers. In attempting to record, observe, and describe nature, they extinguish its intricacy in the process.

If anything, the opposite is true. Theories are not formed by just collecting data points. Breakthroughs arrive when somebody makes connections nobody had thought of before, and previously unrelated evidence is combined to form a bigger picture. Imaginative synthesis is just as important as patient experimentation.

Scientists want to understand nature in a way consistent with observed reality. Their work hinges on the difference between what something is, and what we think it should be. Their purest, and perhaps most unattainable goal, is to comprehend the beauty of the natural world unclouded by human sensibility.

In its bid to explain reality, science is outmatched. The universe is immense. It contains phenomena beyond counting. The grains of sand on earth are outnumbered by the stars in the sky. It would take eons to describe, down to the smallest detail, each mechanism behind nature's function.

The same adverse circumstances also allow it to thrive. Science is exploration in the name of discovery. Explorers survive on mystery. They need to ask questions. They want to investigate. Without an enigma to follow, an explorer would be bereft of meaning. If everything were known, or assumed to be known, they would wither away into senility.

Shed of our misconceptions, nature dwarfs all of history and prehistory. It rids us of anthropocentrism. Consequently, the rest of the world becomes very large. As Carl Sagan said, the main ingredients of science are skepticism and wonder. The first, to verify what is true, the second, to keep alive the hunger to know and understand.

The search for something greater is part of our humanity. There is a reason we feel such wonder for the dizzying size and variety of nature. It is also why we create religion, make faiths, and seek God. Both feed the same desire for spirituality. They fulfill a common need to be part of something much larger than the individual. The same motivation drives revolution and collective action, egalitarianism and generosity, because humans are social animals, and often find meaning through society.

It is, however, hard to trust a stranger. In the modern world, where we are more interconnected than ever before, strangers are another great unknown. Who are they? Where do they come from? Do they eat their bread butter-side up? History is full of liars who pretend benevolence, but instead murder, dominate, and steal.

While people are not all good, nor are they all bad. This ambiguity can be frightening. To make socialization easier, we classify people into categories based on race, gender, income and more. The mistake is when categories are based more off personal bias than actual interaction. Reliance on stereotypes closes people off. In an individual's place we see a shapeless mass instead.

Questions are dangerous because they are hard to control. No one knows where exactly they may end up. They can go completely against those who asked them in the first place. The uncertainty is unnerving, especially for those who benefit from the status quo.

Still, we have an affinity for questions. Unknowns have always fascinated us, despite the risk, or perhaps because of it.

There have been many reactions against curiosity. Some say it is folly to know the face of God. Others think it a crime to dispute authority. The rest believe in the power of bliss. Is it responsible to be blissful about the suffering of others? What better way of communing with God than asking a question? Arguments from authority are invalid and self-serving. They are used only as a tool for perpetuating an existing order.

Curiosity likes to peer behind boundaries. It dislikes rules. As a motivating force it has two essential consequences: empathy and hope. The first emerges by definition. Curiosity is a desire to learn and understand. Empathy, the ability to understand and share the feelings of another. Fulfillment of the former leads to the latter. We interact with strangers when we realize that with the risk comes the chance for a new friend.

The second comes from Rebecca Solnit, who locates hope in two places. The future, and the past. History reminds us that societies are always in flux. Culture is fluid, underlying values

and ideas may shift. Actions are not isolated in time and space. What happened in another century, and on another continent, may inspire events in the here and now. Where there are defeats there are also victories. Revolutions do not strike like lightning. They come about after years of growth, like a tree.

The future is unknown, therefore, uncertain. Uncertainty implies a chance for change. History provides the evidence for our capacity to make change. The space where all three meet is called hope. What curiosity does is look for that hope, and fight for it, seeing both the potential and risk of every unknown, and embracing the freedom of uncertainty.

The essence of existence is transformation. The state of life is change. No species lasts forever. Eventually, it evolves, or goes extinct. Death is when all movement stops, as some think will happen to the universe in old age.

Or not. Who's to say? Other physicists believe it will contract instead, and set the stage for a new Big Bang. The fate of the universe is billions upon billions of years away. What it will look like or sound like is hard to know for certain.

A quote from Ursula K. Le Guin, who passed away recently. "You will die. You will not live forever. Nor will any man nor any thing. Nothing is immortal. But only to us is it given to know that we must die. And that is a great gift: the gift of selfhood. For we have only what we know we must lose, what we are willing to lose... That selfhood which is our torment, and our treasure, and our humanity, does not endure. It changes it is gone, a wave on the sea. Would you have the sea grow still and the tides cease, to save one wave, to save yourself?"

Some achievements may not arrive in our lifetime. As Solnit also said, the impact of a person may be felt most long after they are dead. Just because we cannot see what lies ahead does not mean it ceases to exist. Our presence reverberates throughout the years, in the way even small pebbles affect the flow of a river.

Tyrants have good reason to fear a curious mind. Even one can can break the future open, by asking what can, what may, and what should be.

Sometimes I look at the news proclaiming doom and gloom. Famines. Genocide. Drought. Switch to local channels and still the same. Killings, corruption, scandal. The wrong people in power. Trains not working yet again. And I hear my favorite bottle of juice is about to jump up in price by 70%.

To relax I walk inside the house. My parents bring lots of things home from abroad. A prayer wheel and a Maasai club, a hide shield and a Persian rug. Masks painted red, yellow and green. They are reminders of places I have yet to see, and maybe never will see. But the chance remains, for as long as the places are there, a waiting possibility.

J. A. BERNSTEIN

Desert Castles

THREE YEARS BEFORE ENLISTING in the Israeli army, in December of 2001, I was studying in Jordan on a fellowship—a Fulbright, to be exact—and found myself bored beyond human belief. One evening, I called up a handful of friends, who were less "friends," in fact, than suppliers. Three of them were Bedouin paternally, and all had Soviet-born mothers, whom their fathers had met while studying or working abroad. The fourth was half-Saudi, half-Jordanian, and I had met him at a gym, after which he had introduced me to the other three. We weren't exactly close, but because I was foreign and wealthy by comparison—at least, I had my own place—we formed a natural bond, and I cherished getting to know them more than the other Fulbrighters and NGO-types that frequented Amman's better clubs. It was just after six, and an auburn sky bled through the clouds, tinting the hills of Sweileh. From the balcony of my fifth-story apartment, I studied the foggy expanse, a glass of Ballantine's in one hand, a dog-eared copy of *Infinite Jest* in the other. It was my birthday, though I hadn't told anyone.

Samir, or Sammy, as he was known, was without question the leader of the bunch, and also the best-looking. He had a boxer's physique: thick neck, broad chest, wide arms, and, though he was barely five feet tall, he had sandy blond hair, which was short and messily cropped. His forehead was heavily acned, and narrow blue eyes glittered through their nicotined folds. He always wore a black leather jacket, a ragged white shirt, jeans, and a pale army cap, giving him an appearance of something between James Dean and a young Fidel Castro. He didn't speak English, nor did he try.

That night, as he bounded up the steps to my apartment, trailed by the others, his nervous eyes glanced all around. The four men pushed through the doorway, smelling like smoke, and took a seat on my wicker sofa, as well as the carpeted floor.

I asked if the neighbors had seen them. None of them cared. Their primary concern was getting juiced, as it had obviously been some time.

As I put on some Trip hop and lighted a hookah, Sammy kept rubbing his hands, which, one could see, were quite chafed. We had picked him up at the jail last week—a faceless stone building downtown—and he hadn't spoken of it since. The police, like him, were ethnically Jordanian and thus unlikely to have caused him much harm. (The politics of Jordan are complicated; suffice it to say the ruling family, the Hashemite clan, has forged alliances with the local tribes, and together they comprise the whole of the ruling and judicial class; Palestinians and other refugees make up the rest, comprising about seventy percent of the population, though, since their revolt in 1970, which the Kingdom violently suppressed, they have been widely distrusted and occupy the lower rungs. One is either Jordanian or Palestinian, not both, and one does not consort with both sides. Thus, while the cops might have despised Sammy and his clan as hoodlums, they were treated more like aberrant relatives and rarely detained or abused.)

This time, however, Sammy sat with an air of unease. Others talked about the university, where all of them were technically enrolled, and where I also spent my days studying (in theory). We sipped our drinks—three-parts guava nectar, one-part Russian Standard, dispensed in white Dixie cups— and burned through a pack of Wisams. On my stereo, Groove Collective nearly lolled us to sleep, while the diesel trucks purred down al-Quda. Outside, the sky purpled—that fluorescent hue—and Sammy kept kneading his thumbs.

"Ente qwayyes?" I asked. You okay?

He simply nodded. Then he picked up one of my books, *Portrait of the Artist as a Young Man*, and ran his chafed hands on its flap. What he took away from its cover, which bore a young Joyce, grinning beneath his tweed cap, wasn't immediately clear, but he lit another cigarette, studied it solemnly, and said with those glittering eyes, "I heard today was your birthday."

He must have seen the card, which my parents had mailed, laying along my desk.

"Mabruuk," said the others.

Congratulations. "Let's celebrate," one said.

Sammy reached in his backpack and pulled out a tinfoil sheet, along with a plastic bag. We moved to the bedroom, since we didn't want the neighbors to see. Crouching along the ash-stained carpet, beneath the drawn blinds, he pinched out some flaky white powder, ran his lighter beneath the foil, and chomped on a plastic straw. A milky brown foam slowly bubbled, smelling like eggs, and he let me have a long hit.

§

Later, as I lay against the wall, ensnared in the cords of my laptop, I watched him chasing the smoke—the sheer diligence of it: practiced, conditioned, and true. This is what he lived for. The reason he woke. And it was obvious he wouldn't last long. I had only indulged a few times—this was my third—and I was planning to make it my last. The warm feeling enveloped me, buzzing my soul, and putting me nearly to sleep.

My thoughts turned to one evening last week, which I had spent, unusually enough, in the Baqa'a Refugee Camp. This is a roughly one-and-a-half-square-kilometer, poured cement warren sprawling north of Amman. It encompassed some sixty-thousand Palestinians, all refugees and their descendants. Ostensibly in Jordan to interview them, I had spent my day roaming about the grounds, until one elder invited me to his home for tea, whereupon I inquired of his political thoughts. We sat along his plush sofa, inside the dark cell, and he regaled me with pictures of relatives. Little kids came and went, and veiled women served us mint tea. He said he remembered Deir al-Dubban, his village, southwest of Jerusalem, in present-day Israel, from which the family was expelled in '48. They still had the keys to his home, he explained, and someday they would go back.

When asked what he thought of the King, the Jordanian monarch, he spun his hand and shrugged. He was here in '70, he explained, and he had watched the tanks roll in. Like most

in Jordan, he was obviously terrified of the Mukhabarat, the domestic security service, which was widely renowned for its torture and reputed to have agents in the camp.

His son, he said, was a cleaner at the mall, and glad to have that job.

"Do you want to go back to Palestine?"

"In sha'Allah," he said. If God wills it. He lit a Kareem and exhaled.

§

Later that evening, as I left to hail a cab, wading through the mud-covered alleys, I saw a demonstration had formed in the streets. Dozens of youths—mainly late-teenagers—were holding an American flag. Someone had set it alight, and they were stomping on it now. Also propped up was a puffy white doll in torn khaki, a little charred around the edges. It was an effigy of Ariel Sharon, the Israeli prime minister, who, in September of last year, had led a march on al-Aqsa and touched off the Second Intifada. In the duration, scores of people had died, including hundreds of Palestinians. "Death to the Jews," they cried in Arabic. "Death to the U.S." They were dancing and waving ecstatically, some wearing kaffiyehs, others shirtless and wet. Beyond them, a setting sun burned, and the air smelled of roadside meat—the grilled innards they hawked at the stands.

I had seen protests before—inside the West Bank—though this was probably the first time I was genuinely scared for my life. I slunk away, retreating to my apartment, and I could still see that burning flag, that half-sizzled doll, that rage in their eyes as they spun. I understood why they were aggrieved, though I didn't expect them to afford me much sympathy there.

"Let's go," Sammy said, eying me, blinkingly, as I emerged from my stupor.

"Where to?"

"It's a surprise."

My next impression was of riding in a leather backseat—my gym-friend's vintage Mercedes—as we wound down a dark desert road, through the outskirts of southern Amman, over the shrubby hills. A few construction sites loomed, then we

were out of sight. Two others pressed against me. All of the windows were raised in effort to keep out the desert's asphyxiating dust. No air conditioning was on (the car nearly predated it), and yet I was peaceful here, calm. My blood hummed in my veins.

"How about Trance?" said our driver, my gym-friend, sliding in a disc before any of us could object.

The mountains rolled to the west, revealing the cliffs of Mount Nebo, from which Moses had sighted the Promised Land, apparently. The night reeked of diesel and goats.

We stopped what must have been half-an-hour later at a gas station south of Madaba. My gym-friend—Samir was also his name—uncapped a jug of water from the trunk and poured it over the engine, which crackled with steam. The black sky hove into view, its stars made opaque by the canopy's sulfurous lights. It must have been a hundred degrees out that night, but none of us cared. Someone poured juice down my throat; evidently I, too, needed cooling. The Trance soon resumed, and we skidded east, emitting a mountain of dust.

The nice part about being Bedouin in that part of the country—the south, that is—is that you don't worry about robbers or cops. Both are of the same clan. Your gravest concern is breaking down, which I was fairly sure we would do. At least one of us had a cellphone—myself—though I hadn't used it yet. The closest I had come was several months back, September 11th, the day after I arrived in Jordan, when my landlord, to whom I had been introduced by the Fulbright administrators, was showing me the apartment for rent. It was a penthouse, fittingly enough. His extended family occupied the first through fourth floors, and all were incredibly kind. Suddenly, just as I'd agreed to sign the contract (despite some misgivings about the price), they pulled me into the living room, where a television showed a plane flying into a building. Smoke billowed sharply. Soon another plane crashed. They allowed me to use their phone.

Obviously my parents, back home in Chicago, were a little concerned for my safety, what, with my being Jewish in a nation of four million Palestinians, though I had studied

abroad in Israel in college and actually lived in a West Bank refugee camp, so they were used to my overseas jaunts. I also phoned my ex-girlfriend, who was then living in New York, but was unable to connect with her (later, I ascertained that she was fine, and she would blame me, however sarcastically, for having brought "terror back to the States").

"I sorry," said my Palestinian landlord. "Whoever did this, this not right." He himself had been evicted from Haifa as a child but was now a V.P. for a bank. His wife, who was ginger-haired and dressed in a suit, seemed to share his concern. After that, I remained on good terms with them, despite their distrust of my local, Jordanian "friends."

Tonight, as we circled south, passing the ruins of Kerak, Sammy glanced out with unease. What was he afraid of, I wondered. Returning to jail? As far as I knew, he had only been confined a couple days. Perhaps of his father, who strongly disapproved of him and might well have been abusive. Or maybe Sammy, like me—like all of us, in fact—was just afraid of growing up, of finding another meaningless job and idling away life in this hot, arid desert expanse. Little did I tell him, life in the States was almost exactly the same. Our buildings were taller, our prisons less harsh, our suburbs pristine and new, but nearly everyone smoked and numbed themselves as a way of escaping its hell. Of course, some took up writing, as I still intended to do. Even tonight, I had brought along a notebook, intending to jot down some notes, which, somehow, I would ultimately, dazedly do.

It is said that the Nabateans, in contrast to other ancient tribes of the desert, used to represent their gods with unadorned, featureless blocks, or sometimes tall pillars. In the Temple of Luxor, for example, one can find ornate visual depictions, or lucid engravings of lions and hawks. Not so with the Nabateans, who prized robustness the most. And one can understand that, living, as they did, in a valley of sandstone cliffs, where seasonal rains would come thrashing down, carving their way through the rocks, filling the cisterns, flooding the gorges, inundating all that was.

Emerging from the car, we noticed a collection of bricks, scattered highly among the chalked tableland. Above, a few stars peaked out from the north, though they were soon dulled by the glow of a glaucous moon. It was past midnight, the air a filmy haze.

We picked our way amidst the rubble and climbed the limestone heap. Evidently, this mound had been a castle of some sort. A few walls poked out from the ruins, revealing drop-offs below. We clutched our backpacks, our Sprite bottles, smokes, and mounted the sallow ruins. Dried box-thorn stabbed us, as did some spikelets of brome. There were no guards—or people—in sight. Just the motionless highway on which we had come and the vague, green shapes of far mosques, lighted obliquely and howling away in the dark.

I hoisted my legs along the chalked wall and rolled a shag cigarette. Sammy strummed a guitar—from where it came wasn't clear—and the others engaged in a rock fight, cavorting among the ruins. There are dozens of such castles throughout the southern kingdom, a number of which are unmarked. This might have been one of them, or was alleged to be one, Sammy explained, looking out.

He wore his leather jacket. Ash caked his lips, and his fingers picked the guitar. He played it more like an oud than an acoustic, plucking its chords, emitting a dolorous twang. He didn't speak of his father, nor anyone else, though I guessed that was on his mind.

To the west, I watched the far folds of the Jordan—its dusty clay banks, sprinkled above with gold light. Those were the hilltop settlements: Ma'ale Adummin, others in which I had been, though I spoke not a word of this to Sammy, nor my other "friends." They didn't even know that I was Jewish, though they could probably guess as much. That fall, tanks had thundered on the hills to the west, as fighting had just broken out, though we were immune to it in Jordan, as we were to the rest of the world.

Suddenly, Sammy stopped plucking his chords and glanced at the hills, far beyond. "Do you ever want to go there?" he asked me in Arabic.

"No," I said, with a smile.

He knew I was lying—I would go there quite soon. In fact, I'd eventually serve in that war. And he watched me pensively, hands on the strings, silent, with glittering eyes.

Then he continued his playing—his dolorous tune—biting his smoke, as before. The other guys came. We shared a few beers. Then we set off north for Amman.

CHRISTINE AMOUR-LEVAR

36°C Below Zero—Braving the Freezing Cold Arctic Circle with the Nenets Reindeer Herders of Siberia

ITS HEAD FACING EAST, the animal's eyes bulge out and its tongue hangs limply to one side as the rope around its neck, pulled by three broad-shouldered herders squeezes the remaining life out of it. Slowly its resistance weakens, its eyes are fixed on a point in the Arctic sky above, then suddenly, complete stillness. For centuries, the Nenets of Siberia have been living off reindeer meat and blood, utilizing every inch of the animal from hide to heart, to bone and antlers even— nothing is ever wasted.

As soon as the animal is dead, the hide is meticulously removed and kept in one piece to be used for clothing. Then the feasting begins, and everyone starts to tear out pieces of kidney, liver, heart, or whatever parts they most enjoy, occasionally dipping and swirling the bits in the open carcass, which still holds the reindeer's warm blood. A small saucepan containing blood is passed around, and each one takes a turn to have a drink.

When it's my turn, I hesitate just for a moment. I grab the dripping saucepan, take a couple of small gulps and swirl the warm blood around my mouth to show that I appreciate the full flavor. It tastes salty and not at all unpleasant. I'm certain my eagerness to try these newfound treats is fueled by the fact my "Women On A Mission" teammates and I feel extremely privileged to accompany these exceptional people during a portion of their epic yearly migration across the frozen gulf of Ob, in northern Russia.

We are a team of nine women from Singapore, Dubai, London and Kuala Lumpur and ultimately, we've embarked on this adventure to raise awareness and funds for women survivors of war. By trekking in such harsh conditions, we hope to inspire women to leave their comfort zone, their families and homes for a certain period of time, while pushing their

limits in an effort to rally support for a worthy cause. Our expeditions and fundraising efforts have raised USD900,000 to support women survivors of war, violence and abuse. Our funds have allowed over 500 women in war-torn countries to participate in the Women for Women International year-long training programs. Even if we could never claim to truly understand the suffering survivors of war go through, by doing something challenging, so alien to our own way of life, and dedicating it to these brave women, we believe we are standing in solidarity with them, and it gives us strength as we face the howling Arctic winds and debilitating temperatures of Siberia.

The Nenets of the Yamal Peninsula are among the world's oldest surviving true nomads. They are guardians of a style of reindeer herding that is the very last of its kind. In their language, "Yamal" means "the end of the world" and indeed, as we journey with them in this vast Arctic desert, along with their gigantic reindeer herds, we feel as if we are pioneers, standing at the very edge of humanity's first settlement.

On migration days, we are up at four a.m. helping the women dismantle the camp and load their belongings on the sledges, while the men go off to lasso the specially trained transport reindeer from the main herd. Once the reindeer are harnessed to each of the sleighs, the tribe is ready to go. Then begins the 20 to 25km journey to the next encampment, with the sleighs forming a 2km-long convoy snaking its way across the frozen landscape.

We won't eat or drink all day, or at least until the new camp is set up. It's overcast and so dreadfully cold. When the wind picks up and the snow begins to swirl violently around us, the temperatures plummet to minus 36 degrees Celsius. We are grateful for the reindeer fur coats and thigh-high boots the Nenets have lent us. However, in these extreme conditions, despite the many layers we wear, our extremities begin to feel dangerously numb. The biggest risk, as we spend close to 10 hours without shelter, is frostbite and hypothermia. We are aware that if our body's core temperature drops by just one or two degrees,

hypothermia can set in, thus we keep a watchful eye on each other throughout the day for any early warning signs.

When Yuri, the head of the tribe, finds a suitable place to set up camp, usually near a large, flat area where the herd could easily be rounded up, everyone starts unloading sledges, unharnessing reindeer, and setting up chums (traditional conical tents made of reindeer hides). Once the camp is finally set up, it's time for warm tea, and a feast of frozen fish and bread is laid out in front of us. Antonina, Yuri's mother, brings out the vodka, while the family's nine dogs curl up on the furs around us, watching expectantly for any scraps. She then begins to tell us about the rules. "In Nenets culture women have a lot of mystical powers," she begins. We are elated to hear this, then quickly realise there's more to it. "Anything to do with the birth-giving area of a woman's body can be harmful and is considered somewhat of a taboo," she explains.

We soon discover the laws of the tribe, as it relates to women: We are not allowed to step over men or any of their tools. If we come across one of the men's lassos or tools on the ground while walking through the camp, we must always walk around it and never over it, lest we incur horrible bad luck for the whole tribe. Additionally, we cannot cross or put our hand through the invisible line, which goes from the center of each chum all the way to the back of the tent and extends another 100 meters outside. Toileting activities have to be carefully conducted out of sight of any of the men, which in itself is a real challenge given the Nenets men are in constant motion, coming in and out of the camp from any side and at any time.

Additionally, the landscape around the camp is for the most part completely flat, thus our trips to the "toilet" turn into real treks of 200 to 300 meters or more, sometimes in knee-high snow. Furthermore, despite carefully planning our toileting expeditions with great precision and strategy, we discover, to our horror, that the reindeer crave the salt in our urine! Thus they constantly shadow us like ninjas and pounce

on us when we are at our most vulnerable, with pants down, clinging without any success to the last shred of our dignity.

Other camp activities include chopping wood, in order to keep the stoves in the chums burning and drawing water through a manmade hole and pulling it back to camp on a sleigh. The work is constant and yet when we look up on occasion and take in the magnificent scenery around us, we are reminded of the extraordinary journey we are experiencing and drink in this otherworldly landscape, which keeps us quite literally spellbound.

Living with the Nenets is truly an unprecedented honor. As of today, just a handful of people have ever experienced travelling with them. We are in fact the largest group they've ever hosted and certainly the first all-female team to journey with them during a migration. And as the days go by, we learn to appreciate the tranquility of the boundless empty spaces, while the deafening silence of the frozen tundra keeps us suspended in time. The dramatic sunrises and sunsets are unforgettable; even if we often confuse the two, given the days are so short.

Despite the harshness of the environment, we adapt surprisingly well to our new way of life, but it's also because the Nenets are so hospitable, treating us like their daughters, making sure we are warm and well fed at all times. Yuri's pregnant wife Elena sees that I was about to step out of the chum to go herding with the men, who have made an exception by inviting our women's team to see how they move 10,000 reindeer across the tundra. I can't find my balaclava—essential to avoid frostbite when riding on the snowmobiles to reach the herd. Elena quickly pulls off her own embroidered scarf and ties it tightly across my face to make sure the skin is protected, while whispering words of motherly concern in the Nenets language, as I run out.

Undoubtedly the proud Nenets people have cast a beautiful spell on us. The contrast with our comfortable, materialistic lives could not be more extreme. Despite the fact their world now also incorporates some modern items such as phones, generators and snowmobiles, their way of life remains bound

to their nomadic traditions and reindeer herds. In this fragile ecology, the world's end, as it is called, the noble Nenets people of Siberia remind us of the importance of community and family for survival, how we are all connected, and how the future of their home is inextricably linked with ours.

RODRIGO TOSCANO with AARON BEASLEY

A Poetics of Ghosting

Aaron Beasley: So much is often made of poets' responsibility as citizens of the world, the communities they inhabit, the country they occupy. Jen Benka recently argued that "it's poets who have always served as our country's conscience." As a poet, do you feel beholden to a larger body politic? (Is the answer different when we talk about *poets* in the world instead of *poetry* in the world?)

Rodrigo Toscano: In this political climate, I am resistant to making overarching claims about poetry or poets. I have a deep urge to pare things down, so much so that I am refusing to write, or so it seems. I am also acutely aware that I don't have to do any of this poet stuff necessarily—my work life doesn't depend on it, my immediate relationships don't need it, my body doesn't require it, and I don't cling to the identity of a poet when I move in the world. If at this point in my poetic career "society" expects something out of me in terms of social responsibility or commitment or whatever, I say fuck society. You see, I don't want to "attend" to the current moment, I want to *be* <u>another</u> moment. In a way, a "conscience" functions as a reminder of past values. And that's fine, I totally get that, I've even cultivated a vulnerability to that. But now, no, absolutely not. The times are tricky. Many new ideological traps are being laid every day, especially around the notions of identity. People are going mad with throwing down for identities of every kind, many of them in contention with other identities. But this is not the only time that has been tricky. I'm thinking of Malcolm X, precisely as X. It wasn't just Malcolm the heady black writer who was acutely distressed, or a Malcolm hearkening to a proven past, it was X, of no precise definition, no promises therein, no peremptorily traceable trajectory henceforth. Of course, everything that I am saying right now is "problematic." Alright. But I'm staking out my ground right here in this out-

of-cards mode. I'm not coming back to the table to serve up old saws, or wade through endless "complexities," to play the poet hero—which, of course, is sounding very much like some version of the poet hero. See what I mean! It's monstrous.

AB: To go large a moment before dialing it back, it seems like you're describing a kind of risk or wager, a gamble with a sense of history at stake (or am I reading too much temporality in your use of "cards")? One hears the murmur of an argument happening at the poles of playing too safe and playing too close to the chest, neither of which eludes the problem of historical unpredictability, or chance. In certain (mostly academic) circles it seems that the position of patient vigilance or silent reflection would contradictorily deal in both: a too cautionary bystanderism that simultaneously risks ending up on the wrong side of history. Leaving aside the possibility that history, that record of winners, might end up with no "right" side (though this too is perhaps impossible, all things self-determined), wouldn't endless "complexities" actually make matters worse—in a good way? Where do you see these intellectual traps forming?

RT: One of the traps to avoid would be picking up the baton where we last felt socially "sane," or rather, less battered by the incessant sirocco that is Trumpism. That would mean jettisoning the belief that a sheer quantity of more worthy deeds or being better informed—whatever we deem that to be —might result in a tipping point that qualitatively jerks new realities into place. I rather agree with Slavoj Zizek's provocative injunction, "Think! Don't act!" You see, in my day job, it is exactly the opposite, or close to it—rallying cries like "don't mourn, organize!" predominate. Poets, to my way of thinking, are in an excellent place to enact precisely a *forestalling* of expected returns on moral or ethical investments. They can, with some effort, unbuckle the demands of social time from the needs of social space. And whatever is revealed in that strange moment of suspension, if only vaguely sensed, need not be parked onto a discursive

grid by naming it. But even the notion of "effort" needs to change (hey hey, ho ho, agonistics have to go!). This, of course, does not preclude one from learning, and even championing (with tactical care) movements like the Fight For Fifteen, Black Lives Matter, or the lightning bolt that is the #metoo movement. But I think it is important for poets to resist becoming professional virtue signalers. We can do much more, and quite a bit less. Again, engaging some notion of X as radical fugitivity (with a barricadist's élan), spurns me —"onward"? See! How prefigured the road signs of "resistance" can be?

And as far as any sprouting "complexities" that might "make matters worse [for the Trump/Putin/Orban/Duterte et al cultural-political landscape] in a good way" well, the "might" part of that proposition, I'm open to. At the very least a trained, ready rejection of nationalist reductionism won't add to the damage. But we have to continuously examine what we say, write, or even daydream about, whether it contains elements of the preemptively victorious. Rubble, from the previous House we inhabited, is at our feet. There is no reconstructing it (neoliberal status quo ante + <left or right> nationalism), no way to resurrect the subject (resistant or collusive) that made hay out of it. And now the word "repurpose" is ribbing me for a say. Why don't we ignore it a bit and see if it has enough chutzpah to make its way into the conversation later.

AB: If I am reading you right, but even if I'm not, it would seem that one of the supplementary (necessary?) contributions that poets can make to the symbolic is a careful activation of a plurality of speech/thought functions beyond the tacitly declarative or wishfully imperative. That poets might complicate the modes of demand, indeed of desire, as well as interrogate the forces underwriting that yet-to-come, or forestalled. It seems like the slightest victories in the U.S. political scene carry both a hard-won relief and pre-eminent anxiety: Alabama elected its first Democratic senator in a quarter-century & within a day the FCC canned net neutrality

regulations. These are of course broad targets with not-yet-manifest collateral. (As you say, examine! think!) Do you think, then, poetry has any decisive potential with regard to how such collateral effects get processed by society at large? Or is some hermetic clean-up due at the Unacknowledged Legislators Bureau?

RT: On September 12, 2001, I found myself about 500 meters from "the pile" (as emergency responders then called the remains of the WTC towers). That summer, I had been training members of the Utility Workers Union in health and safety practices, and so I was able to ride to the site in their trucks. Between being transfixed by eerily de-purposed objects, such as fire engines reduced to chest high pancakes of steel surrounded by thousands of day minder pages scattered among a sea of concrete dust (some inscribed with to-do's of months past, others with projected plans), I had to find a spot to pee. I chanced upon small hotel whose staff and occupants had hastily evacuated leaving a trail of personal effects strewn on the floors and stairwells. The Charybdis of the day before had already swallowed up not just the definitions of relations between people (and objects) but the very understanding of the social time undergirding those relations.

I crave a poetics of resolute historical recognition where radical repurposing of the remains of immediate pasts is at a premium. And I want to sense myself as a collateral effect, first and foremost, before moving on to the representation of causes and projected results. You see, in our epoch, we're crazy good at stuffing our heads with globs of information encased in emergent (and often, purely defensive) affectual armor, but we're not so good at ghosting historical experience. And that's where poetics (not "poetry" per se) can lend a hand. Ghosting would first entail that speaking subjects be unrestricted to temporary forms of authority gained by remaining within the social locations supposedly proper to them ("as an American" "as a Mexican-American" "as a pan European" "as a Diasporic South Asian," etc.). Those subjects would embrace forms of Global Citizenship that stem from root needs and desires of

The Living as opposed to the diktats and strictures of Finance Capital and its state networks. Second, the horizons of the Future Living would be thought of as para-individualistic— neither autonomist individualistic nor fully sutured collectivist. In this way, the concept of collaboratively conjoined intellectual/emotional/psychic labor is philosophically eons away from wanting to become Shelley's unacknowledged legislators, or worse, Pound's "antennae of the race." So I'd say, yes, I'm interested in, or rather imagine a poetics of decisive potential that, in bright flashes, recognizes (but doesn't "know" per se) its phantasmal self amidst the torn up, the crushed, the pulverized; a poetics of newly sprung alter-nows pressing their way forward towards a futural form of universal agency (X) that's not yet entirely (if ever) "ours." Short of that, it seems we'll be relegated to retrenching back into whatever identities are most available to us. And that, judged from the present moment, seems to invite deep fatigue and empty antagonisms.

I am thinking about the progressive grassroots Indivisible movement, which is currently picking up momentum with chapters in hundreds of cities. The movement is far from revolutionary, but it does recognize the spectral quality of the current moment, that a page has been not "turned," but *torn* out. The loosed-knit organization basically acts as a central meeting place for new or seasoned activists and resisters to Trumpism to integrate their local/regional efforts into mass action, something like the Tea Party but from the Other Side (important not to express that as Left). So, from ghosting to real monster. And you have to love the name, Indivisible. Long gone might be the days (and merry ways) of the Postmodern Dukedom and its fiefdom of *divisabilities*.

AB: If we try to understand the stakes of a psychology of the "futural," I think one would need to meet that decisive potential, or any sense of "recognition," with a measure of both doubt and hope. Yasmin Nair has spoken of the conscious (self-conceived *woke?*) Left's turning away from the unconscious through an obsession with spectral coherency, with performing its dutiful,

hygienic logic of 'right' word & deed. We trade the mess of drives for narratives of "piety and penitence" ("professional virtue signalers" as you put it) and invariably end up in the self-assured echo chamber, or what Nair calls, a "deep void of blandness that we mistake for politics."

Apart from your activist work with multiple dimensions of labor, you have kept some creative distance from the movement style of poetics, which is often given satiric, playfully-serious treatment in your poems. You came on the scene (long before I read poetry) amid the post-Language diffusion of poetic practices, yet simultaneous with the seminal productions of Flarf and Conceptualism. At this still-early stage of our immersion in the Trumpist era, have we reached a moment of post-movement poetics? Or do you see an Indivisible-esque emergence of poetic thinking, one that might reconsider the kinds of divisibilities that shaped/dismantled collective frameworks prior to 2016?

RT: The practice and legacy of Littérature Engagée—the idea of the artist's responsibility to society, especially as defined by Jean-Paul Sartre, namely, that people existentially define themselves by consciously engaging willed action—has, by now, quite a long and traceable history. Myself, I look at "commitment literature" as one plot along a matrix of many possibilities of social marking. A good part of my poetic trajectory has, up to now, shown a strong tendency to exfoliate and exacerbate the tensions among multiple modalities that make up a "social mark." I'm neither for nor against the modality of alignment literature, per se, but I can tell you that I generally loathe art and literature that doesn't employ some kind of contrast in its composition. But do I think that we're in a post-movement poetics? Not necessarily. I just think that not owning up to, or better yet, not completely embracing the vertigo that is being produced by a sense of historical time unbuckling will not get us anywhere in terms of paths towards liberation. Somebody might say, "but, we measure the sense of social 'time' by our very steps along the path, not by metaphysical meditations," yes, but the

"accomplishments" are not *merely* of this time (though they may even be immediately useful); and that's what I said at the beginning of this dialogue, that I want to *be* another moment. This thing of thinking one's self a node, instead of a relay, I think is holding us ("humanity") back. A relay has completely different set of responsibilities than a node. Nodes defend identities as against identities—to the death even; relays see the current going both ways, and measure progress by differences in potential. People, for example, often ask me, how can I spend days, weeks, *months* listening to Alt-Right podcasts. The simple answer is I assume that we're all constituent of the overall epoch we live in. Sometimes the right is revolutionary (in a horrible way, of course), and not understanding the dimensions of that can be fatal.

In terms of whether certain "divisibilities" should be rehabilitated, people have to decide that for themselves, but from my view, I don't see the point, given that most divisibilities return like zombies anyway. I could very easily unfurl a laundry list of concrete movements, and deliberate on how to shape those movements, but I simply can't bear to at this time. I think I captured that dilemma in a piece called, "Clock, Deck, and Movement" from *Collapsible Poetics Theater*. In that piece, one of the readers repeats variations of a phrase with a machine-gun rapidity. This is done as the other readers are intoning more static ("visible," "understandable") junctures in the social realm. The refrain goes like this:

> jerking-it–around-to-see-what-it-knows-and-what-it-can-really-do-ness, to jerking-it–around-to-see-what-it-knows-and-what-it-can-really-do-ness, by jerking-it–around-to-see-what-it-knows-and-what-it-can-really-do-ness, as jerking-it–around-to-see-what-it-knows-and-what-it-can-really-do-ness, jerking-it–around-to-see-what-it-knows-and-what-it-can-really-do-ness this of...*dot*, 6, siege / counter-siege / siege / counter-siege / siege / counter-siege...spipping a freeze to frizz a spupping to grot grot grot: it's like i—like, *could* like—*not* liking it, "it's their fault we don't live in radical times", *it's actually, our fault, man*

There are fourteen permutations to that particular module, all honing in to the crux of un-sayability *as* sayability.

But I also think it's time now to do fearless test runs on Whoever The Hell We've Now Become (as political subjects), rather than strike a voyeuristic, "critical" stance unto The Era. The poet Sandra Simonds, for example, seems totally bent on a radical immersion into this modality. In her writing, she lets her "self" be split into multiple personas that are totally and not totally her at the same time. And alongside that "self" are hosts of strange societal bedfellows, unwitting perpetrators of their own oppression or momentary motions of freedom. So there's a ton of bardic ghosting going on that's not yet discursively explainable, but that feels essential to a re-tooling of political volition. And it's not achieved by means of slippage (since the early 90's, people have invested in either willful or accidental discursive slippage as harboring a place for potential liberation), but rather through rank *pushage* and *crashage*. So again, there are many modalities to the political besides alignment of the so-called person (node) to preemptively graspable "movements."

AB: Your points here resonate with a passage I just read in the third part of Will Alexander's troika, "On Higher Phlogiston Current," where, speaking to Aimé Césaire (or his "extinguished presence") he says, "I could place your flaws in my hand/ & break them/ & scatter broken advice/ making it linger through ghosts/ in undeveloped refrains." Césaire similarly embraced the vertigo of his social time, embodying a profoundly emancipatory politics while dissenting from Aragon's official PCF (Parti Communiste Francais) doctrine of socialist realism, diverging as well from Senghor's essentialist mode of negritude.

What strikes me in various encounters with your work is a mobility of the word that is both durable and durational. Where a more discursive practice might look away from the disconcerting volatility of language's slippage (or *crashage*), your poems turn that granular instability into a testing ground where thought, subject, predicate, proposition, and

preposition face elemental re-articulation and yet still obtain the impression of something *said*, if unsaying. Since we have more or less discussed here a question of thought (but engagement in action) that requires a continued movement at one moment, and a moment's rest at another, can you say something about your writing practice in light of these states/ processes of being? Is your thinking about a futural political volition in any way tied to, for instance, your deployment of permutative refrain?

RT: You know, Shakespeare invented more than 1,700 of our common words—changing nouns into verbs, changing verbs into adjectives, connecting words never before used together, adding prefixes and suffixes, and devising words wholly original. And I can tell you that I spent sixteen years in New York City attending "experimental" reading series, and I can remember only a dozen or so instances where poets took a chance on the practice of actual lexical contorting. It's mind boggling how absolutely conservative most poets are. If you look at the kind of poets that most institutions lionize, you'll start to see the actual barriers to the reception of revolutionary poets like Césaire and our contemporaries that have an irrepressible bent to de- and re- particularize, *detour*, and salvage language. Of course, poets do not have to stress and test language at every point, but to *never* do it—that, to me, speaks of a passivity toward the social itself, given that the social depends so much upon language. But The Social is also *fatigued* by the corpulence of words that point to it, starting with "social." The same goes for The Body, and, by now, "body poetics." But, I do believe that more needs to be done in that poetic direction. At the end of the day, mind is body, and body is the barter of the system. But the semanticathons many of us have engaged in, have no doubt turned off battalions of would-be poets that might have contributed mightily to the understanding of and perhaps kicking to the curb of the worst abuses of language in our epoch. Then there are the quiet poets. So good. So essential. So indispensable. Simply because they don't exist. There is no

such thing as a quiet poet. Every line of poetry is a pair of symbols crashed onto your nose. But it's quite what I want, a quiet poetry, one that's activated bodily, and phantasmally aware of history's wiles. In terms of my own practice, like dead flora in the stomach after a heavy round of antibiotics, after the battering of the political moment, after the poor absorption of even my best contemporaries, after the aches and bloatedness and bad mood, it needs to come alive again, slowly, and needs to be fed the right nutrients to do so.

But about this "futural political volition" issue: Think of a horizon you're heading towards, gazing on its most distant edges, barely visible, a blurring of land and sky, but still a line, and after that, more blurriness, followed again by a line, and so forth. What is more vital for a poet, to keep looking for the line, or to arrive somewhere? I'd say it is remaining open to the very intensity of that question that makes for the renewal of political volition.

RENATO REDENTOR CONSTANTINO

Detours

WE ARE YOUNG FOR A WHILE. And then we are old.

It sounds like a wise axiom but the truth is it's not; it applies only to creaking bones.

There's always an adventure waiting around the corner, something new to discover, something familiar to find again, something to look back at and something to behold.

As a kid I was ambidextrous, a skill I managed to hone out of a goofy sense of efficiency. I figured I'd move less when called to the blackboard in front of class to write down an equation or sentence. I'd start with my left hand and finish with my right.

My teenage years were spent in the mid-eighties listening mostly to Buddy Holly and Chuck Berry while my classmates feasted on Culture Club and Tears for Fears. I don't think I had a notion of bad music then unless it involved Peter Cetera, Falco, and Chris de Burgh. But I just loved my parents' music, which snuck under the skin and brought me sunshine and Blue Bayou.

In terms of songs the first bridge across genres were built when I encountered David Bowie. It felt strange yet comforting to know he sang both China Girl and Starman. Then there was Tina Turner, whose work floated above all fields. In the end it was the Pretenders and Van Halen that defined the 80s sound I enjoyed. Yet I think I'm disconnected in some ways with my generation. Music my son and daughter insist they got from me is by Creedence and AC/DC.

My wife and son and I once went to my daughter's family day class event. The little girl chose to tell us only on our way to school that each family was expected to introduce themselves by singing together a favorite family song. Even one line would do, she said. And so on the way we chose our song quickly and practiced in the car. I remember when the program opened the first eight families sang cheerful ditties and songs that praised God. When our turn came we sang Highway to Hell and afterwards I remember trying to slink under my seat but I realized it was too small.

Every now and then parents succeed in impressing their children, though every now and then they don't.

Over a family dinner I once told the kids of the night I sat beside the pop star Madonna and her lovely children. It was during a service at the Kabbalah Centre in Manhattan where I danced with abandon and sang with others in complex rituals. I remember stepping out of East 48th St. feeling warm and blessed and joyous despite the cold air and the mind-numbing headache I had developed. I had been staring at the celebrity sideways for two hours, pretending I was cool and that she was unimportant.

Wow, said my sardonic son.

Some memories are for keeps and some we wear literally.

We try to follow the footsteps of our elders. My son wore his great-grandfather's shoes during his elementary graduation ceremony in 2012, and nowadays he wears the boots of his grandfather while my daughter wears my mum's shoes.

We take retro seriously. When she was 14, my daughter once happily wore to a party the yellow Twiggy dress my mum wore during the launch of my grandfather's book *A Past Revisited* in 1975. On the same September day in 1997, my wife wore to our wedding the dress my mum wore when she married my dad in 1967. To this day I wear the pajamas of my grandfather, who passed away in 1999. They're so comfortable my wife wore them in 2002 while she was pregnant with our daughter.

To scour the niches of former joys, wrote Patti Smith in *M Train*, and to halt at moments of secret exaltation is a deep delight. We will certainly need them.

As the world turns and fortunes stir, there's always a table full of inevitability somewhere waiting to be upended.

As activists, it's part of a batch of truths my wife and I have tried to hand down to our kids.

There's always mischief to make.

There's always ice cream to enjoy.

Own up to screw-ups whenever you can; be sorry.

The dog eats everyone's homework.

Punch back.

Linda Rondstadt is love.

Leia is beautiful but Vader is gorgeous.

Rain is awesome, "rain that comes like passion and leaves like redemption," as Rebecca Solnit once wrote.

We tell the kids to keep the tenets to heart, because the world will attempt to beat them into conformity and submission, because things are really not going well.

It's important to pay attention and to learn how things work. To learn how to build and create. To read. To befriend disruption. To finish your drink. Life can be hard.

As Jack Gilbert wrote in *A Brief for the Defense*, "If the locomotive of the lord runs us down/ we should give thanks that the end had magnitude."

My first humid brush with activism was over thirty years ago. It was September 1987. The streets were clogged as hundreds of thousands of angry, grieving marchers came out to lay to rest the young leader Leandro Alejandro, murdered a year after the Marcos dictatorship he helped bring down had fallen.

But the formative years had come far earlier, from a house that valued books, questions, curiosity, and tenacity.

At ten I was already asking my grandmother about Palestine and Israel. It wasn't because I was a genius. It was just because books on the issue were available for me to read, and because she was around ready to converse with a child asking about dispossession. Over the years she wrote me long letters concerning history and literature and social issues. She walked me through Carl Sandburg and Bertolt Brecht and always asked me about food I'd love to eat next.

I remember getting lost frequently in field trips when I was in elementary. The only compass I could follow were fluttering butterflies that always went off trail. Occasionally I'd get into fights randomly defending small kids from big kids trying to intimidate them, and since I was small I'd usually lose.

Years later, in high school, after adding heft to my frame and inches to my height quicker than the bullies in grade school, tables turned and tormentor became tormentee at the hands of the previously tormented. I went down the path of toxic homophobic masculinity and got into random fisticuffs. I thought I was rebellious but I realized later all it was was

corrosive machismo. It was garden-variety, shameful, predictable, and god-awful boring.

In university, I waded through endless debates about power and injustice. Some were sublime, others were ridiculous, and one was quite telling. I remember an activist defending the acts of Black September—the Palestinian group responsible for the monstrous massacre of Israeli athletes during the 1972 Munich Olympics—in response to someone defending the monstrous occupation of Palestine by Israel, a homeland established by Jewish people fleeing the extermination campaign of Nazi monsters in World War II.

I was enrolled at the Polytechnic University of the Philippines (PUP) under the helm of the great Nemesio Prudente. It was a school dominated by working class students and for the first time I was suddenly acutely conscious, often embarrassed, of symbols of privilege I had before always worn with ease but which I had barely noticed as signs of a different economic station.

At a full course load of 18 units per semester, the total tuition fee at PUP was equivalent to the cost of just one subject at the University of the Philippines in Diliman. Yet many of my classmates still dropped out, unable to keep pace with the cost of education.

I enjoyed the friendship of classmates such as Amelia, a part-time student who frequently dozed off in class. Her teachers would berate her for falling asleep. She was the breadwinner in her family and worked two jobs, handling hot liquids and dying skins in a stinking leather tannery in addition to ironing clothes in a dry, decrepit laundromat. My other classmates were the sons or daughters of vegetable vendors, washer-women, city hall clerks, truck drivers, security guards. They represented the norm, and the core of Prudente was focused on providing them access to quality learning.

From a cooperatives course, which had too much math, I shifted to sociology. Undergraduate studies provided for me an arena of inquiry, an opportunity to interrogate theories and the self inside classrooms and on the streets.

Joining and organizing rallies proved exhilarating. I remember the joy of helping mobilize 15,000 PUP students, who joined the colossal throng that had assembled outside the Philippine senate on September 16, 1991 in support of senators who that day courageously voted to boot out the military bases of the United States.

In college I encountered subversives, who lived in cramped, squalid communities surrounded by licentious neighborhoods of wealth. Their affinity with shadows allowed them to navigate around seething anger with starlight and sharp knives. Some remain dear friends.

I met purveyors of dogma in college, people who delighted crowds of the converted with quotes from scripture and evangelical fire. For a time speeches delivered with blistering cadence were fascinating to watch, but the pursuit of correctnesses and adherence to formulaic thinking ultimately disfigured the social causes they sought to articulate. It displayed their inability to speak plainly with people they wished to connect with.

The lived experience in university was lithe yet muscular, sticky yet snug. It was enthralling. And then it was time to find work.

When faced with a choice between the unknown and probable stability, consider choosing the greater challenge. It may not be the wisest counsel, but if you do encounter job options, why not invest in your capacity to grow.

It's how I ended up in Tawi-Tawi in 1992 as a researcher in a seaweed-farming cooperative, a period I still call my wonder years.

From the capital of Bonggao we would travel as we would inside a city from district to district, but instead of land craft we moved through flimsy motorboats across different ecosystems. One island seemed to be made of one piece of gigantic rock, where crabs and stone-dwelling fish were the regular fare. Another was covered in Bermuda grass and looked like a great golf course dotted with coconut trees. Another was comprised mostly of sand, where squid, cuttlefish and octopus were the staple.

During long trips, "gear" sometimes consisted of notebook and pen, a pot of cooked rice and an M14 selective fire automatic rifle both of which I was asked to carry. I was told we might encounter occasional pirates but I never felt fear while in Tawi-Tawi, save for one occasion.

I was with two friends from a local village and we were approaching an island to see some colleagues. Near the shore, a large errant wave crashed into us sideways and overturned our tiny boat. With a loud whoosh and an amused yelp, everyone including myself was thrown into the water. From there everything happened in slow motion.

I saw my friends beaming then suddenly frowning as they looked down at a wide bed of long-spined sea urchins. Upon hitting the surface everyone began swimming frantically like crustaceans in order to stay afloat without touching the spiked creatures. But for some reason I chose to hold up the rice pot and rifle above my head and I landed hard on my posterior. Mercifully, another strong wave came by quickly to lift me up and deposit me on the beach.

Everyone remarked once all were ashore how the gun and the meal I carried remained dry but they were very sorry my butt ended up tattooed with stinging needles. They proceeded to untie their sarongs but I ran away wailing and wincing as they laughed. It was the only time I refused their act of friendship; I knew their intention; the accepted salve in the area is to melt urchin spines with urine.

After a decade of trying new things and happily squandering a chance to gain a graduate degree, I joined Greenpeace in 2001 and worked with the firm for seven years. Stress was persistently elevated because the risks taken were often high. But the spiritual rewards often went through the roof. It was a magical time, albeit very busy.

In the midst of running increasingly complex campaigns I got to eke out a book in 2006, The Poverty of Memory: Essays on History and Empire, while managing the pedagogical agenda of the Constantino Foundation, but campaigning took up an enormous part of my waking time.It was love, laughter, rage, and mischief balled up in one package, and it bounced mightily.

The Greenpeace I knew was filled with some of the most obstinate, highly opinionated, highly motivated people I ever met. Some were gentle and soft-spoken and some were fierce, but they were all intense. They had a fire in the belly fed by a sense of urgency—we are running out of time—and the mad belief that the world can indeed be changed (and to hell with the rules).

For reasons of unruliness and obstinacy I was fired thrice and have walked away three times from the organization. But each time I parted ways with a Greenpeace office I was recruited by another.

I covered climate and energy issues as a Greenpeace campaigner in the Philippines in 2001, recruited by Ateng Ballesteros who later moved me to lead the regional campaign in Southeast Asia and to cover different international work. She valued my ardor and tried to shield me from nutjobs and incompetent bureaucrats.

The first time I was sacked, by the Thai executive director of the firm's Southeast Asian office, I was hired within days by my brother-from-another-mother Sze Ping. Between us we helped set up Greenpeace's first climate and energy campaign team in mainland China in 2003 composed of six amazing young women.

It seemed completely mad then, the idea that we can help move the politically problematic, lumbering economic behemoth towards an energy transition trajectory that could pull other countries in a similar direction. But we did what we could, cajoling, charming, persuading, and creating a range of alliances that would nudge, pressure, enable, and work closely with climate action champions in China's very government.

Today, China is a global leader in the deployment of renewable energy systems and strategies, a pace setter that acknowledges it can do even more where it was once treated as a colossal laggard.

Obviously this is not just because of the work of NGOs. China's strides are the result of an intricate dynamic of different factors and actors, and there's never a single silver bullet that slays complex problems. But there's an important point to stress here: an early sense of the odds may give you an idea of what

you are up against but it won't really tell you what actions will ultimately matter.

Since the speed of the transition taking place globally is very much far from optimal, the answer to the question of what to do in the face of seemingly insurmountable challenges is the same: grit your teeth and make things happen, now, despite the size of the challenge, or maybe because of it. Because the truth is everything adds up; it will all matter. Everything counts in the end.

I've sat through numerous scientific briefings provided by the eminent climate scientist and physicist Dr. Bill Hare regarding risks associated with runaway climate change, but I remember one in particular he gave to a small group at the UN climate talks in Nairobi.

He talked about largely stable forest areas shrinking dramatically and replaced by savannahs, about massive staple crop failure across many regions and record heat waves. I remember his terse opening line. "Okay guys, listen up. This is what we know. It's going to be ugly and the window for action is getting considerably smaller."

This was in 2006.

Today, confidence in scientific projections is higher, with more dire impacts and knock on political effects expected.

Entire marine ecosystems are on the verge of collapse. Scientists project the demise of at least 98 percent of coral reefs globally by 2050—in three decades—if temperatures increase to 2 degrees Celsius above preindustrial levels.

Agricultural risks are heightened, threatening to inflict more instability across countries and continents. The risk of violence flaring up as harvests fail is now increasingly connected to the rise in the number of refugees from collapsing economies fleeing to Europe, North America, parts of affluent Asia, and Australia, and the rise of authoritarian regimes feeding off fears of "invading others."

Rising sea levels due to melting glaciers and the thermal expansion of oceans mean catastrophic coastal floods that currently occur at a rate of "one in fifty years" are expected to take place annually by 2100.

There is a foreground of chaos in the horizon because the consequences of inaction are real and will hit the poor and the vulnerable with frightening velocity and violence. How much harm will befall those least responsible for the climate crisis is a choice many will have to make, and soon. No one will be spared the choice between involvement or complicity by indifference.

$$\mathcal{S}$$

"What some / could not have escaped," wrote Jane Hirshfield in her book, *Come, Thief,* "others will find by decision. // Each we call fate."

We know what we should avoid. We can't buy our way out of this mess and we certainly can't stave off ruin using the same instruments of economic orthodoxy that led us down the very hole we're in.

We know what needs to be done.

The power sector needs to be rapidly decarbonised along with buildings and transportation, including shipping and aviation. We need to stop deforestation and move to sustainable agriculture. We need to defend biodiversity as if our life depended on it, because it does.

Some have decided where their contributions will matter most, contributing to the new insurgency fighting to break the incumbency of fossil fuels slow-baked into the global economy for over a century. But there are also so many other arenas of struggle deserving of popular support.

The point is to wade in and to get involved and in the process evolve a more active and deeper sense of citizenship.

The late writer Eduardo Galeano shared a message he once saw scrawled on a wall in Bogota, Colombia that deserves our pause: let's save pessimism for better times.

Because there's still time.

Life is long before it ends.

ROBERT COWAN

Close Call with Siberian Kickboxers

being deeply loved by someone gives you strength, while loving someone deeply gives you courage

The taciturn kick-boxers and I are exhausting the path of light through the trees, careening down a crevasse of road carved through remarkably straight conifers, when a full black vehicle much larger than our aluminum can charges us directly until we all come to a blinding halt, halogen antlers interlocked. Four men leap out of the car yelling, dressed in full riot-gear and with pistols, what I think are Kalashnikovs, and stammering footsteps demand we exit our vehicle. My insides twist. The three kick-boxers tell me not to say anything. We climb out cautiously, hands up. They make us put them on the car roof, spread our legs, and frisk us by running the cold machine gun barrels up the insides of our bare legs, still hot from the sauna. I assume that they are police, forgetting that this is Yeltsin's Russia, not the Soviet Union.

I had just finished college and was avoiding responsibility. It was during the first of the big bank scandals; people were losing their life savings and no one was getting paid. This area, a couple hours north of the Kazakh border, just beyond the Urals, the beginning of Siberia, is run by the mafia. Why had I thought coming here—to work at an orphanage, of all things—was a good idea? Not that I thought that all the men at the camp were connected with the mafia. Most of them were ostensibly unemployed coaches, though some had shady ties to the Honda Civic-driving toughs in Kamensk-Uralskiy, a small city once known for its cannon works, where the orphanage was. The children were out of school, so the orphanage was emptied, and they had been sent to this summer camp in the woods, populated mostly by children who have families and would make fun of them. There was a

pool, filled with water from the radioactive river nearby, and a music teacher with an accordion. The three sports they could play were chess, soccer, and kick-boxing. It was summer, so the sky got dark around 11:00 and light again around 3:00, but under the trees the darkness lingered for longer.

Druzhba ("Friendship") was an old scout camp from the Soviet era, with a statue of Lenin and slogans about what "pioneer" children—as boy- and girl-scouts are called in Russian—should do to support the system. But my kids, from the Sinarski Children's Home, were not pioneers of any sort. They were not forging new territory. They were more like the kick-boxers—but ones with poor balance, thrown on their backs, kicking and punching with all they had just to get up. Turtle kick-boxers. For children in Russian orphanages are like cases in Dickens novels. The only "toys" at Sinarski, which housed over two hundred kids, were one bicycle with no seat or chain and a pile of aerosol cans. I was responsible for 14 kids, between the ages of eight and 14, 24-hours-a-day, for three months. Two of mine had witnessed one of their parents murdering the other parent. One beautiful boy, Vanya, would run in a circle for 45 minutes at a time, laughing his head off. It was funny, and terrible. But after he broke into the electrician's dacha, he was sent away. To somewhere worse.

At night, I would retreat to my room and read the two books I'd brought: the *Tao Te Ching* and *Ulysses*—one a self-help manual for a king, the other a compendium of obstacles to orgasm—both comforting in their ways. Both with something to teach me about fate.

can you cleanse your vision till there is no blemish?

I was supposed to be working with three other Americans—two women and another man—but, as it worked out, I was alone. The other guy, Michael, was one of the most singularly amoral people I've ever met. We'd bonded on the plane over a

common interest in melancholic British pop music, he a lumbering, affable guy with a Master's in Russian. The children loved him immediately. He was recently married, but fooled around with a girl who worked at the camp his first night there. She was about 17. Then he leveled with me that he didn't care about the children and had only applied to the program to get a visa. He had a job interview in St. Petersburg and when he left, he lied to everyone at the camp that he would be back in a week. They believed him at first. I knew he would not return. I did, however, see him again, years later, on West 57th Street. Michael went ashen as I called his name. He was with the wife he'd betrayed that first night in Siberia and in the intervening period had gone to, perhaps unsurprisingly, law school.

Melinda and Serena, the two women, had mercifully been sent to a camp ten miles away. They were Mormons who did not drink, smoke, ingest caffeine, or take part in any fun that could remotely be construed as illicit. The Russians thought they were from Mars. I thought they were from Hell. They turned out to be from Spokane. They had brought three books with them: *The Book of Mormon* in English, *The Book of Mormon* in Russian, and *Jane Eyre*. In their light, I preferred Michael and Joyce's Leopold Bloom. At least they appeared to enjoy life.

think you're escaping and run into yourself. longest way round is the shortest way home

I somehow managed to get away from everyone one day when I was feeling overwhelmed and take a walk on the path along the river through the forest of birches. There was a tree fallen across the path, suspended so that one had to duck under it to proceed. I was deep in thought—trying to decide whether I too would abandon this volunteer work, which was turning out to be more than I bargained for—but stopped, feeling eyes on me. An owl no fewer than eighteen inches high was sitting

right before me on the fallen tree, about fifteen feet away. An animal maybe fifty yards off broke a branch on the ground, and the owl swiveled in surveillance, forth and back. I was frozen, the two of us in silence, opposites: I motionless but breathing audibly and it turning like a noiseless glockenspiel. The far-off sounds faded and the owl finally came to rest its stare on me for seconds that seemed like excruciating, fascinating minutes, as if my ears were covered and my eyes as large as its discs. Then, it spread wings of four or five feet across and with a single, suddenly loud, rustled beat flew past me, leaving a dark empty space amidst the white birch stripes, and an eerie breeze.

This had been quite the opposite of a night in the forest the following week, when I'd dealt with the stress of being there differently. I'd gotten terribly drunk with the camp staff, which consisted mostly of people who worked at the camp in summer but who, during the year in Kamensk, were normally nurses, janitors, cafeteria workers, and from that enormous professional class the Soviets called "engineers." Drinking vodka with them on other nights, I had found myself forced to be strategic about rationing food so that I could make it to the bottom of the bottle. Following their lead, I would take a big whiff of black bread before downing my shot. I would take every piece of chocolate or *shashlik* offered. But when you triumphantly reach the end of that bottle, suddenly a full one emerges from under the table, and you realize, glancing down, that there are six more on the floor. On this particular night, in a clearing, around a big fire, we had danced and laughed—a lot of jokes about hedgehogs, the humor of which was lost on me. A fat nurse in her fifties, with gold teeth and curly hair in an unnatural orange peeking out from under her kerchief, had gotten down on her knees amidst cajoling and hoots and proposed marriage to me on the condition that I took her back to America.

I don't know how I made it back to my room, but I was poked awake by sunlight and the giggling of a crowd of children

perpendicular to my gaze, as I lay face-down on the steps up to my door, thankfully not quite in the vomit I'd indecorously deposited alongside them.

we walk through ourselves, meeting robbers, ghosts, giants, old men, young men, wives, widows, brothers-in-love. but always meeting ourselves

The day I had the machine gun in my crotch, it was 91° and we were coming back from the farm in Mermansk that belonged to one of the kick-boxers' parents—the one who hadn't even the courtesy to grunt and who looked like he had been carved out of tooth enamel with a dirty, blunt instrument.

We were all sore from a barefoot soccer game earlier in the day. Not everyone who worked at the camp had sport shoes, so, to be fair, no one wore them. This I was used to by then. What hurt was that the stocky, thickly muscled maintenance guy had nailed me with his shins of steel, and I was still hobbling a bit. He was covered in jet hair from his furry toes to his Windex-blue eyes—one of the strange Eurasian looks of Siberia. My friend Genya took him out for me later in the game, laughing. Genya was a martial arts enthusiast and a veteran of the war in Afghanistan, who'd come home at age 19 so disturbed that he'd attempted to commit *seppuku* with a sword. The astonishingly long, deep, twisted scars on his abdomen quaked with laughter as he celebrated his takedown.

One of the kick-boxing coaches, Volodya, had said the silent kick-boxer was from a farm down the road where they had a sauna. So we had smoked some stinky Kazakh weed after the game and driven out there in Volodya's half-cylinder car. I was a little apprehensive since I had heard gunfire out that way a few days before and the swimming instructor's wife had been murdered by the mafia in Kamensk (as a message to her brother) and he had not dared to go into the city for her funeral.

The farm was actually a little outside Mermansk, which was itself only a crossroads marked with three Siberian houses—dark brown with the elaborate blue and white window casings. The quiet pedi-pugilist's mother had given us milk directly from their cow and some radishes, while her son stoked the fire in the "sauna." We filed into his room, which had newspapers nailed to the walls—to cut down on the wind from across the plain, I guess—and a large glass cabinet with about 40 bottles of local vodka and several thousand flies. The so-called sauna consisted of a small set of planks that he had constructed around an old iron furnace hull, which he filled with wood and set alight. It got so hot in there that we had to wear hats so that our ears wouldn't blister. We went in two at a time—the silent one and Volodya, and me and the fourth one of us, the young guy. The young kick-boxer didn't seem to have only kick-boxing going for him. He was handsome and muscular, with more on the ball mentally than the other two, or so it had seemed in the couple weeks I'd seen him around with Masha, a trampy girl I'd wanted to sleep with, who wasn't his girlfriend either. I'd stayed away from her though, for it seemed likely that I could get hurt by someone for making overtures to her.

As I entered the sauna, I hit a moistureless wall and I struggled to figure out whether I'd die faster breathing in the pure heat or not breathing at all. But, Mitya (I think the young guy's name was Dimitri) pushed me in and before I had any time to strain my eyes and lungs open, much less acclimate, he began brutally beating my shocked body with leafy birch branches. I was surprised to find that this was masochistically soothing and, for reasons that I didn't entirely understand, took no small pleasure in beating him back. We stayed in as long as endurance allowed—about four minutes—and then let the real masochists back in.

Afterwards, we walked around the farm a little, eating bitter salted cucumbers from the silent one's silent mother's garden —a silence uninterrupted by gunfire. Twilight seemed far

away, off across the steppe, but we knew that beneath the birches and pines it was already night.

be content with what you have; rejoice in the way things are/ when you realize there is nothing lacking, the whole world belongs to you

I got one day off that whole summer, which I spent curled up in a ball on Zoya's couch in Kamensk, the victim of intestinal mutiny. I had been so careful not to drink any unboiled water. I'd gotten used to drinking immersion-coil-heated Nescafé in the scorch of summer. But the night before, Zoya, the sexagenarian English teacher who was working at the camp, had brought me back to her apartment in the city so that I could meet her children and their spouses, and drink—a lot.

Before they all arrived, she and I watched a game show on which three carpenters used axes, their traditional tool, in various competitions: making as thin and long a shaving as possible from a long plank, hammering in a giant nail through a beefsteak tomato as deeply as possible without injuring the tomato. The winner, after demonstrating not inconsiderable skill, won a boom box, the runner-up (no joke) cans of beans.

Hours later, after many swigs of vodka and much conversation about everyone's lack of money, Zoya brought out a tray with small glasses of water on it and I was so parched that I greedily downed two. Months later, my gastroenterologist in New York said I had the worst stool test results he had ever seen—bacillary dysentery, giardia, and two other kinds of parasites I don't remember the names of. He gave me two courses of the highest dose of flagyll he'd ever given, a drug that kills just about every living thing in one's body. I had diarrhea for the next month after that night at Zoya's, getting to know well the camp's white-washed toilet hut, an enclosed platform with a hole in it, that the children jokingly called *Bely Dom*, "the White House."

My gastro-intestinal tract finally evened out seven years later.

***we mold clay into a pot, but it is the emptiness inside that
makes the vessel useful***

The children would be particularly rambunctious when it was
time to put them to bed. Once, histrionic, 11-year-old Kolya
was standing on top of a dresser introducing a dance routine
two of the girls were to do by announcing, arms outstretched:
"Paramount Pictures presents...!"—the only English words I'd
heard him say all summer. Kolya was the youngest of four
Uzbek kids at Sinarski who had the same mom and four
different dads, so each with a slightly different skin-tone.
Kolya was the darkest and thus the most picked on. He was
my unofficial Sancho Panza, the one who dreaded most the
day I was to leave. I was told only the week, not the day or
time, they were to come for me.

The day they came, the children were in the middle of a
variety show the whole camp had put together. The
announcement came over the loudspeaker—the one that had
woken me up in the morning with songs like "Purple Rain"
and "Jailhouse Rock"—that Robert was leaving. The
performance ended in a vocal explosion—audience and
performers alike—running, screaming at me, and out of the
hall. As I dashed back to my dacha to throw together my few
things, a crowd of at least a hundred children—not just my 14,
but all the others at the camp I'd played with and known—
mobbed me. Most of them burst into tears: "Don't leave us!
Don't leave us, Robert!" In the midst of all this, Vera
Nikolaevna, a woman I had worked with closely, begged me
out of nowhere to take her with me, sobbing. As I climbed
aboard the small bus that had rolled up, the children shook it,
screaming and bawling.

It was arranged that I would spend two days relaxing at a
sanatorium in Kamensk, unfortunately with the Mormons. I

would stare out over broken Kamensk for two days and say almost nothing to them. I turned to my Lao-Tzu and Joyce on the bedside table, but they were as silent as the kick-boxer's mother on the farm.

hold to the now, the here, through which all future plunges to the past

At the sanatorium, my mind drifted back to that day that I'd had the Kalashnikov in my back, a moment in which my ears were not filled with laughter or even sobs, but with frantic shouting, extinguishing the images of the children, the owl, the pragmatically romantic nurse in the forest. I had nothing on me except my room key on a string around my neck, and my clothes were distinctly un-First-World in origin, so I wasn't worried about being robbed or found out. And yet, we had heard of random people around there being shot for no particular reason.

But then, out of the somber gloaming of the road through the forest a third vehicle careered to a screech and men in more professional looking outfits began screaming at our menacing friskers. The Kalashnikov-wielders darted into their car and toward the light between the trees down-road, the M16-handling "professionals" in immediate pursuit. Almost before I could turn around, we were free to go, dramatically unmolested, not entirely sure what had just happened.

The prospects for the kids at the Sinarski Children's Home were not promising. Over twenty years later and with a teenage girl now myself, I know that most of the girls either became prostitutes or went to work in the remaining factories in Kamensk or are unemployed at the jobs they may have trained for. The boys are probably marginally employed, rich gangsters, in prison, or dead, unless they fled for the oil and gas fields. My mother has sent Zoya money for operations for uterine cancer.

Having finally wrestled the children into bed that night, I stumbled back to my own room, trying to decide whether to read Lao-Tzu or Joyce. What light would they shed on the fact that I had so easily escaped one of the gruesome fates that so many come to here? Muscles sore from soccer, my skin smooth from the sauna, I didn't read at all. I lay staring at the cracks in the dacha ceiling, listening to the machine gunfire down the road.

JOHN BLOOMBERG-RISSMAN

My White Privilege

I AM A WHITE JEWISH PETIT-BOURGEOIS MALE who has
been concerned with all forms of social injustice since I
watched black civil rights marchers on their way from Selma
to Montgomery trying to cross the Edmund Pettus Bridge in
the face of a mob of white psycho cops and their snarling dogs
on my parents' tv when I was 14 years old. That was the
moment I knew which side I was on, the moment I had my
answer to the question posed by the old Harlan County union
anthem, written by Florence Reece back in 1931 (which I may
in fact have heard by then; my parents were liberals, but
leaned left). Thus, it was quite distressing to discover all my
built-in privileges. It made me feel like Bruce Banner felt after
his first transformation into The Incredible Hulk, someone
with dangerous superpowers he most definitely didn't want.
Guilty and horrified. "HULK SMASH!" Not if I can help it. But
I can't. How do I know? Let me count the ways. Please allow
me to talk with you about my white privilege, via what has
become known as "the Tuvel affair."

In Spring 2017, a paper appeared in *Hypatia* vol. 32, no. 2.
The author was Rebecca Tuvel, a philosophy professor at
Rhodes College in Memphis, TN, and the article was titled "In
Defense of Transracialism." As the abstract has it,

Former NAACP chapter head Rachel Dolezal's attempted
transition from the white to the black race occasioned heated
controversy. Her story gained notoriety at the same time that
Caitlyn Jenner graced the cover of *Vanity Fair*, signaling a
growing acceptance of transgender identity. Yet criticisms of
Dolezal for misrepresenting her birth race indicate a widespread
social perception that it is neither possible nor acceptable to
change one's race in the way it might be to change one's sex.
Considerations that support transgenderism seem to apply
equally to transracialism. Although Dolezal herself may or may
not represent a genuine case of a transracial person, her story
and the public reaction to it serve helpful illustrative purposes.

The article argues that "[s]ince we should accept transgender individuals' decisions to change sexes, we should also accept transracial individuals' decisions to change races." Needless to say, the article, within academic circles at least, became as controversial as what Dolezal had done, or, rather, had attempted to do. Within days of publication an open letter appeared, one signed by hundreds of scholars, directed to the editor of *Hypatia*, Sally Scholz, and to "the broader *Hypatia* community." It is important for reasons that will soon become clear that I must quote the whole letter [JBR note: it can be found at numerous places on the web. See for instance, https://gendertrender.wordpress.com/alexis-shotwell-open-letter-to-hypatia/Gender Trender, where the names of all the signatories are appended]:

> As scholars who have long viewed *Hypatia: A Journal of Feminist Philosophy* as a valuable resource for our communities, we write to request the retraction of a recent article, entitled, "In Defense of Transracialism." Its continued availability causes further harm, as does an initial post by the journal admitting only that the article "sparks dialogue." Our concerns reach beyond mere scholarly disagreement; we can only conclude that there has been a failure in the review process, and one that painfully reflects a lack of engagement beyond.
>
> While it is not the aim of this letter to provide an exhaustive list of problems that this article exhibits or to provide a critical response, we would like to note a few points that are indicative of the larger issues. We believe that this article falls short of scholarly standards in various areas:
>
> 1. It uses vocabulary and frameworks not recognized, accepted, or adopted by the conventions of the relevant subfields; for example, the author uses the language of "transgenderism" and engages in deadnaming a trans woman;
>
> 2. It mischaracterizes various theories and practices relating to religious identity and conversion; for example, the author gives an off-hand example about conversion to Judaism;
>
> 3. It misrepresents leading accounts of belonging to a racial group; for example, the author incorrectly cites Charles Mills as a defender of voluntary racial identification;
>
> 4. It fails to seek out and sufficiently engage with scholarly work by those who are most vulnerable to the intersection of racial and gender oppressions (women of color) in its

discussion of "transracialism." We endorse *Hypatia*'s stated commitment to "actively reflect and engage the diversity within feminism, the diverse experiences and situations of women, and the diverse forms that gender takes around the globe," and we find that this submission was published without being held to that commitment.

Many published articles include some minor defects of scholarship; however, together the problems with this article are glaring. More importantly, these failures of scholarship do harm to the communities who might expect better from *Hypatia*. It is difficult to imagine that this article could have been endorsed by referees working in critical race theory and trans theory, which are the two areas of specialization that should have been most relevant to the review process. A message has been sent, to authors and readers alike, that white cis scholars may engage in speculative discussion of these themes without broad and sustained engagement with those theorists whose lives are most directly affected by transphobia and racism.

We urge that *Hypatia* immediately acknowledge the severity of these concerns. In addition to retracting the article, we also believe it is imperative that *Hypatia* commit immediately to the following:

1. Issue a statement taking responsibility for the failures of judgment associated with publishing this article and apologize for the initial uncritical response posted on *Hypatia*'s Facebook page;

2. Open its general editorial norms and procedures to scrutiny moving forward;

3. Release a statement about its review practices and a plan for improvement. This statement should identify the cause of the problem and pledge to sustain dialogue with both people targeted by transphobia and racism and scholars who specialize in the related relevant subfields of philosophy in future submissions;

4. Avoid the practice of deadnaming (that is, referring to trans people by former names) and commit to developing best practices for naming trans individuals as authors and subjects of scholarly discussions.

These steps are especially important, considering that areas such as trans and race theory have historically been underrepresented and excluded from the field of feminist philosophy. Given this history, it is especially dangerous for *Hypatia* to stand behind an article that exhibits poor scholarship in both fields and little concern for the voices of those most

impacted by "theoretical" debates on the subject of racial and trans identity.

We write with a feeling of urgency to make the *Hypatia* Editor, Boards, and scholarly community aware of the reception of this article and to register the dismay that we have experienced after seeing that a journal of *Hypatia*'s caliber—the most widely respected journal in feminist philosophy—would see this article fit to publish. As scholars who view *Hypatia* as an important and valued resource, we deserve and demand better.

Note from statement writers (added 5/1, at approximately the 520th signatory): "We acknowledge that this statement should have named anti-Blackness directly. The statement is not an exhaustive summary of the many harms caused by this article. We hope it will at least serve as a way to register that harm and issue a demand for a retraction. This is one step in the direction of seeking accountability for the harms committed by its publishing—and to begin a conversation about the larger problems with our discipline it represents. And we thank Chanda Prescod-Weinstein (and others) for pointing out the dangerous erasure of anti-Blackness and the erasure of the Black labor on which the rhetoric of our own letter is built."

I quote the whole letter because what I find important in terms of my own white privilege is the way the letter's focus shifts from an equal emphasis on what its writers find problematic about the article's treatment of trans and race issues to a specific emphasis on race. As one black scholar later put it, and here I paraphrase, because I don't recall where I saw the quote, "You can become black when I can become white." The emphasis on race rather than gender has continued. *Philosophy Today*, Volume 62, Issue 1, Winter 2018 includes a section titled "Special Symposium: Rebecca Tuvel And Her Interlocutors"; as its editor notes, only one scholar in the area of transgender studies had any interest in participating, but in the end did not contribute. All the contributors, then, focus on the issue of "transracialism," and argue against it.

All this is by way of saying that while it appears possible for me to change my gender, it does not appear possible for me to change my race. Personally, I find that inarguable, if not in

philosophical terms, at least in real-world ones (see the contribution by Lewis R Gordon, specifically, for more on this).

So, I am stuck with my whiteness. Ergo, I am stuck with my white privilege. Even if "real" white people hate me because I am a Jew. I don't want it. I don't want it at all. Or, rather, and better, I want to extend whatever I have to everyone. Which, of course, I don't have the power to do. Some years ago, when affirmative action was being challenged and then ruled illegal, I took part in a demo in support of it, I got into a discussion with a 30-ish white male. He told me that he thought he had been denied admission to grad school because a person of color had gotten "his" place. My response was (and still is), that that's a terrible reason for ending affirmative action, that I personally would be happy to pay more in taxes so that both he and the person who took "his" place could continue to go to school. That stopped him short. He said, you are the only person I have ever met that would be willing to do that. I doubt I am the only person, but still.

I just typed "how to get rid of white privilege" into Google and got "about 207,000 results." I scroll thru the first half dozen pages and if they are at all indicative realize that about 99% of the hits have nothing to do with getting rid of white privilege, they are rather articles or discussions or whatever on "white privilege is real." The few that deal with what I typed include suggestions such as avoiding cultural appropriation, e.g., "Friends don't let friends fix their hair in Bantu knots simply because they saw it in a high fashion magazine at some point during this past year." Another suggested that white people who are "woke" (which is itself "a political term of black origin which refers to a perceived awareness of issues concerning social justice and racial justice", and which I use here to signal how easy cultural appropriation is) call out racism where they see it and drop their racist friends. None of this means I can't get something important when I listen to jazz or blues, or that I can't respond to the work of Noah Purifoy or Kerry James Marshall, or that I can't get angry when the police murder another black male, or that I can't march

with #BlackLivesMatter. It just means that none of those things erase my privilege. I'm stuck with it.

I could apologize, I suppose, but what good would that do? I could call myself an ally, I suppose, but whether I am an ally is up to others, those I claim to ally with, not up to me. All I can do is whatever I can do to fight for social, economic, gender, etc. etc. justice whenever possible. The last sentence of André Breton's *Nadja* reads (in English): Beauty will be convulsive or not at all. I have riffed off that to come up with my own slogan: Justice will be intersectional or not at all. More than by the way, the coiner of the term "intersectionality" is Kimberlé Crenshaw, a black woman and an expert on race and the law. It is improbable that a white person, however thoughtful and educated, would have come up with the concept. That improbability is white privilege in a nutshell.

POSTSCRIPT

Five minutes after mailing off this piece, I come across this article at http://www.philly.com/philly/news/starbucks-philadelphia-police-viral-video-investigation-race-20180414.html *The Enquirer*. I will excerpt some salient bits:

Video of two black men being removed from a Philadelphia Starbucks draws outrage, investigation

Updated: APRIL 14, 2018 — 11:26 AM EDT

A video of two African American men being removed from a Philadelphia Starbucks has drawn national outrage and an "internal investigation" by police after it was posted earlier this week.

The video, which had more than 2 million views on Twitter by 11 a.m. Saturday, shows at least six Philadelphia police officers taking the two men into custody without resistance at the Starbucks coffee shop at 18th and Spruce Streets.

A second video, apparently taken minutes earlier and leading up to the arrest, shows a group of Philadelphia Police officers speaking to the men and removing chairs and tables from around the table where they are seated. The men sit calmly as the

officers move closer. Then a third man, Alan Yaffe, who is white, enters the frame and questions why the police are standing over the men. One officer says they are "trespassing," and adds they had been asked to leave.

"Why would they be asked to leave?" Yaffe asks, adding that the men were waiting for him. "I wanted to get coffee for two black guys sitting and meeting with me," he tells the officer. "Does anybody else think this is ridiculous?" he asks other patrons in the shop. A woman agrees. "It's absolute discrimination," Yaffe adds. He says he and the men can go elsewhere to meet. An officer says it's too late for that, because the two sitting men had previously declined to leave. The video ends as the officers arrest the men and leading them out of the coffee shop.

[...]

"Based on my discussion with witnesses," a Starbucks manager "was the person who called 911," Wimmer [JBR note: Wimmer is an attorney Yaffe called who instantly took the case pro bono] added. Also based on her interviews with eyewitnesses, Wimmer said she believed the reason for the address "was completely based on race. There was no indication any crime was being committed, and the video makes that clear." She added that in her criminal defense practice she has received previous complaints of African Americans arrested at businesses and accused of trespassing who had not committed crimes.

In the short clip shared Thursday on Twitter by @MissyDePino, which shows the two being handcuffed and taken out of the coffee shop and a man, Yaffe, who says they had been waiting for him questioning why they are being detained, has since been retweeted more than 65,000 times.

"The police were called because these men hadn't ordered anything," DePino wrote, tagging the company. "They were waiting for a friend to show up, who did as they were taken out in handcuffs for doing nothing. All the other white ppl are wondering why it's never happened to us when we do the same thing."

[...]

[JBR Note: I have omitted a number of tweets that are interspersed throughout this article. But I thought this one should be kept. One letter, which looks to be a typo, has been silently corrected]

Brittany Packnett
@MsPackyetti
19h
Replying to @MsPackyetti

The extremely jacked up part is how calm these two brothers are as they're walking out in handcuffs for doing *exactly nothing* because they already know their totally righteous anger could end in their death. [...]

MELINDA LUISA DE JESÚS

Hay(na)ku: For the white feminist professor who told me I was "ghettoizing" myself by studying Asian American Literature*

25
years later
it rankles me

her
withering disdain:
"don't ghettoize yourself—

you're
better than
that!" she purred,

expecting
my immediate
agreement and gratitude,

imperial
feminism relentless,
eager to *educate,*

uplift
and civilize,†
and replicate. But

* Hay(na)ku is a tercet-based poetic form created by Filipina American poet Eileen Tabios.

† See McKinley's 1903 statement on the annexation of the Philippines: http://historymatters.gmu.edu/d/5575/

little
brown sister‡
had other ideas.

‡ "Little Brown Brother" was a term used by Americans to refer to Filipinos. The term was coined by William Howard Taft, the first American Governor-General of the Philippines (1901-1904) and later the 27th President of the United States. The term was not originally intended to be derogatory, nor an ethnic slur; instead, in the words of historian Creighton Miller, it is a reflection of "paternalist racism", shared also by Theodore Roosevelt.' https://www.nps.gov/prsf/learn/historyculture/the-philippine-war-suppressing-an-insurrection.htm

CYNTHIA BUIZA

Into the Woods: A Diary of Two Cities (Excerpt from a work in progress)

> It is not only species of animal that die out, but whole species of feeling. And if you are wise, you will never pity the past for what it did not know, but pity yourself for what it did.
> —John Fowles, *The Magus*

YOU CAN'T GO HOME AGAIN. Because the city looks the same but is not quite the city you left. Only the corrupt politicians remain unchanged, pillaging and plotting as they go along. In front of the mirror, the woman is older, flecks of fresh gray hair obscure the right eye, a certain weariness, tamed. The city is now almost entirely made of concrete and compost, or better yet, the decaying windows, doors, rooftops and floors of the shanties that dot this metropolitan landscape of 11 million people, set against the glare of monumental shopping complexes and glitzy "lifestyle" residences. Of malls and men: Manila.

I decided to hide and stay in the city for two days before heading to my hometown of Legazpi. Hiding mainly, for I was scared of the dead weight I felt within, just below the heart, but not quite hitting the floor of my gut. I was waiting it out. In the absence of trees wherever I looked, this part of Manila seemed haunted by the ghosts of nature disappearing behind skyscrapers, the smoke belching out of cars and buses, and the hurried and harried look from the city's wary, weary minimum wage workers. They might as well be telling me: "hey, you tourist in your smug, imported otherness, get out of the way!" I am always equally terrified and ecstatic to be back.

If home is where the hurt is, locating the pain is an art. Everywhere I looked, a sliver of who I was and where I was in the times and in places I spent in this city reminded me of a long past existence that roars back to life at the slightest provocation. I lived in Manila for five years. For five years, the

city let me in on its secrets, and I learned to be a human being, a woman, a loner, a stranger, and a fugitive. But I also became a believer: If I could make it here...

So make it anywhere I did. But I am getting ahead of myself.

Everyone has his or her own claim to a city. Like C.P. Cavafy and his *Ithaka*, my voyage that was Manila stayed with me all these years, coming back in full eminence and regalia on hot and humid Los Angeles days, when the journey to one's memories is short and swift, and the days long and merciless.

Picture this: the year is 1994; a 23-year old arrives at the Cubao Central Bus Terminal in Manila. As the bus approaches and the borderlines between Metro Manila and Quezon Province began to blur, the quality of the air changes. It is heavier, thicker, and it puts me in a chokehold almost immediately. From a distance, in the smog, the outlines of the city have the patina of bygone worlds, a city whose past, if you look closely, laments the present. A certain kind of anticipation begins to rile my insides. I have been coming to Manila ever since I was a child visiting relatives, but the feeling never fades.

Manila was already a crowded city when I arrived as an adult in 1994. As we approached the bus terminal at 6 o'clock in the morning, the city's mechanism began to unfold before my eyes. It was by then, warm and humid, sunlight began to filter through shadows cast by the skyscrapers and shopping malls that surrounded the bus station in Cubao. Smoke coming from breakfast trolleys bearing fresh hot pan de sal and boiled rice soup with egg wafted towards the station. People of all ages and footwear or lack of it, hawked a melange of toys, underwear, umbrellas, slippers, balloons, flowers, soda decanted in plastic bags topped with a straw, jasmine garlands, pork crisps and boiled eggs. Some vendors waved their wares in front of us. Some looked warily at our luggage. The smell of gasoline from the bus' exhaust, the stench of chicken feet and peanuts frying in rancid oil, jasmine blooms, the cacophony of selling and buying, hustling and bustling, and the breeze from the eastern wind, made me feel slightly nauseous, but mostly tired and anxious

about the life that awaited me in the big city. I took a deep breath and scanned the crowd for my cousin's face.

The first place I lived in Metro Manila was a city called Novaliches, about 28 kilometers from Makati, where my first job in the metropolis awaited me. My Uncle Romeo and his wife Sonia lived there with their four children, and based on an informal agreement of sharing in the household expenses, I stayed with the entire family in the 300 square foot apartment that was their home. Needless to say, it was crowded, very crowded, and to this day, I wonder how all seven of us managed to live in that tiniest of spaces. I could not help but grow nostalgic about the big backyard that we had in Rawis, my village's long, dark, sandy beaches and the endless walks I took with my friends Victor, and Joventino. I felt the city begin to close in on me.

How to describe Manila's infernal, enduring traffic? Well, you can't claim to be a Manila girl if you can't describe in a few words how the city's legendary traffic chewed you up and spat you out like thoroughly masticated Chiclet. A typical gridlock could easily turn a one hour commute into three hours, people could get out of their cars or buses, eat a bowl of noodles, relieve themselves on the sidewalk and return to their vehicles, and the traffic would only have moved an inch. For the five years that I lived in the city, heavy, heaving, halting, congested traffic was part of my daily commute and therefore, my daily travails. It was necessary to get up at dawn, usually at four-thirty or five o'clock, take my place among the queue that snaked from one neighborhood to another to get into one of the limited edition Toyota Tamaraw FX shuttle, more expensive but less crowded, or, wait for a cheaper, air-conditioned bus, to take me into the clogged arteries of the Epifanio De Los Santos (EDSA) Avenue and my job in the financial district in the city of Makati. If I was lucky, I could get a seat, and for the next two hours close my eyes until we arrived at my stop. Unlucky days were when the bus was standing room only and I had to stand for an hour at least, holding on to the bus railings for dear life, until it disgorged half of its passengers on Ortigas or Ayala Avenues.

I didn't leave my country until we elected a man called Joseph "Erap" Estrada as President, a philandering, bumbling, slumbering former actor, whose claim to public office consisted of playing good but tough, uber-macho but relatable guys, on celluloid. It seemed by then that the country was up for grabs, available to the next highest corrupt bidder, and the only thing many of us struggling, hapless citizens could do was live out our days in horror and in awe.

As a daughter of two cities, the one that taught me how to live, and the one that bore me and buffeted my dreams, I waver constantly between longing and loathing, loving and leaving. By this truth, I return to these cities over and over again. Every year, like an act of contrition and penance, but also like an act of crazy love, I sit through the 18-hour flight to Manila in coach, on a nearly 9,000-mile voyage, to come home and be home.

After being holed up in Manila for three days, I arrived in Legazpi City, my hometown in the province of Albay, and felt immediately that it had become the city that could, if there were such a thing. I thought, "Ha! Manila has caught up here"—here in this town quaking under the gaze of the mighty Mayon Volcano, a city jostling for longevity, and to simply be more fun in the more fun that is the Philippines. Witness the heady brew of that daily drive and daily will to survive: fruit vendors, shoe repair stands, a boy selling a small basket of the local citrus called kalamansi, an elderly couple with their sinarungsong and puto (local delicacies), umbrellas, Bombay Shoe Store, Luzon Bakery and Wah Foo Chan, accused unfairly of putting cat meat in its pork buns but beloved by my beloved, very dead parents!

All these layered under the new and aspirational: the Embarcadero Waterfront Mall in Google scripts and colors; the Gaisano Mall, the perennial sport and spunky Liberty Commercial Center Mall; the gleaming, three-dimensional Oriental Legazpi Hotel. Two more malls are under construction —just you wait. The streets are cleaner, but the traffic is the same. Everyone is on a cellphone, texting while walking, eating and driving, selfieing while walking, eating and giggling. The

beaches are still beautiful, but you now have to pay admission to walk on their shores. There are more, many more people per square inch of the narrow sidewalks. Inside the Embarcadero Mall, a small luxury goods shop sells only the big name brands: Louis Vuitton, Tory Burch, Gucci, and Kate Spade. I went inside the empty store and wondered who from the populace now had the disposable income to buy a 20,000 peso pair of shoes or an 80,000-peso leather purse? The saleswoman seemed lonely but astute. She had expensive merchandise to sell, and she was determined to look it.

If I felt lost and scared in Manila, a different fear stalked me in Legazpi: I was scared mainly by the absence of words. The city that I loved had nothing for me: no eloquent, waxing sentimental, waxing lyrical about the time three young people, Victor, Joventino and I, walked the length of Rawis Beach, and did not care about the future because the present was too close and too obstinate. No poems rising out of the baking pavement where a homeless woman and her child sat begging. Only the city and its troubling love, ardent and insistent, taking me back as though I never left.

The three of us grew up against all odds and the city watched. Above everything else, we were sentinels of each other's unspoken but thoroughly understood secrets. As we walked the length of Rawis Beach, or sat before dusk at the city's harbor, none of us discussed running away from all that seawater and fresh air and dreams held at bay because we were preoccupied, even if we didn't know it, with witnessing. It was the least, and also the best, we could do for one another: bear silent witness to each other's lives. As hard as I tried, I could not remember any of us dispensing sage advice, but we broke the bread of silence, in the spaces left between being who we were and going home to where the hurt lay in wait. We let the wind carry our longings and sat and waited by the waters of Legazpi Harbor, in the city that waited with us for things to change.

When, ultimately, some of us decided that leaving was the only way to survive, the country and the cities we left behind also moved on. Like a child abandoning one wilderness for

another, I carried with me memories that sharpen whenever news of a monsoon arrives, or when another super typhoon gives my beloved cities a violent lashing. These memories travel with me. And on this quiet day when the sun is rising over Manila Bay and the day is ending in Los Angeles, I rummage through them like an eager, faithful offspring.

GABRIELA IGLORIA

Catastrophizing

The first time I rode a rollercoaster,
my harness wouldn't lock into place.
I remember calling out for help
and no staff member taking notice;

I imagined the ride starting
and me being launched into a canvas
of clear blue nothingness, and that
would be the end of that.

Since then years have passed,
but still I find myself second-
guessing everything's security.
So when we go around the room

sharing what we fear most,
I don't know what to say,
not because I'm not afraid
of anything but because,

I think, I fear too many things.
Like loneliness, getting left behind,
and falling out of rollercoasters
into a dizzy sky. I'm not afraid

of death, just of dying the wrong way.
I fear things like pap smears, the KKK,
growing up too quickly, cancer, making
small talk, especially with strangers.

I fear that someday soon
the icecaps will completely disappear,
and with them they'll take their lakes
and rivers and springs; and mountains

will crumble like sand and
then the trees will stop singing.
Perhaps it will be like the movies:
a sunny day, a sudden change

in the weather vane's direction.
Nobody notices a thing at first.
They are safe behind their white
picket fences and the mechanical chorus

of their lawnmowers and leaf blowers.
What will they do when they realize
the earth has stopped spinning?
I imagine the children will see it first,

how the sun refuses to set, how suddenly
everything is afloat: jump ropes,
lawnmowers, the house cat, rollercoasters.
A child cries out, *the sky is falling.*

S. LILY MENDOZA

Composting Civilization's Grief: Life, Love, and Learning in a Time of Eco-Apocalypse

Introduction

A version of this essay was originally given as a keynote address at the Third International Babaylan Conference held in the Unceded Coast Salish Territories, in Vancouver, Canada in September 2016. The conference, organized jointly by the Center for Babaylan Studies (CfBS) and the Kathara Pilipino Indigenous Arts Collective Society, centered on the theme "Makasaysayang Pagtatagpo (Historic Encounters): Filipinos and Indigenous Turtle Islanders Revitalizing Ancestral Traditions Together." It was the first intentionally cross-cultural collaboration undertaken by the CfBS that specifically sought to build relationship with North America's First Nation Peoples. The task of the keynote was captured well in the words of one of our Kathara partners, Sobey Wing, who wrote in an email:

> I see this conference as a great place to practice being clear on narrative so that by the end of it all participants can give historical context to oppression on Turtle Island and in our ancestral homelands and feel empowered to be the ancestors we wish to see.

It was a daunting task that nonetheless needed addressing head on. In my classes, I once described what I do as giving a "history of everything." In other words, for every phenomenon we study, the one thing I always have us ask is, how did things come to be the way they are today? Nothing is exempt from this questioning or allowed to be simply taken for granted. This is because the one most prevalent narrative abroad in our world today is that which says that the awful conditions we find ourselves living in (the violent hierarchies, wars, selfishness, greed, cutthroat competition, domination of the

weak by the strong, etc.) are just "human nature;" that this is a "dog-eat-dog" world and will always be because "that's just the way we are as human beings." And I ask, is it, really?

Our Cree brothers and sisters have identified our modern civilization as suffering from a serious disease of the soul or spirit they call "wetiko" (in our case, "ang Pilipinong nawawala sa sarili," the Filipino lost to herself) and whose grief we must now learn to understand and find ways to metabolize if we are to heal ourselves and the earth from its long reach and shadow.

Given the limited space I have with which to historicize this often taken for granted narrative of human beings' supposedly inherent calumny and create room for something else, I hope you, the readers, will stay with me as I strive patiently to coax out of its maligned, twisted, and disparaged telling the seed of an alternative story whose transformative power awaits release through honoring and remembrance. My hope is that in the process of doing so, we may commit even more deeply to growing that glorious, magnificent seed-story in our lives, nay, actually to becoming the seed—to walk in a manner capable of sprouting new life and causing everything else, in the favorite phrase of the Tzutujil Mayans, "to jump up and live again."

This is spiritual work. We live in a time of great peril and crises; many say we are now at the cusp of the Sixth Great Extinction, past the tipping point where the downward spiral of ecosystems collapse seems anything but reversible. To do this kind of work is to come face to face with immeasurable grief and sorrow. We cannot do this work alone. It is work that requires community (both of the human and the more-than-human kind), deep love, and, most especially the capacity to compost grief into life-giving beauty. Anymore, mere anger and denunciation of wrong will not suffice. We must dig deep, beyond our hatred and despair. In the words of indigenous writer Martin Prechtel (2012), we need a "mountain-like love for something [that] is bigger than [our] righteous hatred over the unfairness of others," the only thing that can "override our violent need to win..." and that can "cause a real spiritual intelligence to sprout out of the hard shell of needing to be the one who is right" (p. 37).

A few caveats before I launch into my main discussion. It is important to mention briefly a number of concerns that must be addressed more in depth, beyond my ability to do so here, given the space limitations.

One is the need to challenge the default notion that the nation as a political entity is a viable "unit" for thinking about identity and the host of issues we want to address here. We use it as a heuristic, an occasionally useful tool—as in the reference to "Filipino" Indigenous Knowledge Systems and Practices (or Sikolohiyang "Pilipino"). But nationalism itself, beyond its usefulness in service of the anti-colonial struggle, I suggest, is a bankrupt ideology. This is so given the nation-state's singular commitment to modernization and development, which has required for its attainment increasing dispossession, impoverishment, and murder of our indigenous brothers and sisters, and also given the historical provenance of the state structure itself as primarily an instrument of the elite for the protection of private property and hoarded wealth and not the flourishing of all, as political philosophers Hardt & Negri (2009) avow.

Likewise, the fascination with shamanism (or in our case, the *babaylan* tradition) as a mode of healing that can easily reinforce notions of Western individualism and entitlement if it is not continually connected with local communities of humans learning from and caring for local communities of plants and animals, seasons, and soils. Sadly, it is the case that White anthropologists have abstracted a notion of "core shamanism" that they now market in workshops all over the Western world, where middle class people are invited to discover their "animal familiar" and work on healing their various maladies, without having to face the need to give up middle class priorities and begin to ally with indigenous communities in both lifestyle and politics.

Another issue that requires its own keynote is gender oppression and patriarchy and its roots in the turn to urbanized, monocrop agriculture, i.e., the effect of settlement and surplus food production on women's ovulation cycle and the shift in balance in women's roles from active

participation in food procurement during the era of hunting and gathering to primarily domestic childrearing and caretaking responsibilities in state-organized agricultural production, along with the hardening proscription around diverse sexual orientations in the later advent of modernity.

And lastly, there is need to nuance the broad strokes in my (forthcoming) discussion on agriculture in a way that would distinguish low-tech, horticultural forms of subsistence cultivation—practiced by relatively intact indigenous cultures whose rituals and myths continue to place real limits on human alterations of the environment—from the state-enforced, monocrop agriculture that arises in the Mid-East 5,000 years ago and sweeps the planet as an imperial project of mass production, reaching its nadir in today's industrial farming enterprises that are rapidly destroying what remains of wild habitat and viable watersheds for otherkind to survive.

The Story of the Trespass Against My Indigenous Soul

I originally titled this piece, "Composting Civilization's Grief: A Work of Love" because in many ways, my journey as a modern Filipina into the path of indigeneity *is* a work of love. It wasn't always that way, but through a very circuitous path, I did find my "bigger-than-a-mountain love" that now compels all my journeying.

I was born second to the youngest in a brood of six, (one boy and five girls). We lived in a little barrio in San Fernando, Pampanga in Central Luzon Philippines called Teopaco. Our Tatang worked as a sales representative of the Philippine Bible Society and our Ima earned a small income on the side as a piano teacher. To supplement our family income, our Tatang raised pigs and chickens. I still remember the fun of searching out eggs that the hens would have laid in the early morning as a kid and having my turn at collecting kitchen scraps from the neighbors, pail in hand, to supplement the store-bought commercial feed that my father reserved for the pigs.

In the kitchen, I routinely assisted my Ima in killing chickens when we needed to cook one, helping to hold it down while she slit its throat and waited for the blood to drain onto a

bowl with uncooked rice that my Ima would also then cook and make use of later (no part of the fowl ever went to waste).

Thus, I never had the luxury growing up of not knowing that a life had to be taken in order for us to live.

When it came time for the pigs to be slaughtered, it was an especially hard time because somehow you would have bonded with the feisty creatures through the daily chore of feeding, but it also caused us never to forget that their life was what allowed us to go to school, as proceeds from the sale of the meat were what were used to pay for our tuition.

In those days, we didn't have refrigeration. As a result, my mom would always go to the wet market each day to buy fresh fish and vegetables. Some of the fish she would cure with vinegar and garlic, along with salt and pepper and set the pieces out to dry, giving us delicious daing (dried fish) for breakfast the following morning.

Being a lover of animals, birds, trees and plants, our Tatang kept a lush garden in our front and back yard. He also dug a huge compost pit at the back of our modest nipa hut where we would throw in kitchen scraps and other organic material and wait for it to "cook" and magically turn into this rich organic nutrient that is good for growing things. And because we were surrounded by calesa drivers (drivers of horse drawn carriages that kept their stables right in their own backyard) we also regularly collected horse, or sometimes, carabao, manure to use as additional fertilizer in the garden.

Those were the days when I had no fear of dirt, nor was I overly squeamish about manure or rotting things. (For before the massive invention of disinfectants, insecticides, and all kinds of modern chemicals, what is one species' defecation is simply another's food.)

Our Ima sewed all our clothes, including our underwear. At Easter and Christmas, we could always count on having new hand-made dresses courtesy of our mom.

I don't remember us having much of store-bought possessions. Our toys growing up were mostly found objects—sardine tin cans that we turned into go-carts using soft drink bottle caps as wheels, gumamela leaves that we pretended were

tea cups, and soft twigs of the saresa tree that became our convenient hair curlers. And because we didn't own a television set then, we made up our own entertainment, having a contest on who could find recognizable shapes and figures among the thick cumulus clouds, inventing animal shadows on the wall with adept hands using a flashlight at night, and best of all, sitting at the feet of our Apu Sinang listening to her tell stories. Life was good.

Until I got to college and became exposed to life in the city and realized all of a sudden that we were "poor," never mind if we've never had to skip a meal, had decent clothes to wear, and pretty much had all our needs met. That's because I didn't come to campus chauffer-driven like my collegiala classmates from the exclusive girls' schools who, unlike us mortals, never had to take public transportation. I also learned quickly that I lacked the cultural markers of "class" because my Kapampangan accented English-speaking easily marked me out as "promdi" (from the province). As the revolutionary writer Frantz Fanon said,

> "to speak the colonial language means above all to assume a culture, to support the weight of a civilization...To speak a language is to take on a world, a culture" (Fanon, quoted in Perry, 1987, p. 29).

And that was precisely what my twisted rebellious tongue never allowed me to do—to fully take on that foreign world, the exclusive world of the elite or, in today's parlance, the upwardly mobile folk who knew how to assimilate successfully into that world's idiom.

My hand-made clothes also readily marked me as being out of synch with the ready-to-wear, industry-sewn fashion of the day. It was the moment I first became ashamed of my mom's sewing (something that now fills me with great sorrow) when I hankered for store-bought clothes instead.

When my mini-skirted older sister, who was quicker to adapt to city culture than I was, came home one day boasting proudly that she had been mistaken for a "Theresiana" at a college dance party (St. Theresa's then being another one of

those wealthy exclusive girls' schools), that sealed even more my awareness that either I would work hard to find ways to shed my "promdi" ways and be part of the in-crowd or find an altogether different basis for self-worth as an individual striving to belong.

It is this early awareness of an invisible unnamed measure determining who is and who is not a worthy human being that became both the source of my intense struggle and my intellectual fascination to try to figure out.

In college, I became a born-again Christian and began what would become one of my life's great adventures, discipling many in bible study and "leading many to faith."

But also unbeknownst to many, the sense of being "weighed and found wanting" (*tinimbang ka nguni't kulang*) that defined my experience of socialization into modern society persisted. My Christian walk was anything but life-affirming. My prayer life, as far as I can remember, was always full of groveling and morbid introspection, of asking for forgiveness for never measuring up, of feeling unworthy. It was as if God's unconditional love, however fervently my mind sought to believe it, refused to pass through my body and heal my wounded heart.

It wasn't until a graduate class in the humanities taught by ethnomusicologist Felipe de Leon Jr., that I would have a different kind of spiritual awakening. In the course titled, "The Image of the Filipino in the Arts," Prof. Jun, as we called him fondly, would bring into the classroom samples of the artistic productions of our various indigenous communities that still managed somehow to retain their traditions despite centuries of colonization—their dances, music, weaving, basketry, epic stories, etc.—and would talk about what they signified in terms not only of a different aesthetic sensibility but of a different mode of being in the world. I was stunned! Nothing prepared me for the power of that encounter with wild untamed beauty: complex geometric weaving designs that mathematicians noted could not have been willfully conceived by the rational mind, mellifluous melodies able to call up grief out of all its hidden places, polyphonic sounds

and rhythms coming from native instruments that not only sounded but looked utterly beautiful, dances as diverse as their ecologies of origination, intricate architectural structures that used not a single nail to bind parts together, etc. and all of these creations of beauty ritually sourced, many given in dreams, with materials taken from the wild only with the accompanying respect, honoring, and asking for permission, and always in service of beauty.

I still remember walking back to my dorm room bawling my heart out, not knowing what it was that hit me from all the innocent descriptions of those works of art. It was as if my body knew something that my mind could not yet fathom. That face-to-face encounter with the grief of something I had always known in my bones but had somehow lost and been searching for ever since, like an exiled dearly Beloved, had me utterly broken, shattered to pieces, but in a kind of delicious way. I didn't even realize it was the Indigenous Soul hinting the possibility of homecoming in my then tear-soaked, confused, and dejected life. Martin Prechtel (1998) had words for the unexpected epiphany:

> It was nature, wildness, this undomesticated spirit that fled when it got enslaved, insulted, maimed, beaten or scared off. This trespass on one's personal nature or soul is what Mayan Shamans considered the prime source of illness to humans. People simply forgot that the non-ritual inventions of the human mind insulted the human soul, which, like a deer, was frightened by the unnatural." (P. 164).

How did that trespass happen? How did that separation from our Indigenous Soul begin?

And it is here that I ask your forbearance to stay with me as what I am about to unpack is but the gist of a very complex, convoluted history, one that I can only, in the barest of outlines, attempt to lay out in the space I have left.

The "Trespass" from the Long View of History

One of the things I found is that the phenomenon of the oppressed, insulted, and enslaved Indigenous Soul is by no

means exclusive to historically colonized peoples, but a characteristic of all who have made their peace with this thing called "civilization." And speaking of being clear on narrative, it is now our responsibility, if we are ever to make our way back to our Indigenous Soul to understand what this thing is that has effectively chased away and driven into hiding our Beloved since its fateful irruption into our species' journeying on the planet.

And so we ask, what is civilization and what is its story? How did it become today the only story that most people know about and embrace?

I believe there is no arguing when I say that the story civilization has always told of itself is that of greatness, achievement, evolutionary progress, and development. To be "civilized" is to be fully human. To not have the trappings of civilization (the high rises, the flushing toilets, the criss-crossing highways and other infrastructure that free us from having to "live like animals"—as though being animal were the greatest insult) is to be "backward," "primitive," to be "less-than" human. Which is why when the European colonizers came to indigenous lands, they invariably pronounced them "empty," "uninhabited" or "terra nullius" (empty lands), with the people living on the land deemed as merely a part of what they called "the flora and fauna."

Today I would say is no different. Consider: despite the purported valuing of indigenous traditions in official discourse, whenever any well-meaning government functionary, research scholar, or advocacy group representative visits an indigenous or tribal community, the first thing that comes to their mind is the question, "How can we help?" which, in translation really means only one thing: "How can we intervene to enable these poor backward people to live like the rest of us (civilized modern Filipinos)?" Often what we fail to realize is that the only reason they are ever in a position of needing "help" in the first place is that they have been coerced to live in our world, separated from the land, with the animals they hunt driven away by industrial logging, the fish and rivers killed by damming, and the soil that used to grow their crops poisoned

by industrial run off. Truth is, if we have the eyes to see, we will see that *we* are the ones that need help, not they.

This patronizing attitude of the civilized mind towards indigenous life is so ingrained that to dare question it is to be deemed "out of one's mind." And yet, I would submit that civilization has another story that it would rather conveniently forget and not have broadcast, and that story is one of conquest, enslavement, and genocide.

A fairly good number of scholars and writers (Rasmussen, 1996; Shepard, 1973/1998, 1982/1998, 1998; Quinn, 1992/1995, 1996; Wells, 2010; Zerzan, 2005; among others) trace the roots of civilization-building back to the originary project of plant and animal domestication that began roughly 10,000 years ago—a relatively recent phenomenon when compared to more than two to three million years of human history.§ Domestication entailed humans drawing a line of separation between themselves and the wild and is generally understood as a process of re-engineering wild nature to serve exclusively human purposes. This is in contrast to an earlier recognition of all beings in nature as having the right to exist "in and for themselves" quite apart from their usefulness to us humans. Domestication, according to Prechtel (2012) and other scholars (Abdelrahim, 2013; Zerzan, 2005; Wells, 2010, etc), "was the beginning of the unconscious pervasive presence of human viciousness and cruelty in the world" (p. 317). In mythological speak, this is the equivalent of the "abduction" of the daughters of the Wild in Nature— the plants, the animals, the minerals, etc.—that have no desire whatsoever to leave the Holy Wildness of nature to be cross-bred and re-crossed in order to feed and service domesticated humans on the tamed side of the dividing line.

The truth is, prior to domestication, we ourselves were part of the wild, and as a wild people "we were equally hunted and eaten by other beings in the wild.... Our lives, like all other lives [in the wild], vegetable or animal, fed the world as much

§ Depending on what one considers a human being, e.g., *homo habilis, homo erectus, homo sapiens,* etc.

as we consumed during our lives. That's Holy" (Prechtel, 2012, p. 318).

We don't know exactly when or how domestication started, but most scholars agree that its invention made possible the transformation of the relationship between humans and other beings in nature from that of mutual belonging (as in "all our relations") to one of separation, use, mastery, domination, and control—wild living beings (and that includes rocks, mountains, rivers, underground minerals, etc.) turned into nothing but dead "resources" to do with as we please.

Domestication is at the heart of the turn to settled agriculture** as a mode of subsistence, in contrast to hunting and gathering that had been the lifeway of our human ancestors for 99% of our time on the planet. (I sometimes think that the Genesis story in the Bible actually encodes a much older memory when our ancestors lived by the generosity of the land, when there was no toiling save for the energy it took to harvest and gather food from the garden. Life in the garden was good, and the Fall, was a fall into agriculture; remember the curse: "From now on, you shall live by the sweat of your brow and the toil of your hands.")

The gradual shift to state-controlled monocrop agriculture from hunting and gathering resulted in a series of epochal transformations that affected the way subsequent human groups and their descendants would come to live on the planet. For one, it made possible the production of food surplus (remember that prior to this, there was no need for surplus production; people had no need for storerooms, you gathered what you needed at the moment you needed it and no more, since you know there will always be provision for tomorrow—a worldview that assumed an economy of abundance, not scarcity, unlike today).

With surplus food came an exponential increase in population. Unlike in the era of hunting and gathering when population growth was naturally limited by a given land's carrying capacity (and women's menstrual and ovulation cycles

** To be distinguished from diverse forms of subsistence farming that did not engage in surplus production and monocropping.

regulated by an active nomadic lifestyle) (cf. Glendinning, 1994), surplus food production in state-organized monocropping gave rise to the vicious cycle of population growth, followed by the need to take over more land to support the growing numbers, resulting in further increases in population requiring yet more land, and so on. It is for this reason that scholars such as Jared Diamond (1987) call the turn to settled monocrop agriculture as perhaps "the worst mistake in the history of the human race" in the way it introduced a dynamic of expansionism, domination, and eventual scarcity hitherto unknown when humans lived in close interdependence with their environment (see also Manning, 2004; and Scott, 2017).

Surplus food production and the resulting population growth also made possible increasingly concentrated sedentarism in a given area. The abandonment of the nomadic lifestyle in favor of large-scale population settlement in one given area often meant the outstripping of the land's carrying capacity, along with the outbreak of contagious "crowding diseases" such as smallpox, typhoid, measles, dysentery, etc. previously unknown in the "un-civilized" world when people didn't live in densely-concentrated populations and in close proximity to domesticated animals. Village communities typically numbering anywhere from 50-150 members that used to live face-to-face began to expand into much larger numbers, thereby necessitating the need for representational politics, and with it, the fabrication of hierarchy (both organizational and gender), the tyranny of rulers and standing armies, the concentration of wealth in the hands of a few, and the invention of laws, religions, and ideologies to rationalize such hierarchical arrangement (e.g., the Divine Right of Kings, or the Doctrine of Christian Discovery that served to justify European takeover of so-called "heathen lands" and the enslavement, if not outright genocidal elimination, of their populations).

Such large-scale societies invariably required a level of organization capable of fostering order, levying taxes to support the non-working elite in the social hierarchy, and the

hiring of a standing army to protect city assets, wealth, and resources (cf. Perkinson, 2016). Urban centers that served to host such wealth concentration soon became the primary expression of civilized life.

However, since cities do not typically grow their own food or produce the fibers and materials needed to clothe and shelter their populations but are largely dependent on the surrounding countryside for their basic provisions, by definition, cities constitute "structures of violent appropriation" (Jensen, 2006; Perkinson, 2016). This is given the fact that such outside dependency typically requires the use of coercion, threat, intimidation, seduction/co-optation, and various kinds of PR manipulation (in today's world called advertising) for the city center to secure what it needs.

With the advent of the Industrial Revolution in the early 1800s and the exponentially increased efficiency of resource extraction, production, and use, made possible by the discovery of "cheap" fossil fuel (in reality, nothing cheap about it, the costs are simply externalized), we see a tremendous ratcheting up of this dynamic of violence.

Invariably, as urban development and the industrial way of life spreads across the globe convincing everyone that this is the only "civilized" way to live, we begin to see the encroachment of this monocultural vision on indigenous lands where the ultimate mission is conquest and assimilation, *never* co-existence. For in order to gain access to the "resources" under the feet of indigenous peoples, in a world that still has pretensions to civility and "the rule of law," what industry has to do, in collusion with the nation-state which has no other vision than to join the march to modernization and industrialization, is either to forcibly re-settle the population, co-opt them into selling their lands in exchange for subsidies, or, all else failing, undermine their very means of subsistence, thus leaving them no choice but to relent, assimilate, and give up their chosen way of life, or be destroyed in a violent encounter if they resist.

Stanley Diamond (1974) describes this process of acculturation into civilization in the following way:

In fact, acculturation has always been a matter of conquest. Either civilization directly shatters a primitive culture that happens to stand in its historical right of way; or a primitive social economy, in the grip of a civilized market, becomes so attenuated and weakened that it can no longer contain the traditional culture. In both cases, refugees from the foundering groups may adopt the standards of the more potent society in order to survive as individuals. *But these are conscripts of civilization, not volunteers.* (P. 204, emphasis added.)

It is in this sense that for all its glowing connotations of "civility," refinement, and escape from barbarism, civilization actually hides at its core a patent form of violence; first, in the way it sets itself up as *the only* legitimate way to live on the planet discounting all others; second, in the way its chosen orientation, premised on human entitlement and utter disregard of the Holy in Nature, compels it to take forcibly from the Wild and from other beings in order to keep itself going (the resulting impoverishment, severing of relationship to the land, loss of wildlife habitat, and degradation of the ecology not an accident, but inherent in the logic of the civilizing process); and, finally, in its inability to tolerate "otherness" and its demonstrated willingness to annihilate those with a different imagination or lifestyle.

Ultimately, it is culpable in destroying the planet, and climate change is now its harbinger. This is now the issue that defines us for the rest of our lives and if we fail to understand how deep it goes historically and structurally, we're doomed to become its unwitting consorts and our own executioners, not to speak of killing off much of the rest of what's left of the earth.

And it is here that I must bring our story back to our dearly Beloved. How now move forward? How create a throne in our lives, in our civilized culture for the lost Indigenous Soul to once more take up residence and find a home?

Coaxing the Indigenous Soul Back

In recognition of the increasing threat to planetary survival posed by our now globalized, heavily-resourced civilizational

culture (prompting the invention of the term "Anthropocene"[††]), there is now in various places around the world a turning toward alternative cultures deemed to represent a different, more holistic way to live. What did our ancestors know about living sustainably and honorably on the planet that we have forgotten?

The Center for Babaylan Studies is one such group committed to re-creating the soil of culture that might coax the Indigenous Soul to once more take up residence in our spiritually parched and dying world. But perhaps, you've also heard the oft-repeated snicker from those who only stand outside and critique: What are these babaylan-pretenders doing, donning malongs and dressing up native, taking up drumming, kulintang, kulitan, baybayin, offering tobacco, saying prayers as if they were natives when the rest of their lives they live just like the rest of us—by the grocery store, by blood-drenched iphones, ipads, laptops, and computers, driving cars, flying in airplanes. Such hypocrisy! Why don't you run back to the forest, or grow your own food if you're truly going to be indigenous and that way earn your credentials to speak?

And indeed, we have ones among us who in various ways have sought to do just that—grow gardens, request the sufferance of those who still know how to live beautifully on the land for tutelage, asking permission to be allowed to take up periodic residence with a village or a tribe in a humbling process of immersion and learning.

Yes, we hear, we reflect, and we listen. And yet a warning seems also apropos, for part of the imperial mind's bent when presented with the seed of a witness it cannot itself embrace is to search for purity, separation, and perfection, constantly self-righteously drawing lines.

The anthropologist and Jesuit scholar/priest Fr. Albert Alejo (2004), noted in his research that ours has never been a spirituality of separation, exorcism, and confrontation, but of respectful negotiation, of learning *pasintabi* (asking permission). In this regard, I also spoke earlier of the need for us to find a mountain-like love that is bigger than our hatred capable of

[††] Indicating an era where humans, for the first time, have become a force of nature.

metabolizing the grief and violence of our pitiful domesticated civilized culture into "a nutrient of spiritual awareness of our real place on earth...cultivat[ing] in that cooking mound of composting tears and detours a future worth living in" as indigenous writer Prechtel (2012, p. 133) beautifully notes. And we are called to do this right where we are—"in the middle of modernity's meaningless waste" (p. 133).

This is what we're doing when we come together in this way, and in our respective local communities, when, in ritual and ceremony, we ask help from our Ancestors to joggle our memories so we can remember once more how to live on the earth in a good way, in order that we, as a people seeking to rekindle our Indigenous Souls can remember once more the Original Instructions that every natural people has lived by for hundreds of thousands of years.

What we're doing, often in fumbling, bumbling, and groping ways—in the process, inevitably making many mistakes—is striving to create cultures capable of sprouting seeds of vitality worthy of feeding a time beyond our own, cultures that could not be designed by humans using the imperial mind (Prechtel, 2012, p. 133). In other words, such "soils of the soul" could not be grown by us simply upping and leaving our cities and current places for a hoped for "new life" among our indigenous kin (for Empire is there, too!).

Prechtel's (2012) caution is instructive in this regard when he warns:

> We could never transcend the mad toxic trap of the present without deferring the Hell of it on the next generation. Nor could we "perfect" ourselves or "purify" ourselves or the world without becoming spiritual fascists.
> [A]ny worthy culture has to sprout right out of the slag heap of the world's present condition, that love would have to manifest in hell for heaven to begin. These cultures would start in many small ugly places in ways hardly noticed at first." (p. 133)

And here I leave you with a hopeful thing, a final beautiful quote one more time from Prechtel (2012):

I'll tell you...the seeds we seek are here already, but *we* are not
here. When we are here, the seeds will begin to appear, for we
first must make fertile cultural ground for them to want to
appear, and to do that there are any number of things you and I
can go towards, maintain, and live by if we have the
dedication. (P. 314)

We're not here for long, we're only here for a short while,
so let's commit what's left of our lives to hearing once more
the cry of Wild Earth who is truly our home, the Holy in
Nature. Let us find a place that has claimed us and dig in and
begin to recognize once more the face of Her in the most
enslaved of places. Only in this way can we begin to heal our
wetiko, our civilization's madness—by becoming once more a
natural people, not shunning suffering, but "suffer[ing]
together creatively in a beautiful way...[and keeping our
delicately balanced world alive] by feeding it the grief of [our]
human failures and stupidity" (Prechtel, 1999/2004, p. 198)
and thus rejoining community with our original relatives, the
original plants, original animals, and original earth. *Siyanawa.*
May it be.

REFERENCES

Abdelrahim, L. (2013). *Wild children—Domesticated dreams: Civilization and the birth of education.* Halifax & Winnipeg: Fernwood Publishing.

Alejo, A. (2004). Popular spirituality as cultural energy. In *Lecture series 3 on spirituality: Context and expressions of Filipino spirituality* (pp. 33-52). Center for Spirituality, Manila.

Diamond, J. (May 1987). The Worst Mistake in the History of the Human Race. *Discover Magazine*, pp. 64-66.

Diamond, S. (1974). *In search of the primitive: A critique of civilization.* New Brunswick: Transaction Books. Coronel, S. (2002). *Memory of dances.* Quezon City, Philippines. Philippine Center for Investigative Journalism.

Jensen, D. (2006). *Endgame, Vol. 1: The problem of civilization*. New York, NY: Seven Stories Press.

Glendinning, C. (1994). *"My name is Chellis & I'm in recovery from Western civilization."* Boston, Mass.: Shambhala Publications.

Gowdy, J. (Ed.). (1998). Limited wants, unlimited means: A reader on hunter-gatherer economics and the environment. Washington, D.C.: Island Press.

Hardt, M. & Negri, A. (2009). *Commonwealth*. Boston, MA: Harvard University Press.

Manning, Richard. 2004. *Against the grain: How agriculture has hijacked civilization*. New York, NY: North Point Press.

Perkinson, J. W. (2016). Religion and the class status quo. In J. Vereecke (Ed.), *Macmillan Interdisciplinary Handbook on Religion: Religion-Just Religion* (199-217). Farmington, MI: Greenhaven Press, Macmillan Reference.

Prechtel, M. (2012). *The unlikely peace at Cuchumaquic: The parallel lives of people as plants: Keeping the seeds alive*. Berkeley, CA: North Atlantic Books.

Prechtel, M. (1999/2004). *Long life, honey in the heart: A story of initiation and eloquence from the shores of a Mayan Lake*. Berkeley, CA: North Atlantic Books.

Prechtel, M. (1998). *Secrets of the talking jaguar*. New York, NY: Jeremy P. Tarcher/Putnam.

Quinn, D. (1992/1995). *Ishmael: An adventure of the mind and spirit*. New York, NY: Bantam Books.

Quinn, D. (1996). *The story of B.* New York, NY: Bantam Books.
Rasmussen, L. (1996). *Earth, Community, Earth Ethics,* Geneva: WCC Publications.

Scott, James C. 2017. *Against the Grain: A Deep History of the Earliest States*. New Haven, CT: Yale University Press.

Shepard, P. (1998). "A Post-Historic Primitivism" in Gowdy, *Limited Wants, Unlimited Means,* pp. 281-328. Island Press.

Shepard, P. (1973/1998). *The tender carnivore and the sacred game.* Athens, GA: The University of Georgia Press.

Shepard, P. (1982/1998). *Nature and madness.* Athens, GA: The University of Georgia Press.

Shepard, P. (1998). *Coming home to the Pleistocene.* Washington, D.C.: Island Press.

Wells, S. (2010). *Pandora's Seed: The unforeseen cost of civilization.* NY: Random House.

Zerzan, J. (Ed.). (2005) *Against civilization.* Los Angeles: Feral House.

LENY MENDOZA STROBEL

Holy Tunganga: Meditations on Becoming an Ancestor

> Note: I started writing this essay before The Firestorm that visited Sonoma and Napa Counties on October 8, 2017. It is one of the most devastating catastrophes in California history. We are all still in shock and will feel post-traumatic stress for a long time. We all know people who have lost their homes. We will be telling stories for a long time about how we were roused from sleep that night and fled without knowing where to go. After two weeks of mandatory evacuation, we are home again. But nothing will be the same again.
>
> Fire came and ate until she was satisfied. Rain came to quench the Fire's thirst. Humans ask: *Why?*

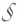

THE SUMMER OF MY HOLY TUNGANGA in 2017: Do Nothing. Do not travel. Do not plan conferences. Do not write and publish. Do not organize. Do not do research. Do go for long walks. Do take up pilates, qi gong, and cardio toning. Do not talk too much. Be alone. Just BE and see how that feels. How different it is from DOing. See how the rhythm of your life changes. Feel your skin. Feel your breath. Feel your heartbeat. Play the piano. Weed the garden. Bring in the herbs and vegetables. Cook. Cook some more. Lie on the ground and stare at the sky. Watch the clouds. Listen to the birds. Listen to the rustle of leaves. Listen to the flapping of wings. Listen to the crickets.

Three years ago, I filed my retirement papers at the small public university where I have taught American Multicultural Studies for over twenty years. The faculty early retirement program allows us to teach half-time for five years but I've decided I would quit on the third year of the program.

§

Three years ago, I started visualizing life-after-academe but nothing particularly revelatory came of it. I know that I will continue to obey the bidding of my Ancestors as I have done for over two decades; that I will continue to deepen my spiritual practice that is rooted in my Filipino indigenous spirituality—a path that began almost as soon I uprooted myself from the Philippines in 1983. I needed to be uprooted in order to find Home.

My life's journey has never followed a map. I have failed every criteria for "normal" in comparing myself to my childhood peers who went on to live "normal" lives: graduate from high school, finish college, establish career, get married, have smart and cute children, become successful in corporate careers, travel abroad, build or buy a nice house. Upload photos of wonderful life on Instagram and Facebook. Not me.‡‡

I am an introvert who doesn't mind getting lost in daydream and reverie. Introspection is what allowed me, throughout my personal and academic life, to carve out a space for meditations about meaning and purpose and share them with readers. Key words: decolonize, re-indigenize, Kapwa/the Self is in the Other, Babaylan/healer, Loob/inner core of Self, indigenous. I am grateful for being a part of a bigger community of folks enthused about the work of re-membering and suturing the forgotten fragments of Filipino indigenous cultural material that colonial history has not managed to fully silence and vanish.

As a consequence of our colonial subjugation, this work of decolonizing ourselves is messy and full of potholes. Boxed in and blindsided by the received knowledge of our colonial (mis)education, we find ourselves arguing and disagreeing, then disconnecting from each other and our communities. In the U.S. we are called "silent majority", "a sleeping giant"...and we also always wonder if Filipino Americans are also "model minority" even though this myth is already largely debunked. Without a beautiful Story of our own, we rely on the old tropes of binary and hierarchical thinking within the culture of

‡‡ I wrote about my view of retirement here:
https://medium.com/@lenystrobel/leaving-academe-2-b508db49832a

capitalism—a globalized economic system that is beginning to collapse under its own weight as it exceeds the carrying capacity of a finite Earth.

It is in this rubble that I find that there are still gems hiding in the shadows of our history of displacement and uprooting.

§

When we organized the Center for Babaylan Studies (CfBS) in 2009 we explicitly maintained that this is a babaylan-inspired endeavor of study, research, and community building. It began as an imperative to learn about the historical babaylans (the shamans/medicine men and women) and it expanded to include other discourses within Filipino Indigenous Knowledge Systems and Practices (IKSP). At our early conferences and symposia, we focused on Filipino Indigenous Psychology (or Kapwa Psychology) and Indigenous Spirituality and how these frameworks could take us out of the old colonial frameworks. We focused on indigenous communities in the homeland and their cultural practices that still survive (albeit under duress) and what they can teach us.

We wanted to recuperate the ancient Babaylan tradition that is still alive and well today even though still relatively unknown to many of us in the diaspora and even in the homeland. The Babaylan listserve started by Perla Daly in the in early 2000 served as a catalyst for the desire to call together folks who are interested to learn about the historical Babaylans —their history of 'disappearance' as the Spanish went on an extermination campaign in the first 100 years of colonization. We learned about the transformation of the babaylan into beatas within the Catholic church; we learned about the babaylans who led revolts during the colonial era. Then we learned about the Philippine feminist movement's appropriation of the babaylan as a figure of power and courage and how it inspires culture-bearers and artists today. Katrin de Guia profiled many of these culture bearers in her book, *Kapwa: The Self in the Other*. Grace Nono, who has spent twenty years being with chanters and oralists, also chronicles

babaylan stories in her books, *The Shared Voice*, and *The Song of the Babaylan*.

In 2005, *A Book of Her Own: Words and Images* to Honor the Babaylan, a creative non-fiction book of my personal meditations on decolonization, was published. It was followed in 2010 by a collection of stories and narratives of decolonization in *Babaylan: Filipinos and the Call of the Indigenous*. In 2013, my sister, Lily Mendoza, and I published another collection of scholarly research and personal narratives in *Back from the Crocodile's Belly: Philippine Babaylan Studies and the Struggle for Indigenous Memory*.

My small public presence in this space renders me grateful for the hearts and ears that were open to receive my meditations, visions, and my personal stories of decolonization and re-indigenization as they became public. CfBS also created a container for the scholarship, research, teaching, and organizing that also now include the increasing number of scholars and culture-bearers that are on this path. For me, it's all about the Love for a Homeland that I thought I had lost (and now realize that I didn't really). All for the Love of my Filipina self that I thought was too fragmented to be put together again (and now realize that I have always been Whole). All for the Love of my Kapwa that I thought would forever be lost (I am not) in the fog of colonial history.

I witness the resurgence of culture-bearing movements in the diaspora. In my part of the world—the Bay Area in Northern California—artists, healers, cultural creatives, social entrepreneurs are creating festivals, night markets, workshops, street art and on-site performances, blogs, and other events that are marked by a pride in our Filipino indigenous arts and practices. They are also re-creating and discovering new forms and finding new ways of sharing with a community that, heretofore, has not really paid much attention to the beauty of Filipino indigenous cultures. Today there are weavers (Kalingafornia led by Jenny Bawer Young), canoe-makers (Bangka Journey led by Mylene Cahambing and Alexis Canillo), Baybayin entrepreneurs (Kristian Kabuay, Ray Haguisan, Norman de los Santos), tribal tattoo/batok artists (Lane

Wilcken), herbalists (Abi Huff, Holly Calica), dancers and choreographers that highlight Philippine myths and stories (Kularts/Alleluia Panis, Likha, Parangal), musicians reviving Harana (Florante Aguilar, Fides Enriquez), and so many more.

Many of these folks try to understand and embody indigenous values; their personal understanding of Filipino indigenous spirituality and cultural resilience is what informs their creative expressions. I am thinking of Sammay Dizon and her UrbanXIndigenous team of young Filipino Americans who raise questions like: what does it mean to be urban and indigenous? what does it mean to be a Filipino in the diaspora and a settler on Turtle Island? what does it mean to heal communities of color and their colonial trauma and historical amnesia? I am thinking of young chef/educators Aileen Suzara, Lawrence Festin, Mikey Herrera, Allen Byron, Deodor Tronco, Nico Dacumos, and their crew who advocate for food justice in food deserts in the Bay Area. These young educators teach in schools where there are many low-income students of color who may not have access to healthy food. They are informed by the importance of decolonizing foodways to enliven communities through holistic well-being. I am thinking of Joana Cruz, "womb manager" of Audiopharmacy, a group of avant-garde artists and musicians who create music while building community and advocating for decolonized and indigenous values.

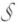

In other parts of Turtle Island and Canada, there are small communities of young Filipino Canadians and Filipino Americans who are not deterred by lack of numbers and visibility in their communities. They create out of inspiration and knowledge gathered from their repeated sojourns and relationship-building with indigenous communities in the homeland. KAPWA Kolective, Datu, and Hataw in Toronto; Kathara Society in Vancouver; Jana Lynn Umipig in New York; Nicanor Evangelista, Diyan Valencia and Marybelle Bustos in Los Angeles; Mamerto Tindongan in Ohio; Perla Daly and her Babaylan mandala in Texas, and Grace Caligtan and her group

of Urban Babaylans in Hawaii. You can google all these names and check out their projects.

This indigenous cultural revival in the liminal spaces of a global capitalist culture is akin to a warning system of what is at stake. The continuing subjugation and manipulation of our desires and dreams in the homeland and in the diaspora continue to this day under the regime of white supremacy, patriarchy, and a capitalist system that, in the long run, cannot be sustainable. As I became aware of the unsustainability of the current economic system that is based on "unlimited growth" and the global exploitation and extraction of limited/finite resources of the Earth, I also slowly became aware of how I had bought into this system, and participated in it (with a measure of "success"). My disillusionment has been slow and it came in through the backdoor of my awareness.

I first learned this perspective intellectually after reading many books and online sources on global capitalism, on environmental impacts of overdevelopment and impacts on people in the Global South, third world poverty and hunger, and indigenous resistance around the world. I've also been reading and listening to the many voices that represent communities and movements that are building resilient futures and waging a resistance against the modern/development paradigm. There is the Slow Food Movement, Transition Communities, Bioneers, Biomimicry, Another World is Possible, World Social Forum, Black Lives Matter, Occupy Movements, YES Magazine, and so many more social media-activated groups.

At the heart of these movements is the resurgence and re-emergence of Native Communities/Aboriginal Communities/First Nations within the "First World" with their calls for a movement that is inclusive, that respects the rights of the Earth, that listens to the Land and the Ancestors and their Original Instructions for guidance. What happened and is still happening at Standing Rock is the hallmark of a new form of activism that touches on key elements such as the role of elders, of prayer, of social media, of global support, of women

leaders, of veterans asking for forgiveness for the history of genocide—all of these constitute an integral/wholistic understanding of the interconnection of All. It is all Sacred.

Traditional ecological knowledge, indigenous science, Original Instructions—all these are increasingly taking up space now in the public discussion of alternative and resilient futures. Scientists are more willing to dialogue with indigenous experts in looking for climate change solutions, for example. Whether it's Noemi Klein, Bill McKibben, Al Gore, or Michael Pollan, there is a growing consensus that the global capitalist system is going to be our undoing as an invasive species on the planet. But Joanna Macy, a Buddhist elder, reminds us that in this sixth extinction phase we are facing, we can create Beauty as we disappear. I, too, intend to disappear and disintegrate elegantly.

§

The Firestorm brought us to our knees. It humbles me. It is heartening that more and more people are becoming cognizant of climate change impacts because of this catastrophe. How shall we rebuild our communities? What needs to change? How do we change?

How do I change? How have I changed? This is not a new question for me; in fact, it has always been part of my process as I tune in to the call of my Indigenous Soul on a daily basis. My previous writings and publications focused on the process of decolonization for post-1965 Filipino Americans and subsequently, the question what do you do after you decolonize? pointed in the direction of learning about indigenous perspectives. Is it possible to become indigenous again?

Most of my more recent writings on medium.com are about Dwelling in Place. I've also done a three-part interview on Revolutionary Wellness Talk Radio on this theme.

At my age, I now have the the benefit of hindsight tended to by Big and Small stories that I have lived by. As I see babies and their young parents, I often wonder what kind of Earth they are inheriting and how they will adapt to it. What

new stories will need to be told? Will the homeland (and its gifts of Roots) continue to provide a grounding point of reference if identity politics eventually diminish in importance for generations of Filipino Americans who are twice or thrice removed?

These questions are coming up for me now because I have lived over half my life on Turtle Island and I have made a conscious decision to root myself in Sonoma County because this is where my body is. The two decades of decolonizing led me to this angle of repose. It doesn't mean I have turned my back on the homeland; it means that the homeland is in me now. All the gifts that indigenous friends and communities have shared with me, I have embodied: to know what it means to be of a Place (like Jenita Eko's T'boli village); to know what it means to have Nature as Sacred Text (per Datu Vic, Talaandig chief and babaylan Reyna Yolanda); and to know what it means to be connected to the Ancestors. I bring all of these Original Instructions with me where I am a settler who is learning to build a new relationship with the human and non-human Beings of Pomo and Coast Miwok land.

This desire to be claimed by Place requires a slowing down so that I may learn the names of the trees, plants, hills, creeks, insects and other beings in my neighborhood; or to sit down by the creek and introduce myself so she would know me; or to praise the tall redwood tree and the crows that make their nest in her. In this slowing down, it has become necessary to say "No" to projects in need of Doing. It's been a struggle letting go of all the projects, conferences, and events that I used to do. It's been a struggle letting go of the reins of CfBS and entrust it to younger folks who will carry its vision into the future.

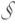

Once, a friend gave me a poster that said: What kind of Ancestor are you going to be? I had this on my wall years ago—like a beacon pointing in the direction of where I needed to move towards. That pointing led me to Poetry, to Taoism, Buddhist teachings, and teachings of Vedanta, to indigenous literature, to the practice of meditative qi gong. In my limited

access to a body of an expanded codified knowledge about Filipino indigenous knowledge systems and practices, I found resonances in these ancient traditions of Asian animistic cultures; after all Vedic and Buddhist and Islamic influences can be found in the homeland just below the sheen of western and Catholic influences. My body knows these ancient healing practices. Sometimes a story, a flash of insight, a remembered fragment, the floating scent of fragrant ylang ylang oil washes over me and releases all the toxic dramas of a restless mind. This is how I am learning now about embodied practices—a belated realization from the trauma of an educational system that privileged the mind over body and spirit.

The discourse of *Sikolohiyang Pilipino*/Filipino Indigenous Psychology or Kapwa Psychology was a gift that affirmed the tacit knowing I have always known in my bones. My immersion in a Protestant upbringing and Americanized colonial education didn't totally erase what the bones know and what the heart knows. In other words, the values of *Kapwa*/Self in the Other, *Loob*/inner core of Self, *Dangal*/integrity, *Pakikiramdam*/deep empathy were, to me, a scaffolding that supported the psychic and epistemic work of unlearning colonial mentality. These concepts took the form of Spivak's "strategic essentialism" that was medicine for a wounded psyche and heart at that time. This strategy also provided necessary grounding in a narrative that centers Filipino indigenous and cultural values and practices.

These days the daily practice of ritual making, of a growing awareness that the Earth literally cradles me or that energy or Qi can be cultivated and harnessed to nourish our lungs, heart, kidneys, liver, spleen—is medicine. In the Taoist healing system, the lungs carry our grief; the heart carries our agitation; the kidneys carry our fear; the liver carry our anger; the spleen carry our worry. The practice of meditative qi gong nourishes the organs so that all these emotions are transmuted into equanimity, tranquility, courage, kindness, and trust, respectively. This alchemy of body and spirit which has been known to my ancestors gives me a sense of well-

being and peace. In turn, this fuels my practice of culture-bearing in the diaspora.

And then there is Silence and Solitude as worthy companions on this journey. Be careful of what you criticize; it is calling out to you. There was a time when I silently mocked tree huggers—too hippie, new agey, too white. I should have known then that my resistance is also the invitation to move closer to my truth that was hiding behind my rational modern mind. Giving in to my resistance and allowing signs from a secondary reality, I now take time to hug a tree and feel the aliveness of a non-human kin. Take in the sky, fog, rain. On an early autumn morning this is the only prayer I need. How blessed.

§

Meantime, back in the homeland and Duterte's war on drugs, I was asked by the indigenous filmmaker, Aureaus Solito: Where are the voices of the Babaylans today? What has happened to our sense of Kapwa? What do these extra judicial killings tell us about ourselves? I didn't have an answer. I wanted to offer a beneath-the-surface kind of analysis and argue for the adamantine sense of Kapwa that still undergirds the culture but I couldn't articulate this. I felt I didn't have an accurate sense of what was happening in the homeland since the election of this president; relying on Facebook feeds alone didn't feel right to me. I also haven't been home for almost five years and my attention since has shifted to more local, place-based events and concerns.

In fact, lately I've been meditating on this sense of distance from the homeland. I feel a kinship with second and third generation Filipino Americans who have never been to the Philippines, whose attachment to a homeland is tenuous and nostalgic at best. I watch some of them trekking back to the Philippines for two to three weeks hoping to get a taste of what it feels like to be "home"— they hike up Lubuagan to get tattooed by Apu Whang Od, they go to Bahay Kalipay in Palawan, dip their toes in Boracay. And they do come away with that feeling of belonging, a bone-deep knowing beyond

words. How this translates to culture-bearing engagements in the diaspora, I surmise, is what is palpable in the cultures of the diaspora but it is also subjected to criticism of cultural appropriation by gatekeepers in and out of academe. Gatekeepers keep the borders closed; as if they can contain or tame what is beyond taming.

Gatekeeping: the dying remnant of a modernity based on binaries and hierarchies. This has shown up in my life as a long search for Certainty in making sure that I always end up on the "right" side of every moral dilemma. In hindsight, this insistence on being right simply creates shadow material that would later on erupt to destabilize all the certainties I have tried to cling to.

In My Country by Mia Alvar posed this challenge of gatekeeping for me. In reading her stories about the lives of Filipinos in the diaspora, I could no longer apply identity theories or conceptual frameworks that have served me as a scholar writing about the cultural identity of Filipinos in the U.S.. These lives are too wild to be tamed by theories of identity and cultural formation. Our stories of displacement are also stories of love affairs, of dreams pursued, of unrequited desires, of finding home and belonging outside of the homeland. Even the idea that we are the "servants of globalization" was no longer resonating with me like it used to. I was taken in by this Wildness and it surprised me that I love the feel of it. I love the uncertainty of not being able to put the stories in a box and label them. I think there is something about our Filipino stories in the diaspora—the largeness of spirit that enlivens us in the midst of pain and suffering, in the midst of a disenchanted world—that hasn't been theorized yet. And maybe it can't be. Maybe it just needs and wants to be sang, painted, and danced. Maybe it just needs to be cooked and eaten kamayan style. And this we do.

§

Nora Bateson in *Small Arcs of Larger Circles* writes about the dangers and consequences of the "mental mono-cropping" born of the tradition of academic disciplines and their

boundaries. The ecology of the mind is complex and disciplinary expertise alone cannot hold this complexity entirely. In fact, perhaps no academic discourse can.

So as we get unmoored from our tenacious clinging to absolutes and certainties, what can we turn to then for a sense of purpose, home, and belonging? If I want to leave behind a legacy to my descendants that will last for seven generations, what would that be? What does a good Ancestor look like?

The answer depends on the world view one lives by. If you believe that the Earth is god's gift to humanity and therefore, was meant to be exploited and extracted to sustain a modern lifestyle, then you will have a different relationship with the Earth than someone for whom the Earth is alive and breathing. And if God is viewed as a transcendent but not an immanent figure in Creation—this, too, will shape your thoughts and actions. In the modern era, we see which world view has been translated and manifested into concepts of domination, competition, individualism, freedom, rights, democracy, development, and progress.

We are now seeing the consequences of this world view as we deal with climate refugees, droughts, hunger, war, and different forms of violence. We are traumatized and we are offered drugs and reality television to numb our feelings, to hide our confusion and anxiety, to silence our angst. We have been tamed and they call it 'civilized.'

And yet...

We know deep in our hearts and in our guts that this should not be what it feels like to be human. There are stories and myths that remind us that there are other sources of meaning and purpose. And they have never left us; they are merely waiting to be remembered.

I remember the story of Mangatia, the weaver of heaven and earth in the Kapampangan creation story. I remember the story of Mungan, the first babaylan of the Manobo people. I remember the story of the babaylans who were chopped up and fed to crocodiles by the Spanish colonizers. I remember the story of my magical grandmother who raised seven children by herself when her husband died young. I remember the famous

Luna brothers—Antonio and Juan—and their not-famous brother, Joaquin, who is my great grandfather. They made history as revolutionaries—in battle and in the arts. I remember the beauty, strength, passion, humility, resilience, wisdom, integrity of my Kapwa. How else would we have survived our violent history?

Let our mythical imaginations enliven us... again.

This violent history of empire continues to cast a shadow that envelopes the Earth now. We have reached the tipping point, the scientists at 350.org say. They keep dangling the carrot of hope that humans and their technology may still save the planet. Perhaps. Perhaps not. All the best-intentioned efforts to curb carbon emissions, to divest from fossil fuels, to shift to renewables, to noncapitalist economic systems, to build social justice movements—are all good. Yet what I do not hear enough is the need to downsize our consumerist lifestyles, to downsize our ambitions, to downsize our appetites. Question the need for 800 US military bases around the planet to secure the American lifestyle. In popular discourse, I do not hear enough about the need to restore a relationship with the Earth and all her non-human children. Just watch your nightly news on television and you will know what I mean. This is the Old Story that wouldn't die.

But there are cracks in the Old Story where the ancient-new story is emerging if you know where to look.

What stories do I want my descendants to remember? Who do I want them to remember? I want them to remember their ancestors. I want them to know their history in all its complex entanglements and how it shows up in their lives. I want them to know their non-human kin—the trees, creeks, mountains, oceans—and I want them to feel the heartbeat of the Earth as she breathes. I want them to fall in love with a Place and be claimed by her. I want them to look up at the night sky and be swallowed by her vastness...and then be reminded that Mangatia is weaving heaven and earth with her needle and thread and you can see where the knots are because they sparkle like diamonds. I want them to put their hands in the soil and feel the fertile magic of microbes that keep everything

alive so that we may be fed. I want them to know Coyote, the village chief beloved by her people, who is married to Frog Woman...and all the inhabitants of Sonoma Mountain where all the animals were people once and will be again.

If only we can shift our gaze towards this gentle horizon of the Local; if only we can decide to stay put so that we may become more intimate with our landscapes; if only we no longer feel the need to escape to exotic destinations; if only we no longer need to fill our houses with stuff to feel satisfied and enough; if only we no longer need to buy the sales pitch of glamour and celebrity—we might begin to quiet the hunger in our modern soul. We might begin to turn to a more beautiful Story.

The future is indigenous, says Fr. Albert E. Alejo, poet, philosopher, friend, and mentor. In my little corner, it already is.

KAREN BRYANT SHIPP

Coyote at the Crossroads

IN NOVEMBER 2016, TWO DAYS AFTER AN ELECTION that left many of us reeling, I was driving home from work through the early evening, in moderately busy traffic. I could see ahead of me a construction site: new condos going up where a venerable old church had been, at a busy intersection of three different roads. From the construction site, I saw a large dog run out into the lanes of home-going cars; the SUV ahead of me braked and swerved to miss him, but nipped his back legs, spinning the dog around in circles until he landed in the left-turn lane in the middle of a seven-lane road. Without thinking, I swung into a big U-turn, came up behind the dog and stopped, blocking him from being hit.

I turned on my flashers; the headlights of my car shone directly on him. He was sitting there in the middle of the lane, very casually, as if he had just paused to rest. I got out of my car and moved toward him. He watched me quietly through narrow eyes. Now, my daddy grew up on a farm, and if he'd told me once, he'd told me a hundred times: A wounded animal is a frightened animal and therefore a dangerous one. I talked to the dog as I walked around him, my voice low and gentle, then slowly stooped down to him. He looked me steadily in the eye, and I thought, He looks like a very big fox. Cautiously, I reached toward him and petted him gently on his back, he watching me the whole time, eye to eye. There was no collar, and his fur was thick and matted like that of a wild animal. Clearly, this dog had been living in the wild for quite a while. He wasn't bleeding or visibly wounded in any way. I petted him tenderly, saying to him over and over, "I don't know what else to do for you. I don't know what to do."

To my left, I noticed that a line of cars was forming behind mine, trying to make a left turn. I went back to the driver of the first car to explain what was happening.

"Is the dog still alive?" he asked.

"Yes."

"Well, let's take a look at him."

As we turned to go back, the "dog" suddenly leaped to his feet, ran back toward the construction site, then, in a big circle, dashed back through the busy traffic, across all seven lanes, and into the woods.

The man chuckled. "That was no dog. That was a coyote. Good thing we didn't try to pick him up."

We got into our cars and drove away.

Coyote is the Trickster among the Lakota (Sioux). He is met at the crossroads and on the periphery. He is found at the threshold; he resides at the boundary line.

Wily and clever—though not nearly as clever as he thinks he is—Coyote constantly gets into trouble overreaching himself, pushing the boundaries of every situation. A thief and a liar, he is at the same time often foolish and susceptible to others' lies. But Coyote also knows how to steal the bait and spring the trap without getting caught; he knows how to cover his tracks, circling back again and again to throw the tracker off his path. Coyote has been known to disregard others' instructions or to try to sidestep doing things the way he has been told to do them. He often ends up paying a high price for his disobedience, but sometimes he discovers a new way. He is a complex, ambiguous character.

There was no Coyote, no Trickster, in the Southern Baptist church tradition into which I was born in the 1950s. The only coyote I knew about was on episodes of *The Road Runner,* where Wile E. Coyote is forever trying to catch and eat the Road Runner, a fast-running bird of superior intelligence who repeatedly outwits Coyote and escapes his traps. It was a cartoon, strictly secular, limited to Saturday morning TV viewing.

In my family's religious tradition, on the other hand, I was raised to believe that there was One God, Omnipotent, Omniscient, and Omnipresent. This God had rules; and the Ten Commandments were only the beginning. One either

obeyed those commandments (and all the others) or disobeyed them, and disobedience was sin, plain and simple. There were, of course, characters in the Bible who were trickster-like figures, but their behavior and actions were held up to us as a strict example of what we should never do, under any circumstances.

A thing, a person, or a behavior was either right or wrong, good or bad. There was no room for ambiguity, at least in the Sunday Schools I attended. How often did I hear Jesus' story about the wise man building his house upon the rock, and the foolish man, on the sand? Jesus was the Rock; the Way, the Truth, and the Life, and there was no other way to God but through Jesus Christ.

How could there be a Trickster in that tradition? The Trickster makes his home on the shifting sands of ambiguity! He is not above lying, cheating, and stealing to get what he wants. Driven by appetite, he is by Christian standards an unsavory character, to say the least.

But here's the thing about Coyote: Because he is not committed to one "right" way of doing things, he is flexible and adaptable. He is the one who finds it possible to change to meet the challenges of a new environment. In *Trickster Makes This World*, Lewis Hyde reports, "One story has it that in the old days sheep farmers tried to get rid of wolves and coyotes by putting out animal carcasses laced with strychnine. The wolves, they say, were killed in great numbers, but the coyotes wised up and avoided these traps." (p. 21) I've read that coyotes can figure out how to spring traps set for them without getting caught. They may even dig up the traps, turn them over, and urinate or defecate on them, as reported by naturalist Francois Leydet in his book *The Coyote* (quoted in Hyde, p. 21). Coyote hunters write pages on the internet about how to call a coyote, but they also warn that experienced coyotes quickly learn that the rabbit-in-distress call means a human with a rifle. Coyotes also know how to circle back around and throw the hunter off their scent.

In times of great change, Coyote isn't afraid of the crossroads or the shadowy periphery or the ambiguous. If we

pay attention to him, he can remind us not to take ourselves so seriously. He makes us laugh when he bends the rules or finds himself the butt of someone else's joke. But he also embodies the possibility that when we don't do something the way it has always been done before, the way that is recommended or considered "right," we might discover a way that is new.

Three months after our encounter at the crossroads, Coyote showed his face again: At the Oscars ceremony in February 2017, the presenters of the award for Best Picture were given the wrong envelope and announced that *La La Land* had won the Oscar. As the proud producers came up on stage and made their heart-moving speeches, a flurry of confused activity behind them finally led to the announcement that, in fact, *Moonlight* had won Best Picture. It was a painfully awkward moment; Coyote turning things upside down, to the chagrin of everyone involved.

The November 2016 presidential election had already felt to many of us as though the rules as we knew them (or thought we knew them) had been flipped on their heads. In the contest between a highly experienced stateswoman and an unqualified and unscrupulous businessman, we assumed experience and integrity would win. The businessman was known to be a tricky character, declaring bankruptcy and leaving others to hold the bag, proud of his sexual prowess and power, a braggart and a liar. When the 45th President of the United States was announced, we felt sucker-punched, tricked, humiliated. After I told a good friend of mine about my encounter with the coyote, she said to me, "Coyote is loose. Trickster energy is in charge now."[§§]

My upbringing in the Southern church of the 1950s (though the ground shifted in the 60s) led me to believe that life made sense, that good people were always rewarded, and bad people were always, always punished; or, if not punished, converted, brought to see the light.

All of which meant that if I did the right thing, if I were a "good girl," everything would turn out fine. I would be

[§§] I do not mean to suggest that our current President is the trickster. But there was definitely trickster energy afoot in the 2016 election and beyond.

rewarded, would flourish and be successful and loved and praised. Things could be expected to move in a straight line; consequences would proceed directly from actions. Good actions guaranteed good consequences.

Admittedly, these beliefs had more to do with Southern culture than they did with anything Jesus preached. However, as a result, I found myself totally unprepared for a world of uncertainty and ambiguity; that is to say, the world as it is, where the "right thing" is often not apparent, or changing circumstances turn a past right into a present wrong. A world where choices do not fall into such clear categories. A world where there is unyielding hatred, impervious to conversion, and prejudice that will not bend even in the face of the facts.

Straight lines: Again I am reminded that Coyote moves in circles, as big as the circle my coyote (may I call him that?) made in the middle of a seven-lane highway. Nothing with Coyote is a straight line. One moment he is creative and crafty, and the next, destructive and disruptive.

Maybe Coyote is returning to remind us that nothing is a straight line; that nothing is all "sweetness and light," all creation and no destruction; that, in fact, destruction is a necessary prelude to creation. Hyde quotes anthropologist Paul Radin (*The Trickster: A Study in American Indian Mythology*):

> Trickster is at one and the same time creator and destroyer, giver and negator, he who dupes others and who is always duped himself....He knows neither good nor evil yet he is responsible for both. He possesses no values, moral or social...yet through his actions all values come into being. (quoted by Hyde, p. 10)

Coyote disrupts, overturns the perceived order of things, the straight lines, and in so doing, he brings us back to the wild, which has its own, more organic order. And he is anything but a cartoon!

What is lost when we make God all one thing? What is lost with monotheism, the belief in an Omnipotent God who is all Creator, and no destruction? all Light and no shadow? all Good and completely separate from what we then call Evil?

We become the creators of a dualistic world, where Right and Wrong, Good and Bad are separated in our minds and therefore in our experience. In this either/or universe we are left impoverished.

Monotheism is fertile ground for intolerance and fundamentalism and exclusion, because if my "One God" is the only Way, then you must either convert or be damned.

How different a world mine might have been if I had grown up with Coyote! If the religious tradition in which I was raised had told me stories about the Trickster and his antics, perhaps the world's snafus would not be as likely to throw me off course or into deep depression. The trap inherent in the belief that there is One God who is All-Powerful is that, when things go horribly wrong, there is no way to grasp what is happening without accusing the One whom we believe to be "in charge." If God is Omnipotent, how can we not blame God? Without a world view that includes the Trickster, we cannot help being forever confused by the uncertainty and ambiguity of our world as it is.

Was it an accident that Coyote crossed my path that night? In the metropolitan area of Atlanta where I live and work, constant construction is destroying Coyote's home, pushing him into the backyards of suburban homes. And although he is remarkably adaptive, it is inevitable that at some point Coyote will try to cross a road at a busy intersection and be hit—as he was two days after the election of a President who, by all indications, is intent on cutting down every protection that Coyote or any other wild creature has been given.

Still Coyote surprises us, leaps up unexpectedly, backtracks, then circles around to continue the way he was going, toward the wooded areas that still remain; teaches us how to continue, how to adapt, how to maneuver in the shadowy periphery, how to find our way through the ambiguous and over the threshold —how to navigate this increasingly tricky world.

MURZBAN F. SHROFF

Making the Invisible Visible—A Writer's Journey Into The Unknown

FAULKNER WAS ON THE DOT when he said in an interview to *The Paris Review*: "The writer has a dream. It anguishes him so much he must get rid of it." For me, it was the dream of being a writer that led me to give up a lucrative career in advertising— one in which there was success and gratification but little satisfaction. Initially, inspired by writers like Somerset Maugham and F. Scott Fitzgerald, I wrote plot-based stories with a conventional twist in the tale. I wrote for two years, and found myself dissatisfied, the reason being there were too many writers writing and too little literature. At least that's what my visits to the bookstores informed me.

Why do we need another Mumbai writer? What did I have to say that was any different? These were some of the questions that haunted me.

I realized that if I had to make a difference, I would have to produce something substantial, something more interesting than clever, entertaining stories. After all, my making a career switch wasn't about self-indulgence but about making a meaningful contribution. At the same time I realized that I did not know how several of my fellow-Indians thought. I realized that I not even attempted to understand the holistic picture that was India. As an advertising man, the really poor never mattered, for they did not have the buying power. But as a writer I had to understand the motivations of the less privileged.

So, accompanied by a filmmaker friend, I travelled to the villages of Central India, to the site of a large dam where tribals were being displaced en masse. There I learned how over two hundred villages had been submerged by the water from the dam and over fifty thousand families had been displaced. To make way for the dam, villagers were evicted by uprooting their water pumps, demolishing their schools, and cutting down their trees. To get compensation they had to go through

brokers and middlemen, who would take their pound of flesh. The rehabilitation schemes would compensate landowners, but not landless laborers, forest tribes, artisans, tradesmen, and fisherfolk. Overnight, these people lost their lands and livelihoods and became paupers. Removed from their roots, they would have no option but to head for the cities and towns.

The problem with displacement is that it breaks up a well-established ecosystem. It breaks up not just a village but a close community and families. In a village, people are collaborative: everything becomes a community activity, be it a wedding, a festival, or the building of a house. Unlike in a city, where residents are more guarded and private, in a village people take joy in each other's progress. But displacement changes all that. It drives people from one state to another, a state with an altogether different language, culture, and traditions. Sometimes it thrusts the victims from a cashless society into a cash-driven one, which can be traumatic. More often than not, it sends the evicted to an alien land (which is the city), to an alien neighborhood (which is the slum) and to an alien livelihood (which could well be manual labor).

Speaking to the tribals, I realized that they had no desire to come to the cities and live in slums or reside on pavements. In the villages, there is self-sufficiency and respect. They get their food, water, and sustenance from the land. How can we then expect slum dwellers and pavement dwellers to feel any ownership for a city they have been forced into? No one willingly wants to build his house on a gutter, or defecate in the open, or sleep his children on a bed of concrete, or make love to his wife in the open.

Having understood this, I returned to the city with an entirely new sensibility. I knew what I wanted to write about: they, the invisible; migrant workers like the washermen, the cabbies, the carriage-drivers, the truck-drivers, the masseurs, and the street vendors, who—with their silent labors—kept the city moving. I realized that Mumbai had three kinds of people: the haves, the have-nots, and the know-nots. The know-nots were people like me, who did not know how the other half lived. It would be my duty to sensitize the know-nots to the

have-nots, to bridge this seemingly wide divide and create understanding where there was none.

Returning, I spent time with various migrant communities, striving to understand their issues, their struggles, their dreams, and their realizations. I also spent time with sex-workers and their children, with drug addicts, transgenders, and HIV-infected persons. And I explored issues such as civic apathy, encroachment, usurpation of green zones, corruption in the public sector, and class envy and class divide. I discovered that there is no there is no point living in India if you are not conscious of the "other." The inequities are a constant reminder of what has been delivered to you and what is denied to the others. This was an approach that would inform my work, inspire me, and lead me to explore spaces and subjects unknown to myself and to my readers. It would enable me to shift my focus from plot-based writing to thought-based narratives. And to create scenarios of a wider, more alert humanity.

§

An excerpt from *Waiting for Jonathan Koshy* (Independent Thinkers, 2015) a postmodern novel about a genial, high-IQ bohemian struggling to prove his worth in modern-day India:

> He liked to recount the woes of the flesh trade, which he'd narrate on the way home. It was either Dhruv or me he'd speak to, rarely with Prashant, who was burdened with an over-sensitive nature, nor with Anwar, who had a patrician dignity about him, a genteel softness you didn't want to disturb or sully.
>
> One time he had gone with this whore who reminded him of Jhootika, his neighbor in Khar, who went with the biker-boys from Carter Road. She was a good looker and he had paid a fortune for her, reserving her for the length of the night. According to him, she had the same honest black eyes, the same dimpled cheeks, and the same sharp nose as Jhootika's, and she was modest, too, her features wearing the softness of the unspoiled. But with all the booze and weed in him, he had felt impatient. Leading her to a room, he had gripped her in a tight embrace and buried his lips in the curve of her neck.

To his horror, she had started crying. She had buried her head in his chest and sobbed her lungs out, and the same booze-and-weed combination that had moments before sent his hormones racing now made his heart pound with compassion. Stroking her head, he managed to coax the reason for her outburst: it was her birthday and she was missing her family back home in the village. There, in his arms, she had cried miserably, insensibly, hacking deep wrenching sobs of hopelessness.

His shirt damp with tears, Jonathan struggled with his conscience. "There were two thousand rupees at stake and a raging libido. Not an easy choice," he said gravely.

Then he had decided. Extracting himself from her arms, saying he'd be back soon, he had walked out of the room and approached the madam of the brothel, a woman with a creased face, painted lips, and shrewd eyes. To her he had suggested a party.

The madam had refused. It was unthinkable, she said. Today he was here, but tomorrow she would have to pay for the other girls, too, in case they decided to celebrate. Best to let matters lie. The tears would dry, sooner or later; they always did; what choice was there, what choice, indeed?

Then sternly Jonathan reminded her that the girls called her maushi, meaning aunty, and that they trusted her in the way of a guardian. Failing them, maushi would have to repeat this existence in her next life; she would be born again as a whore; and did she want that, did she really want to bring that onto herself?

Listening to this fat, angry boy seething with conviction, the madam had relented, saying she was giving permission for a party but for one hour only.

Promptly Jonathan had swung into action. He had rushed to the restaurant around the corner, and there he bought some packets of chocolate biscuits, jam, vanilla ice cream, and candles.

Returning to the brothel, he had gone around knocking at doors, rousing the whores and their clients, explaining to them that there was going to be a party, a surprise party, to which they were all invited.

Some of the whores had cursed him, shouted at him. They demanded to know if he was drunk or just plain crazy.

But he had persisted. It was their sister's birthday, he said. She was eighteen, and they, being her family, should be there for her. "Come on, your sister needs you. Give her your blessings and then get to work. You will enjoy it better, I promise you."

Slowly the doors had opened, and the whores had emerged, their hair loose, their stomachs exposed over low petticoats, their breasts plump and swollen, in low-cut blouses.

Jonathan had herded them into the main waiting area, and there he sat on the floor and made the whores sit too. They sat on chairs, on sofas, in their clients' laps or at their feet, making sure they kept up contact; they stoked passions already stirred and heated.

With Jhootika by his side (mentally he had decided that was to be her name), he had arranged the biscuits on a tray, on the center-table. He arranged them in rows, so they made a large rectangle, and then he had lathered them with jam, and set another layer of biscuits over the jam. On this he dropped spoonfuls of vanilla ice cream, soft and creamy, and he spread this all over, like icing, and in between the biscuits he inserted small candles, and these he lit, one by one.

And then, lights off and watched breathlessly by all, he cut a piece of the cake and held it to Jhootika, and she, who was smiling now and blushing, leaned forward eagerly.

And as she bit into her cake, he clapped hard, and all the rest did the same, and at the same time he broke into a song, a filmy version of *Happy Birthday* rendered in a jocular, quivering Shammi Kapoor style that made everyone laugh.

Rising to his feet, he demanded some music, and an old radio was produced, and some music came on, and to this Jonathan began dancing. And, as was the case whenever he took to the floor, all the whores watched spellbound, and so did their clients, who cheered Jonathan loudly, and then, as though struck by his magnetism, the whores all joined in; one by one they came forth, raising their hands and dancing, as though they were free, happy, liberated souls. And the madam, too, smiled. She had never witnessed this before – all her girls so happy, all their clients, too.

With each new song, the whores crowded Jonathan, hoping to learn from his footwork. But he stuck to Jhootika. He knew her real name by then. She had whispered "Shabnum" into his ear.

MARTHE REED AND **LAURA MULLEN**

On Shame

WHEN I GOT TO HER HOUSE I went into literary executor mode (for no good reason—my friend Marthe Reed didn't leave a will): I was taking control mostly to stave off despair. I'd been there less than an hour when I found myself telling her husband, "The first thing is, *nothing* gets thrown out." "Oh," he said. Pause. "Well we threw out the poem Galway Kinnell wrote for her...—her sister wanted to burn it." And then (he saw my face) he said, "Wait," and he went to the recycling bin and fossicked there and pulled out and handed a page to me. Later I'd learn that the typewritten poem had been found folded up in one of their photograph albums. Even Marthe had believed it was lost. But now her family was combing the albums for pictures of her (who had so often been the photographer), and I was there, in Syracuse, for the memorial service.

Every 80 seconds, I find, after entering the search terms, a woman dies of heart disease or stroke. 6 in 10 people who die of stroke are women. The number of women who die of stroke is increasing rapidly. It's the 5th leading cause of death in the US "and about 60% of people who die from strokes are women." My friend had a stroke on April 9th, and died on April 10th—never having regained consciousness. It was "instantaneous," there was "no pain," she made a small noise and was on the floor (in the basement where the activist group she'd joined [after November 2016] was meeting), unconscious. "The brainstem was crushed." She'd been Googling, as we use that verb now, "signs of stroke." Then the seizure. I can't bear the thought of her, quietly trying to find out if she should be worried about what she was feeling, but it is true—and so she would want me to tell you. I think. She loved me for some things—my honesty a part of that.

She was there—and now she's gone. She was everywhere, it seems like (because she was so active in the real and virtual community of poets), and then not. When she died, I said to

someone, she'd been so many things to so many people it was
as if there'd been a mining disaster or... It was as if 300 people
died at once. But those who mourned her would keep talking
about the ways she'd comforted them—and her unfailing care
for others and her skill as a baker threatened, in the
spontaneous outpourings on social media, to upstage her
importance as a visionary publisher and brilliant poet. Those
aspects of her reputation were still (when she was on the edge
of 60 years old) in process: a chapbook, a co-edited anthology
from Wesleyan and an important book-length work from The
Operating System will be posthumous. I know a white guy
whose first book got him a nomination for one of the major
literary prizes (one of those often given out for a lifetime's
worth of work)—nothing like that ever happened for Marthe:
co-editor of Black Radish Books and author of six books, and
still somehow a bit easy to overlook. Female and vulnerable in
a world which still tends to believe those attributes identify
not so much the maker of the art-work as the renewable fodder
for the maker, whose hunger (and whose ability to create)
depends on sacrifices...that basic prejudice is part of this story,
or anecdote, about Marthe's #MeToo moment with Galway
Kinnell. Maybe we should start saying #HimToo or (with an et
tu slant to it) #youtoo. Too many of you.

In Syracuse, in 2018, Marthe's sister Bess was still, 36 years
later, recalling how Marthe had talked of Kinnell (the famous
poet, interested, *really*, in her work) *furious*. "The fucker!" How
flattered and hopeful Marthe had been, and how—her sister
remembered—dangerous it seemed, even then, such hope. Too
many of us can list the sad instances of that same hope in our
own lives, examples of brief and disastrous hope. Fearful but
eager to be encouraged, the sense of the man's *interest*
wishfully seen as maybe a door opening, and that absurd hope
—encouraged and badly misplaced. Angry still, my friend's
sister, and anxious: *how do I talk to my daughter about this*, she
asked. I didn't and don't have an answer to that question—
what I have are these pieces Marthe left, which I am going to
make available, as I think she would want that. They are part of
the story, and they give us something we need, which is A)

access to the mind of the abuser in the instant of planning abuse and B) access to the mind of the victim, where the abuse resonates long long after the event. I brought back the 13-line poem, and I have (thanks to Marthe's husband) the piece she wrote about the encounter, after Kinnell's death. I am posting them here because I believe they add to the conversation we are having, as a nation (as well as a specific—literary—community) about abuses of power and their effect.

Just in case the fact eludes some readers, I will note that Kinnell's almost-sonnet (missing the form by a line) is clumsy and weak: at least for those who can read past reputation, past maleness, past whiteness—past all the framing systems in place to hold what is pure garbage up as if it were gold. But bad art reveals so much: here we can easily see that the male poet is almost as frightened of his own mutable body as he is terrified of the female poet's mind. Her "hard" eyes "directly connected to the brain," appall him: and he tries to move the mouth he imagines "kissing the words" far away from eyes and brain, some incredible distance we are meant to see as impossible to close, at least for someone who has only "one lifetime." Intervening "Gods of the imagination" (huh?) give the poet some noisy indigestion at this point, and the reference to the "stomach" twice in the same poem is not chance (in some ways the sonnet might be summed up as this—O he wanted to consume her, and he can't. Poor guy). The poem is a flop—and ends with a flop (the best one can say here is that the poet *knows* it's trash). But the point, throughout, is a specific (and completely false) imbalance of good fortune and power: she has a car, he has his "old park bench"; she is "beautiful," he is "derelict." As a poem of seduction it sucks: is the author thinking that *pity* is going to lead to sex? Well, why not? This imbalance—as palatable or even seductive proposition—would have been familiar: illustrated (and celebrated) in the paintings, sketches, and etchings of Picasso, where the stumpy wizened painter (sometimes depicted as a minotaur) frolics happily with his straight-limbed young mistress. In other words, "poor me" works. The point here is that Kinnell imagines that it's the young woman he's taking

advantage of who has all the power. The point is this: the self-pity of the abuser has no limits.

Reed's piece is a model of complexity, dense with self-interrogation and a vivid awareness of the layers in the experience that her younger self missed. (Just a reminder: Reed wrote Kinnell "a real poem" which—apparently—he didn't want, and which [as far as I can tell] no longer exists.) In "on shame" Reed relives the complicated hope that she might be seen as a real writer and explores the contempt she interpolated. Read "on shame" to understand how it feels to be invisible except as daunting prey (your brain a problem the abuser has to somehow get past), read it to understand what it means to disappear as a writer and reappear as potential "conquest." Read it to hear the object work the long uncomfortable way back to being subject, a subject damaged, a subject hurt: having been taught her false place, which was to serve as an amusement, a distraction, a sort of relaxation and refueling stop for the visiting poet, Reed goes over the steps she has to keep taking to find her real place as the writer who survived being treated as trash—and she shows us what it means to live in the shadow of a reputation you're afraid to "tarnish" with the truth. Whenever you hear a woman talk about abuse, think about silence—think about the women who didn't make it through with their sense of self intact (and who kept quiet so as not to be expelled from the community invested in the abuser's success): think of the women who didn't make it back from the understanding which was forced on them—the understanding of their own worthlessness, yoked to a deep sense of guilt. *Look what you made me do* is the abuser's usual defense. *Look what he did.* I am writing this to say that: *no one made him do it.* No one made him act this way: he was *allowed* to do this, because too many people didn't give a fuck about what it cost his victims—and it might take 50 years for people to stop celebrating Kinnell's stupid "Bear" poem (infected by the same self-pity we see in this untitled work) and begin to give Reed's complex, ambitious work (which describes and enacts an ethical relationship with the environment) the attention it deserves. *Look what he did*

because he could do it: because the literary community, and the academic community, together, agreed it was okay for him to do this. Not "okay" enough to admit, but just fine and dandy to continue in silence... That bullshit has to stop.

Laura Mullen
May 9, 2018

```
She is tall and beautiful with much hair
and stands by her car smiling to the derelict
old man whose stomach muscles are dragging
his torso upright thus to be properly amazed by her.
She looks at him her eyes smiling and hard
and directly connected to the brain showing everyone
who she is, behind the two walls of glass, alone
and true and a long, too long for one lifetime
to overtake, distance from the mouth the lips
kissing the words until they tremble out from her.
Gods of the imagination being jealous strike
his poor stomach with her beauty and strangeness
and he groans and falls back on his old park bench.

                                    --Galway Kinnell
                                      Jan. 27, 1982
```

on shame :: a remembrance of things past

When my FB feed filled up with grief at the news of his passing, filled up with favorite poems, grateful homage—that goddam bear thing—I scrolled past. Kept quiet. Scrolled on. *Let it go.* Absurd anger scratching under the surface (scab or scar). *Whatever.* Saying this under my breath, the sound of half-swallowed shame. *(What a fucker.)* What I wear as armor.

 Then, or once. I was someone else: womanandgirl, girlandwoman. Neither. I had been "in love." Or in the shit, which

was it? The deep end. When he vanished by train, riding north on the pressure of our embrace (the semblance of that gesture to shame: *embrace, embarrass,* sibilant rictus.) Swimming in the brilliant light of illusion and desire.

Later, months later, after a hesitant letter or three, sent to his university address (which I found, that is, on my own initiative, having, that is, "heard" nothing), I drove to see him read with Denise Levertov and others in a church in San Francisco. Poets for Peace. *(Piece of shit).* Let's just say he did not look thrilled to see me. More...anxious. More "oh fuck."

As before, as months before, he made his goodbyes and I drove him back to his hotel. It was odd. Tense. (Oh girl, you are so naive, how can you be so <u>thick</u>?) A parable of folly, that fall from grace: my blind infatuation, his awkward problem. He had to explain.

It is *awkward,* you see, He had a wife, a life. This (*you,* i.e., me) is not a thing, but just a *little* thing. Once. Not quite. And done. Not now. Not here, not done but. Undone.

You have not stop writing me. It is awkward. I have to go.

Oh. Oh, right. Right. () Right. (Now you understand?) The way of things, in the way of what gets. Lost. In the way that one seduces and another is seduced. That palliative sex. I drove two hours home, the rain-smeared dark on the windows of the car a kind of veil pulled around me in that torrent of confusion, tears (inevitable leakage). Hurt. (Surely I brought this on myself. What was I thinking?) Thinking I had been *in love.* Or, perhaps, loved? (Sexual attraction is not love, dear. Do try to remember.) *Known,* recognized. That I existed in the paradigm of lover/ beloved. That I, in a word, mattered. What passes for, what knee-deep fables promising, proffering. "If you are pretty enough, slender enough, *good* enough..."

Galway Kinnell arrives by train tomorrow afternoon. Would you be able to pick him up and take him to his hotel? (We'd been reading the poems, those lumbering bear poems, poems-in-rut.) Awash in honor, excitement, flattered pride. Chosen to meet the visiting poet, spend time with him. Perhaps...what? Validate my work? *Yes, of course. I would be delighted. Glad to.*—There will be no thought given to the cost of the gas, this is an honor, after all, for which I have been (gratefully) chosen. (Or *thrown,* I will wonder, though much later. Much much later. After I get over—*get over it*—(most) of the humiliation.)

What is seduction? Or, for that matter, the anxiety of masculinity approaching the monstrousness of its own imminent collapse? *Today's my fiftieth birthday*, he says, anxiously, when I meet him at the train. Or is that part of the seduction already? Preparing to collect him I dress in my best elegance, a slender skirt and jacket, a cream blouse, pumps. I am 22, older than many of my undergraduate peers. Also, impossibly young. (You *should have known, you* idiot.)

I was a fool, as I understood soon enough, later. I think I was meant to both recognize the accomplishment (the poet's eminence) and commiserate on the doom it fore-spoke. Death was the 'deep image' dragging its obscene corpse through his poems, his inevitable death (the *duende*, another of his miserable affairs. Fucking around.) But I am not honoring the dead. I am here to drive a stake through his heart. (Or what stands in lieu of empathy.) Finally. A belated castration (the one dreaded-age came wielding). Castrated bear. How...heroic, how deeply felt. How profound. (You *fucker*.)

I do not think of him, or the occasional others, the inevitable older men certain my youth would return their waning vigor (mastery?) to them. Vampires. A retired judge 'interviewing' me for an internship, a friend's father, Rabbi Baruch Korff. Yevgeny Yevtushenko. *When I tell you how <u>beautiful</u> you are, why do you tell me about your husband?* Oh I don't know, why do you think? —Why indeed do I insist on keeping to the polite surface of this game, pretending not to know what he angles for? Fending him off, again and again. I just *want to go home*, I just want to go home. I get someone else to take him off my hands (body) and split. The colleague, who invited Yevtushenko to campus, sent me, by far the much too-junior colleague, to 'entertain' the program's guest, this colleague who I will later understand used the women graduate students as his personal stable from which to select lovers. Seductions, *trysts*. The ubiquity of it.

Relegated to the frozen wastes of the past, the graveyard of humiliations: when brought into the light, anger flares up undiminished. Pride is an odd (off?) word for what I wish to say here, or articulate. The sense one has of innate *worth*, struggling inchoately against the hysterical (absurd) privilege that reduces me/you (tender things) to morsels fed to the anxious (voracious) libidinal urge, staving off potency's crumbling infrastructure.

Potential collapse of the member(ship) drive. Tenderly buttoning up his fly.

I drop Kinnell off at his La Jolla hotel, returning to classes only after he has extracted a promise that I will show him some of my writing, that I will come back, give him a ride to the reading. That I will return. *Of course.* I am flattered, honored. Excited. (*Lucky. I am so lucky!* I think to myself. The Poet wants to see my work, wants to talk with me about it.) Do I imagine I have promise? What are promises, anyway? Borrowed or broken, maid.

What is this anger but the face shame wears in public. After more than thirty years? (*You should have known, you should have —No. Shame.*)

I am tall, very slender then, desperately longing for the currency of elegance, that puissance Audrey Hepburn possessed, a potency both in a particular expression of Euro-American feminine beauty and a hidden strength (armor?) just beneath the surface. Is it possible to be both beautiful and strong? I needed these affirmations. That I could be understood as *valuable* in the economics of heterosexuality. Valued (what price tag should we put on this?) without losing the ground of me, without erasure.

Kinnell must have read me as passing the test: 'pretty' enough? And young. So distant from the specter of the fifty years he found himself precariously teetering above. I gathered some poems, anxiously selecting my "best" and, yes, aware that a certain sexual tension lay in the matrix of this exchange. I was flattered to be pretty, to be noticed, that The Poet noticed me. *Did I believe that I, too, would someday be a "real" poet, possess that other potency—a language which would speak to others?* (What lay beneath this? Fretful, irritant dread that I would never carve my way out of the fortress in which I had barricaded myself against everything I could not control. That is, everything. That is, sex.)

I have few memories of the reading, except the storied memorized performance, Kinnell's eyes never leaving the audience to glance down at the page, performing the 'bear' in his thick height and voice (thick about the waist). Did his eyes make contact with mine? I don't recall. I took him back to the hotel after the "wine and cheese," the small talk at the tail end of the evening. Was he in a hurry to leave not too late?

I don't recall the conversation on our way back to his hotel. Perhaps he asked about my work. (My work.) *Of course* (this does

not need to be said but) he invited me to come in for awhile. To talk about the poems. Of course. I was ill at ease, alone in the hotel room with him. (Shall we note the innocence of our speaker? She had never *been* with a man. (At 22?)) Why did he stretch out on the bed? Surely there is not a lot of room to sit in the hotel room and the bed is there, *so*...soft.

I sat at the far edge, near the foot. Perhaps too near. He must have realized I was nervous. I was, also confused, uncertain. Anxious. (Now we move to the heart of this matter, her insecurity, riddled with self-doubt, even self-loathing. She had been 'fooling' people for years, just once more here, at the crux. (Was this tear in the armor something else he had read, sizing me up?))

Would he like my work? (That is, approve it. Would it/I please him? (*Father*, oh father, who will justify my existence.) Note the excess of parentheses here. She *is* anxious. Also, uncomfortable.)

Neophyte, newbie, *fresh* as fresh can be, straight from the shelter of a sheltered, rural upbringing. *Pastoral* childhood. In the parlance, a *virgin*. (Absurd, stupid, shameful: a failure. What an *idiot*. Really. What. An. Idiot.)

He suggested we write a poem for each other. How...*romantic*? Except I had no idea this was meant as a romantic gesture. Or rather, a stage in the seduction. (*Really?* The insistent soundtrack of my thoughts unspooling. This capacity for both self-doubt and shame.) Oh, Audrey, remembering him, dear, means remembering you. How you failed to leave any windows in that fortress you built yourself. How did you see *anything*? Or I?

I took it seriously, writing the poem. At face value. This was the test. I would demonstrate I had the 'stuff.'

When we exchanged poems—so much heat in that exchange, the scrape of paper on skin, the subtle touch of fingers. Poems, potency, sexual awakening. That The Poet read me as having both potencies, poetic and sexual, was gratifying. Also unnerving. I had no idea, was without a compass to navigate these waters. ('Tread' water is perhaps more accurate a description. (I had no fucking idea.)) I was flattered.

He was so much older than me, older than my advisor (also a serial seducer of coeds, I would later come to learn. Where does this stop?), more than twice my age. I did not imagine sex with Kinnell. That is, had I been capable of imagining sex with anyone. That I wanted to be understood—*seen*—as sexy, is understood. But what *then*?

I don't recall the poem he wrote for me or even if he let me keep it afterwards. Nor the poem I wrote for him. The white heat of the moment now, from the vantage of time, lies in what he said when he looked up from reading it. *Oh. You wrote a real poem.* Was he crest-fallen? Had I bested him at the game of poems? Of course not. I had failed the test. I hadn't even known what test I been set. (Talk about showing up late for the exam.) He had offered the gesture of seduction, the *grace* of The Poet's sexual interest. To the neophyte, baby-girl poet. Or perhaps, more clearly, to my body. Swiftly divorcing *me* from *myself*. Though in the confusing, to me, flux of that moment, I could not parse the tangles of this knot. We talked, there must have been other gestures. I was *aware*. He was attracted to me.

There I sat, at the foot of the bed. Did I move forward? Did we touch? There was an awkward goodnight. A hug. Another arrangement: I would take him to the train in the morning.

What did I feel?

Jumbled. Turned around. Uncertain. Awakened, also perhaps, to the potency of my own sexuality. This new thing in which the question of my value had been read. Scanned. Like a poem? (Oh, stop.) More like a barcode. I was pretty and young and therefore available. For the taking. (Plucking? The inevitable correspondence between ripe fruit and a young female body.) Though this understanding comes much later. In the moment, only a confusing heat. I am flattered, unsettled, confused. My admiration for The Poet, the affirmation, though <u>not</u> the one I had sought, was after all a kind of affirmation. (I feel the absurd need to clarify again, to explain, to *say*: I had never had a boyfriend, had only dated one guy, had broken it off when gentle kisses became tongue kisses, probing a desire I had not learned to feel for him. Though I had allowed the kisses to go on, while inside, inside I shrank away, undone and embarrassed. Ashamed at my failing. (*What is your problem, anyway, you wanted to be* wanted, *right?*) To have no idea what I was up do, let alone wanted. Or felt.)—You cannot tell what comes of taking wild fruit.

At the train station, Kinnell lunged at me across the stick shift, kissed me, shoved his tongue into my mouth, took my left hand and pressed it to his crotch (I use this word here, *crotch*, because it is the one that came to me in that queer moment). And I returned his kiss, understood what my hand was to do, though his dick steadfastly refused to get hard. (Was this another of my failings? Or

his?) My surprise quickly gave way to a (I shall claim it here, though it evokes an awkward queasiness) profound gratitude to the heat of desire (I was not *dead*, after all). One could say this was a moment that was long overdue.

One could also say it was out of place.

He rushed away to his train, leaving a well-thumbed copy of his book with me, adorned with a quick sketch of (his) a train pulling away below his signature. *How—*

Sitting alone in the car, I was swept away, out to sea, in that vivid, brutal, ecstatic physical awakening. Alone there, and awake.

What Kinnell took. That nascent, too tender sense of innate worthiness (worth a while, anyway), that I mattered. (Silly child. Do try to keep pace. What he favored were the tender bits—or rather, *naughty*.) Person and poet. But he was quick to reassure me. He didn't mean it, didn't mean any of those things. Indeed, I didn't matter, at all. *(Her.)* Except as a moment, then later, a problem. A morsel got out of hand. A gift to the alter of his fissioning, already fractured potency. Poetry.

Invisible. Except in the searing heat of humiliation. After all these years. Shame's idiot, exhausting weight. *(You idiot.)*

Its inevitable return, more than thirty years on. Heaped on. There were other inevitabilities. I got on with it, whatever it was, grew up, found love and grew there still more. Found women writers as models for being, knowing. Writing. And got over it (mostly *(fucker)*). Still, I hate writing these words, the weight of shame that bears against me when I turn back. Hate remembering him, remembering the hapless girl I was. Any of it. Even now he's dead. Nothing there but the ghost of lack.

A real fucker.

Marthe Reed
December 1, 2015

EILEEN R. TABIOS
WITH JOHN BLOOMBERG-RISSMAN

The Arduity of Poetry

Introduction

GENERALLY SPEAKING, THE FOCUS OF *ARDUITY* [interview journal] has been on the poem itself, on the difficulties involved with coming to grips with examples of a certain kind of writing that is often identified as "obscure and elitist." It doesn't strike me that focusing on the micro, as it were, on allusions and non-standard syntax, etc etc totally exhausts the meaning of poetic arduity or difficulty. Personally, I find something arduous in simply trying to think thru what it is one is doing when one is making or reading a poem. This might be seen as a more meta or macro difficulty. Macro-meta thinking does not of course replace close reading, just as close reading does not replace an investigation into poetry as a cultural practice, and of poems as cultural objects. When I decided to interview Eileen R. Tabios, I thought to do so because, besides being a poet I greatly admire, she is a woman of color originally from the Philippines, which has a long colonial history, and that, positioned thus, she might be able to talk about "allusions and non-standard syntax, etc etc" from a different perspective than that of, say, a Prynne or a Hill or even a Celan. Being a "post"-colonial woman of color really does, I think, change things. As Žižek has it in his notion of the parallax view, "Parallax can be defined as the apparent displacement of an object, caused by a change in observational position. [There is a] 'parallax gap' separating two points between which no synthesis or mediation is possible, linked by an 'impossible short circuit' of levels that can never meet." In other words, the "one," above, in "I find something arduous in simply trying to think through what it is one is doing when one is making or reading a poem," is irreducibly multiple.

John Bloomberg-Rissman (JBR): I want to start by quoting a bit from Enrique Dussel's *Ethics of Liberation* and then elaborating on it. "We are confronted by the overwhelming but contradictory reality of a 'world system'... which has globalized its reach to the most distant corners of the planet at the same time that it has paradoxically excluded a majority of humanity." Dussel goes on to identify the world system with the hegemony of Western Europe, the United States, and a few other "latecomer" countries, e.g., post-1989 Russia and Japan. It seems to me that this hegemony has been more or less firmly in place since the 18th century which also saw the birth of aesthetics as a new and specific disciplined way of relating to " art objects" (including poetry), which took as its other ekel, disgust (the fact that ekel is German is not just gratuitous information), which as Winfried Menninghaus' research has shown, is best exemplified by the figure of the old woman, by people of color, especially Africans, by the actual human body, etc (e.g. a runny nose). At the same time that aesthetics was being formulated, the same generation of Germans was beginning to redefine philosophy as that which began with the Greeks, and to exclude everything Asian, African, etc as not-philosophy, because only white Europeans were capable of actual rational thought. This kind of thinking clearly came to dominate western thought, and, dare I say, helped justify colonization and exploitation, and Dussel's recognition of the exclusion of the majority of humans from a seat at the table. OK. Sorry for being so long-winded, but I wanted to set this up. Though I don't want to ask you to speak for anyone but yourself, you are a woman of color hailing from the Philippines, a former colony, who has nevertheless chosen to write in a conqueror's language, no, has done more than to choose to write in English, but who has actually taken it as your beloved. What kind(s) of difficulties (if any) has this presented? I would like this question to be heard on both a macro and micro level, but let's start with the macro, a lá Spivak: "can the subaltern speak? and, if and apparently so, what difficulties, to use an Arduity-word, you might have / continue to encounter, and how you see your work fitting / not

fitting / etc into an aesthetic regime that is at its very heart racist, misogynist, etc etc?

Eileen R. Tabios (ERT): John, thank you for your Introduction—I should clarify that I consider myself more of a "trans-colonial" versus "post-colonial" simply because I'd like my work not to be constrained by inherited history (that may be a futile desire, but I identify the need to go beyond what others have imposed on me and my background). As regards your first question, I initially took your question at face value and wrote an answer. When my answer was at 2,999 words, I realized that my answer was not reflective of how I truly feel because it didn't question the premise which you mostly intended for setting up the conversation. I guess I am not totally comfortable with all of the framing (so to speak) of your question—the frame being the first part of the question up to when you said you "wanted to set this up." A longer look at history may be relevant—I think humans, especially after switching from the hunter-gatherer to agricultural-based lifestyles, have displayed a tendency to improve themselves at the expense of others' positions. Thus, the matters you note are just examples of a longer-lived pattern which is more directly the problem. I think the problems you rightly note come from this tendency, and as enhanced by the introduction of such matters as surplus and ownership into human lifestyle, and that the immensity of the problems we have today is not (just) because of the other-ing tendency you observe but because we have a larger population than we've had before and their consumption is not supported by the planet's resources.

Also, I have no particular problem with how the three Greeks have come to be identified as some philosophical core in the West since the same world has accepted India's form of numbering.

So perhaps I should start by just saying that first, and seeing what you think as I sense the frame of your question is important to you...

JBR: First of all, I hope you did not trash your original response because it's probably interesting in itself and I'm sure bits are salvageable. In any case, OK, your response is fair enough, and, really, I would expect no less.

So, you ask: what in my framing is important to me. There are two ways of answering that which occur to me at the moment. The first is: what is important in that frame to me, regardless that we are having a conversation and/or interview. In other words, what bothers me about living under the intellectual hegemony of the west? The other way to answer this is: what is important to me about the way I frame the question in terms of this interview? In other words, what was / am I hoping to elicit?

I'm going to answer the second here, because that seems more relevant to us, not just to me. Though I could answer the first if you'd like me to. This is what occurs to me. Paul Celan continued to write in German because even though it was the enemy's language it was also his language. But the fact that it was not just his anymore, but the language of those who had killed his family etc etc, had certain effects on his use of the language (led to the rise of certain "difficulties" in his work) (this is not, of course, an attempt to reduce his work to some sort of monocausal thing). You have chosen (for the most part) to write in not just the enemy's language, but to (more or less) embrace an aesthetic that was designed to exclude you, as a woman and as a person of color. What difficulties has that presented you with? How have you managed and/or subverted them?

Of course, I understand that that's just a paraphrase of my original question, shorn of the footnotes and references. But maybe that helps narrow down what I am really getting at. I'll veer now a bit into a "what is important in that frame to me" zone. Yes, every culture has done that same kind of "othering." I don't like that aspect of them either. And I know that western culture is much more than just an exclusion machine. But what troubles me right now about western culture is its globalization. It's like a monocrop. And monocropping is never a good idea. Using the monocropping metaphor, it seems that one thing

poets might be about today is, well, if Monsanto is a black magic way of inculcating disease resistance into a monocrop, maybe poetry might be a white magic way of doing the same thing. What's really interesting to me about your response is how different it is from what you told me yesterday, that I had asked exactly the right question. Apparently ... not. Or something.

ERT: The easy part first, John. Yesterday I read "the right question" because I'd focused on the second half of the question which mostly addressed poetry. Today, my attention snagged against the framing, too. But that the question is the right one is still true, as befits how much I wrote in response and how much the rest of my answer now recycles much of what I wrote yesterday. So, I'll continue below and with some clarity of your "frame." But before I do so, I want to present an answer that was created with your frame in mind; it was written on my behalf by another Filipino poet, Angelo Suarez, whose books include *POEM OF DIMINISHING POETICITY* and the forthcoming *Philippine English: A Novel*. I asked Angelo to speak to your first question as if he was me because I thought it would be interesting if not relevant to see a version of a reply from someone who does not see me as a subaltern and whose knowledge of me revolves mostly around my published writings (including on social media). As you know, the person never exactly matches one's public persona but my public persona mostly revolves around poetry which is the matter we're discussing. So, to your first question, here is Angelo's response on my behalf:

> Obviously I can speak: that you are interviewing me is an indication of my work's & also my visibility within this aesthetic regime. Nevertheless my visibility comes marked with both complicity & oppression, i.e., my visibility is an indication of an ability to play along-or perhaps not so much an ability to play along but an ability to survive being played by the oppressive conditions that you speak of. This love affair for English, for instance, finds me producing texts not only in what you see in books, but texts that come in the form of a publishing practice—by which I mean to say I have also come to run a publishing house. It is one thing to exercise resistance

by writing poetry; it is another thing to exercise resistance by taking control of the forces of production that allow my poetry to be printed & disseminated. Publishing & affiliating myself with communities of independent publishers present themselves as forms of composition outside of books that help determine how books are made, presented, distributed— conditions that in turn generate, in a simultaneously Foucauldian & Benjaminian sense, the author-as-producer function. But look—I can only carry out this so-called resistance insofar as I can afford it. It's one thing to be Filipino; it's another thing to be poor. Beneath all this talk about visibility is whether I can afford to make myself visible. I don't pretend to be dirt-poor. Let me just say that I was lucky enough to not have been born into a subjectivity that is genuinely subaltern & therefore cannot speak. I can speak, my poetry is recognized as poetry in the poetry & publishing communities I move in, but first of all because I have time to produce it rather than rummage through garbage bins looking for food to survive on.

And while there's nothing in there for me to dispute, I affirm that its incompleteness (not Angelo's fault) affirms my discomfort with your original question. So let me add to Angelo's words by continuing to say:

As you know, history obviously didn't begin with the Western articulation of it, though it can be true that its economic power affects/widens the distribution of its point of views (it wasn't that long ago, for example—and maybe it's still the case!—that U.S.-American textbooks portrayed the Philippine-American War as a Filipino "insurrection" or "rebellion" against an implied legitimate U.S. rule when it was actually a defensive battle against U.S. invasion).

But I try to go long on history, reaching certainly further than your frame. My understanding of such a history contextualizes how I view events. So, if we go back to, say, the human switch from hunter-gathering to agricultural-based lifestyles, we will see how certain lifestyles bring out or reward or encourage certain values over others. To live by agriculture (which means re-engineering plants and animals for human consumption) you fundamentally change the human-nature relationship from one of reciprocity (you care for the land and it cares for you) to one

of use and exploitation. War, slavery, etc.—these things are ancient. Indeed, if we go back even longer to the hunter-gatherer stage, we'll still see elements, I believe, of man's self-oriented nature (and maybe that's just part of creatures who have to be concerned with survival).

So while I am as appalled as you over abuse and injustice, I'm not ultimately surprised. I am responding this way because you mention "globalization" which I also feel is an overall profile and arc of historical events. And a trajectory. When you combine overpopulation and/or human levels of consumption with growing scarcity—and even if not scarcity but the imbalanced distribution—of resources, there's a logic I see in the resulting inequitable distribution of resources, and the resulting biases in terms of such areas as aesthetics. A logic because I identified (grumpily but so what?) long ago this tendency in the human race to act only or mostly on its behalf.

Now, certain decolonization scholars (I think of Leny Strobel and Lily Mendoza) offset my dour view of human nature by reminding me of various indigenous practices whereby humans were very careful about not taking more from the land/natural resources than they can put back. Even when, with the effects of elements out of human control—specifically climate—people thought it wise to generate surpluses, many of those early folks still didn't abuse the environment—tried not to take more than they needed to take ("need" would include appropriate surpluses). I'm not an anthropologist or expert historian, and am forced to elide the controversy as to how much of a paradise existed in pre-modern times. But we've obviously gone a long way from respecting, and loving, our ties to nature. It's not such a stretch to move from there to colonizing other people; much of the Western (though this tendency is not just Western) cultural elements you decry rely on having other peoples as well as the environment subservient to one's use or advantage. Thus, it would seem logical that aesthetics, too, becomes a tool for larger forces more directly concerned with power: the Other is not just disgusting but it's convenient that they are disgusting. And of course! The nature of

selfishness—and power (you know what that Greek said)—is such a strong force! As well, racism is not just a disgust with the other. Racism is a convenient tool for trying to keep another group subservient.

Entonces, we come to today where much of the wealthy and powerful have incentives not to change their practices in that necessary changes would require diluting their power. A way to facilitate change is education, assuming they have the moral compass to abide by what they learn about unsustainable and unfair practices. But while it can be a convincing argument that taking care of the planet generally benefits them, they're also being asked to forego short-term gratification for long-term benefits. It is difficult to improve our record when the system is so structured towards shorter-term priorities (e.g., for politicians, winning elections and employing the voters, and for financiers, hitting profit returns that are often calculated annually). Even as there is progress in disseminating more information about racism, misogynism, climate change et al, it is taking a long time for progress to occur because of the underlying power structure. (By the way, I focus on the wealthy because they own more assets and thus behavioral change on their part would have a larger impact; but the change in better behavior needs to occur for everyone.)

As I write this, two moments have just occurred: the anniversary of the martial law declaration in the Philippines (Sept. 21) and the largest-recorded global climate change marches and protests. Two different issues but sharing the same impediment: the people who have the ability to make the biggest change possess incentives not to make those changes. In the Philippines, the political elite is the economic elite and so are invested in preserving their power rather than advancing the nation's overall development in a positive way (I actually wrote my senior political science paper on this topic at Barnard College and nothing's changed in this dynamic since 24 years ago when I was a colegiala). In the climate issue, those who can make more impact are the countries who also take the most benefit from pollutant practices. At the U.N. summit following the global marches, many asked for wealthier, developed

countries to be the first to act on climate change, both because they are the primary contributors (even as much of the effect is suffered by poorer countries) both historically and presently. Nothing yet on the negotiating table indicates we are on the path to meeting certain goals as noted by Ban Ki-Moon to the U.N. summit attendees: having emissions peak by 2020 and drop sharply thereafter so that the world will be carbon neutral by the end of this century.

I am quite pessimistic about the human race winning its race against time. I feel that sooner or later the human race will have to undergo a massive transition to reboot itself from what's down the road we're traveling. Perhaps many of the historical horrors you note—like Germany during WWII—are just smaller manifestations of the inevitable cataclysm awaiting the human race absent a global shift to the kind of culture based on not taking more than what we can replace. The hope is that before that transition which may not be survivable, there would be sufficient education and moral fortitude to make the tough decisions that will improve our future. But despite the many positive developments on the individual / grass roots / micro level, the trajectory continues to be dire. Systemic change isn't happening quickly enough. I think the human race is on a suicide path. I've wondered if possibly the only solution would be if technology advances quickly enough for space travel to occur and humans find empty planets where more Earthlings can go to survive. Assuming such planets exist, of course. And if the culture they bring with them has progressed beyond the current ownership-based culture (man's innate nature may continue to be self-oriented but culture can develop to control such).

Here's where the poetry, for me, now arises. (I'm ignoring for now religion's salve to the picture I just described.) Poetry (or my poetry, since I don't wish to speak for anyone but myself) arises as both behavior and language.

In terms of behavior, where are the moments of joy, of beauty, of grace within this doomsday path humans are on? From where or how do we come up with reasons that make it worthwhile to continue living? To rush out of our beds to greet

the day? To smile? To laugh? Well, for me, these moments would occur through the positive interactions made possible by love and respect for other people, creatures and the environment. Many are already behaving this way—including those working for policies curbing drastic climate changes. But they continue recycling the plastic bags, if you will, without dampening the overall rise of emissions! So if I look at these moments, and if I bear in mind my own apocalyptic forecast for the human race, I view these moments—the stubbornness of their continued existence against all odds—as poetry in the sense that poetry's task is not to affirm the (unjust) status quo but to disrupt it. And so language. I write in English, you observe. But no. I write in Poetry. (It happens to be English poetry but I think the language we are addressing for purpose of our discussion is Poetry and not English.) Poetry is its own language. It can be the case that poetry, by being different from language's usual usage for communication, politics and commerce, questions if not disrupts societal norms. Such norms encompass what you call "an aesthetic regime that is at its very heart racist, misogynist, etc."

Thus, my poetry language reflects having to disturb the norm which, even when generating moments of beauty, encompasses states of complacency and lack of imagination; such factors often create poor poems as well as no effective solutions for societal problems. In other venues, I've actually said that my (poetry) words attempt to transcend dictionary definitions. I also reflect the influences of abstraction and cubism to disrupt syntax. I use these and other elements (collage, found texts et al) also to reconsider the notion of "author" when each individual is bound by his/her/hir times and I rebel at these times. As a poet, I attempt not to work only within what I inherit because what's inherited is fucked up, of which my colonial history is only one facet. English was the colonizer of my birthland, the Philippines. English, but not Poetry.

And where's the difficulty? The arduity, for me? It gets back to something I discovered as a newbie poet which took me 18 years to begin to comprehend. It's a statement by the Danish

poet Paul Lafleur when he said, "Being a poet is not writing a poem, but finding a new way to live." (I hope my memory is correct; I've not found Lafleur or this statement since but it's sufficient that the statement sticks.) The arduity of my poetry is that if I'm not living a certain way, it won't matter how well my poems are crafted. My desired poetry is an action, not an object—a verb, not a noun.

"A new way to live" is a call to act. It's not enough to have experienced something and then write a poem about it. It's not even enough to use poetry as a questioning or searching device, which is the fashion in some quarters by poets who agree that poetry is not just writing about what someone knows or has experienced. Self-epiphany or just epiphany, by the standards I desire for poetry, is too modest a goal. For me, one must also choose to do something as led to you by how you live as a poet. Since I didn't start paying attention to poetry until my mid-thirties, I have a convenient basis for comparing my two ways of living: one without poetry and one as a poet. A key difference between the two ways of life is that if one is to be an effective poet (or probably any other type of artist), one must be as observant and intelligent as one is capable. I call one of my primary jobs as a poet to be that of maximizing my lucidity. (Not to say I'm brilliantly lucid but just to see as clearly and as intelligently as I can.) And in seeing the world more clearly, one ends up writing better poems. You bring more material to the poem-making; by being consciously aware, you bring more intelligence, empathy and other elements that can improve the poem.

And it is circuitous. As one tries to be a better, more intelligent observer—thus a better maker of poems—one also becomes a better citizen. Unless one is a psychopath or just plain greedy or selfish, one becomes a more responsible citizen —thus, one becomes more concerned over such ills as racism, misogynism and environmental damage. Here, for me, is where the arduity of poetry lies. Here, for me, is why I say poetry is not words. Yes, the poem is word(s) (or the visual image or how else poets may manifest their poems). But the difference for me between a poem and poetry is that the poem is a moment in

time or a still object and poetry is what went into its making as well as the effect that it causes. A poem is a snapshot; poetry is the movie. So the arduity of poetry for me is figuring out how to live as a responsible human being in a larger context where what I do and how I behave ultimately will be meaningless.

You're a librarian. I love humanity for how it's created its libraries. But if one reads all the books available and extrapolate knowledge from what's not written, surely the conclusion is that nearly all of human history after our hunter-gatherer stage has been consistent in manifesting a suicide pact. Do you agree, Señor Librarian?

But as I said, the poetry behaviorally has been to live as if the human race is not extinguishing itself. To be good when it ultimately doesn't matter. For me, one of poetry's recent impacts has been delving deeper into a particular parallel world that exists alongside of us all: the world of orphans around the world whose plight doesn't receive the media coverage of wars and natural disasters but where the numbers and lost human potential involved make it one of the top two humanitarian tragedies of our time (the other, of course, would be the damage we are perpetuating on our planet). I ended up doing some orphan advocacy work (I won't get into details on that, partly for privacy issues), but my involvement also led me to poems about this situation, including the first book-length haybun poetry book, *147 MILLION ORPHANS* (gradient books, 2014). A similar relationship between orphan advocacy and poems exists in my collaborative book with j/j hastain, *the relational elations of ORPHANED ALGEBRA* (Marsh Hawk Press, 2012). The key thing here is that neither project would have been possible were I not doing something in my life that helps alleviate the plight of orphans. Those books are not just a function of imagination but actual (and non-virtual) action. The aesthetic results could not have occurred without certain prior acts, as facilitated by my refusal to simply accept what is the (dominant) status quo in many countries where insufficient support is given to orphaned children. Indeed, the fact that there are 147 million orphans— possibly more; I've seen estimates go as high as 217 million—is a statistical effect of this culture that's formed through power. A

child orphan quite clearly defines the powerless. Nothing I do will likely change this terrain on a macro level. But I don't accept it and disrupt it to the extent I can.

Thus, there's logic to how my poetry (what I read in addition to what I make) leans towards (though not solely) what others categorize as experimental or innovative. I have theorized this preference—it's easy enough for me to do so just by hearkening the role of language, in this case English, as a colonizing tool by the U.S. on my birthland. I could theorize it further by simply accessing some of my experiences as a Filipina immigrant to the United States. But I can also simply say that, aesthetically, I am attracted to what is not the "same ol' shit" so that, actually, unlike how you cite the formulation of disgust, I look at something different as something more interesting and, thus, often more compelling (ultimately attractive) for my attention.

Being open to difference can dilute disrespect such as what too many show our planet and other peoples. But it circuitously tracks back to how the attitude of not taking more than one can return is an attitude of respect and love towards others outside of our individual selves. It's an apt attitude for befitting how all of existence is interconnected. The arduity of Poetry which has both widened and clarified my lens is to live responsibly when my decisions ultimately will go up in the flames of humanity rebooting itself. It is arduous but the poet or person who lives this way paradoxically would not find it arduous if one attempts to behave from a position of Love. And Love is one of the most successful mitigants of Power—that such happens more in the micro rather than the (disheartening macro) is not cause for discouragement. We all live in the micro.

Also, let's say that I'm wrong with my dour view of the future. If so, it's because Love will have won in the macro as well, and it behooves me to not let myself get in the way of that possibility. But what I learn from my decolonizing scholar friends is that humanity cannot rely only on the rational—it's not sufficient to try to persuade others to do the right thing based solely on what is presumably the good thing to do vs. the

bad. So what might turn the Love for ourselves and our immediate families and communities to a more universal love that would hasten systemic change—that would take down power? Perhaps this particular type of Love must reflect remembering the position of not taking more than one can return. Such requires one to have a spiritual connection with the land, with other creatures (human and non), with the environment and so on. On this matter, by the way, indigenous cultures have much to teach us.

In sum, the arduity of my poetry is to behave and write as if we are not doomed. To behave by not merely accepting the behavioral manifestations and language of injustice. To behave as if justice matters.

JBR: In a way then, this quote, which sort of sums up the macro-arduity of being a poet these days, and which pierces me to the core, René Char's "I want to never forget how I was forced to become a monster of justice and intolerance, a narrow minded simplifier, an arctic character uninterested in anyone who was not in league with him to kill the dogs of hell," which I took out of Sean Bonney's completely to the point "Lamentation" of 24 Sept 014, would appear to have relevance to you, too. I mean, that Paul Lafleur quote, "Being a poet is not writing a poem, but finding a new way to live," is apparently not only an arduity in itself, it's also an arduity in this particular world, the poet's "given." It's not as if finding that new way to live occurs in a vacuum, it occurs in a world with 147 million orphans, who are just some of those who may be taking this planet past its carrying capacity, it occurs in a world in which there may well be "no future," to quote the famous and still apt punk expression. Oh, there are so many directions I could go in response to what you say here, and I wish we were sitting at the same table and had all the time in the world so I could, but I'd just like to touch on one here, which I think relates to at least one of the difficulties many people have with contemporary or perhaps I might say better say modernist poetry. You write: "But what I learn from my decolonizing scholar friends is that humanity cannot rely only on the rational..." I'll stop the quote here,

because it's not the ethical aspect of this I want to discuss, it's how a sense of the limits of the western rational post-Aristotelean logical space, might manifest in a poet's syntax, which I take to be, really, just a way of connecting one thing to another. How might this sense of the limits of the rational manifest in your work?

ERT: I believe the definition of "rational" is not fixed. But let me try to answer your question by not (immediately) digressing.

My "work," as you put it, is incentivized by love. Because of that, the rational would be a limit to my work. Love is not rational if it spurs—and it often has—actions belying logic. Is it rational for one to die for a cause when self-preservation is such a strong instinct? Is it rational to behave against one's principles because of love? Is it rational to sense, or have faith, that one is so interconnected with the rest of creation that, as I've penned in a poem, No one or nothing is a stranger to me? Is it rational to write poems? The interesting thing about Love is that because it defies mere logic it also can become a great source of creativity. For my work, creativity demands going beyond acceptance of what one inherits, whether it's a world order and/ or language. Having said that, I will say that it is rational for one to wish to not abide by inheritance because look at the world! So, I would answer that my sense of limits from the rational manifests itself in the many ways I as a poet, among other things, have attempted to disrupt notions of authorship as well as the conventionality of language: the way I've torqued language through such points of views as abstraction, randomness, cubism, music, erasures, etc. Linear narrative comes up short for my poetry since it is contextualized within a world that contains results not derived from linear progressions. Certainly, justice does not unfold linearly, if it even unfolds. I've also done other things as a poet—Suarez, for instance, noted my approach to publishing—but am only addressing the specifics of your question revolving around syntax. (By the way, I don't do nonsense—a reader may call one of my poems nonsense but as a consciously-applied tool I don't do nonsense.) My most recent work, "Murder, Death and Resurrection" (MDR) includes an MDR

Poetry Generator that brings together much of my poetics and poet tics. Basically, the MDR Poetry Generator contains a data base of 1,146 lines which I can combine randomly to make a huge amount of poems; the shortest would be a couplet and the longest would be a poem of 1,146 lines. Examples of couplets (and longer forms) are available at my e-book *44 RESURRECTIONS*, also the first poetry collection emanating out of the generator. A book forthcoming in 2015, *AMNESIA: Somebody's Memoir*, would be an example of a single poem of 1,146 lines.

The MDR Poetry Generator's conceit is that any combination of its 1,146 lines succeed in creating a poem. Thus, I can create—generate—new poems unthinkingly from its lines. For example, several of the poems in *44 RESURRECTIONS* were created by me blindly pointing at lines on a print-out to combine. While the poems cohere partly by the scaffolding of beginning each line with the phrase "I forgot..." (a tactic inspired by reading Tom Beckett's fabulous poem "I Forgot" in his book ~~DIPSTICK~~ *(DIPTYCH)*, these poems reflect long-held interests in abstract and cubist language such that I'd always been interested in writing poems whose lines are not fixed in order and, indeed, can be reordered (as a newbie poet, I was very interested in the prose poem form and was interested in writing paragraphs which can be reordered within the poem). Yet while the MDR Poetry Generator presents poems not generated through my personal preferences, the results are not distanced from the author: I created the 1,146 lines from reading through 27 previously-published poetry collections. If randomness is the operating system for new poems, those new poems nonetheless contain all the love that went into the making of its database of lines. The results dislocate without eliminating authorship.

Now, the math is over my head for calculating the number of poems possible from these 1,146 lines. I ended up hiring my son's math tutor, Carl Ericson, to calculate it for me. For the $30 (don't laugh) I was paying for his efforts, Carl could not find an explicit formula for evaluating my question. But he did find an approximation formula to use. His approximated answer to the total poems possible to be generated by the MDR Poetry

Generator is a number that has 3,011 digits. I don't know enough to dispute or accept the math (I am working on getting a second opinion, actually, from a brilliant man who won the equivalent of the Nobel in some kind of engineering field). But if it is true that the number of permutated poems is huge, I can keep handing out poems for the rest of my lifetime without having to write anew. (Are the poems any good? Using publication as a means of answering that question, the poems are just like my other non-generated poems: despite some rejections, there are also acceptances such that a significant number has found publication homes.)

Obviously, the MDR Poetry Generator is not limited by Aristotelian logic. And I'll add this non-Western theoretical component: I also practice what I call "Babaylan Poetics"—a poetics that's based on indigenous Filipino practices. There's an image from pre-colonial Philippine times of a human standing with a hand lifted upwards; if you happened to be at a certain distance from the man and took a snapshot, it would look like the human was touching the sky. In a poetics essay in my book *THE AWAKENING*, I'd described the significance of this image as:

> "...the moment, the space, from which I attempt to create poems. In the indigenous myth, the human, by being rooted onto the planet but also touching the sky, is connected to everything in the universe and across all time, including that the human is rooted to the past and future—indeed, there is no unfolding of time. In that moment, all of existence—past, present and future—has coalesced into a singular moment, a single gem with an infinite expanse. In that moment, were I that human, I am connected to everything so that there is nothing or no one I do not know. I am everyone and everything, and everything and everyone is me. In that moment, to paraphrase something I once I heard from some Buddhist, German or French philosopher, or Star Trek character, 'No one or nothing is alien to me.'"

Within this indigenous moment or space, both intentionalized authorship and the randomness with which the lines are combined from the MDR Poetry Generator are

irrelevant—All is One and One is All. There is no separation between writer versus words versus reader. And when I pollute the planet, I pollute myself; when I debase someone else, I debase myself; when I take advantage of another, I take advantage of myself... you get the drift...

So what does the MDR Poetry Generator allow me? Time. It requires time to make poems. Now, I can make new poems in the time required to copynpaste them onto a page-saving time from having to conceptualize, imagine, experiment, edit, etc.

Thus, the MDR Poetry Generator allows me more time for poetry-as-behavior. For poetry as action. For poetry as disrupting the human race's hurtle towards oblivion. For poetry as good works, if you will.

JBR: Thanks. Two more questions.
1) You seem to accept that within the poem anything goes, except for "nonsense." Why no nonsense? Why that limit?
2) I'd like to pass a long passage by you, from David Buuck / Juliana Spahr's *An Army of Lovers*, because I am relating what, if I understand aright, your notion that the real difficulty relating to poetry these days is simply being a poet as a form of "trying to stay [or become] human!" in a real mess of a world (the quote is from a OD [original dadaist] Hans Richter). I wonder how you might respond to it? Is there overlap between your "positions"? Are there distinctions?

> They had fought a lot about this, how to get themselves out of what they had taken to calling the impasse, which was their inability to figure out why they continued to write poetry in a time when poetry seemed not to matter, and when their attempts to collaborate with one or maybe two or maybe four hands in order to break through this impasse continued to fail. They had said to each other that they didn't want to write any more poems that demonstrated their adept use of irony and book smarts to communicate their knowing superiority to capitalism. And they didn't want to write any more poems that narrated their pseudoedgy sexual exploits in a way to suggest that such exploits were somehow in and of themselves political. And they didn't want to write any more poems that made people feel sad or guilty or go oh no. But still, it was

hard for them to figure out what to do with poetry in a time when 19.5 acres were required to sustain their first-world lifestyles, not to mention that within the 19.5 acres were the deaths and devastation from the mining, oil, natural gas, and nuclear industries, the deaths and torture from the policies of their government, the rising acidity of the ocean, the effects of climate change on populations without access to the equivalent of 19.5 acres of resources.

ERT: As regards nonsense, again some of my poems may be considered nonsense by a reader. But I'm referring to how I don't want nonsense to be an intention at the time I write a new poem. For what interests me in poetry, I feel nonsense is too superficial. I am idealistic when it comes to poetry—I'd like to make sense in the sense that I'd like to touch a reader somehow, or have the reader have a fruitful engagement with my poem. Thus, I want to bring to the poem a sincere effort to reach out to that reader (regardless of whether the poem will succeed), rather than elide through the excuse of deliberately presenting nonsense. It may, of course, be an artificial concern since poems have significances separate from authorial intention and certainly readers have shown themselves capable of having well-considered engagements with what may seem nonsense to others. But that's my response as an author, and the author has never been dead.

As regards your second question, did you miss the parts that allude to why I'm also a misanthrope? I believe humans are a mess. That's why the world (humans have created) is a mess. So the literal notion of "'trying to stay [or become] human' in a real mess of a world" is something I'd find nonsensical, though my initial response may just be relating to the question too literally. What I'd rather say is I honor what I perceive to be the intent underlying the quote which (correct me if I'm wrong) is a desire to live better and/or more responsibly.

As for David Buuck / Juliana Spahr's *An Army of Lovers*—a book I've read, by the way—I truly appreciate and respect how these two poets bring so much more awareness than many other poets (and people) to the state of the world and poetry's

role in it. I don't want to judge overlaps or distinctions between their approaches and mine based solely on (your excerpt of) their book. It's possible though that such may be discerned by the reader, with mine, say, being what's shared through my answers in this interview. The more important question may be how we behave in response to our thoughts as regards the state of the world and poetry. What I call the poetry-as-behavior aspect. On that, I don't have enough information about David's and Juliana's lives. As for my life, I don't do enough.

SAMPLE POEM:

from "I Forgot the First Woman General"

I forgot the sun hid from what I willingly bartered for Lucidity.

I forgot commitment costs.

I forgot radiance must penetrate if it is to caress, and its price can never reach blasphemy.

I forgot my heartbeats succumbing to radiance after curiosity taught me to bait handcuffs and whips.

I forgot "Geisha" lipstick clung to nights jousting at the West End Bar (New York City) when jazz still rained and reigned.

I forgot schools of fish dispersing to reveal the undulating sea floor as "suddenly flesh, suddenly scarred, suddenly aglow."

I forgot diving so deeply into salty seas I witnessed coral form skyscrapers upside down as they narrowed towards the molten center of earth.

I forgot the scientist-poet who cautioned against "enhancing music" as more would trip "the fragile balance between sterility and sensuality."

I forgot possessing money for perfect hems consoles like martyrdom.

I forgot how to long for rose petals yawning like little girls, like the daughters I never bore.

I forgot how to italicize the word God.

I forgot no metaphors exist for genocide.

I forgot how the mountains of bones shared the pallor of thick, white candles burning in helplessly tin candelabras.

I forgot the green stalks holding up ylang-ylang orchids—how their thin limbs refused to break from the weight of lush petals and overly-fertile stamen.

I forgot where bones erupted mountains in Guatemala and Peru.

I forgot your reputation for waking at quantum velocity.

I forgot whether Love was relevant.

I forgot those days of unremitting brightness from ignoring all ancestors to stare directly at the sun, only to discover myself clasped by the cool dimness of a cathedral where hands penetrated marble bowls for holy water whose oily musk lingered on my filigreed fingers as if to sheathe my flesh—

I forgot centuries of woodcarvers immortalizing stigmata on the limbs of virgins and saints, eyes wide and white in exaltation—

I forgot the thermodynamics of farewells wherein exhaustion yielded the scent of armpits until sight clung to a riding crop, suddenly admired for its stiff leather spine—

I forgot black dimes interrupting the sun's glare, an experience familiar to travelers visiting "Namibia in search of pure light"—

I yearned for amnesia when I saw dragonflies off-kilter, shoving through air like husbands with bruised eyes—

I forgot I yearned for amnesia—

AUDREY WARD

A Miniature Study in Humanity

HOW LONG IS IT BEFORE WE BEGIN to account for our selves: The life which we are given or we give; that which we spend? Not until it's threatened, usually. After a tornado strikes, a hurricane comes ashore, or wild fire rages through the canyons. Too many rush hours become numbing, habitual days.

Six year old Preston told me with some authority after I suggested, Well, it's your life:

"I don't have a life."

But of course you do.

"What? No! I don't."

Well, you were born, you breathe, don't you? You think; you run and play, go to school and do karate. Yeah. You have a life.

"No. I. Don't. Not yet."

Ah. Well, I did not know that.

Then I considered his answers. Why not, after all, delay the inevitable; who needs all this scramble? Let somebody else do the heavy lifting for as long as you can. Especially when you are gifted with those who will, though all children do not have that luxury.

A philosopher and storyteller—a rabbi—lifting a child up in the middle of a gathering of politicians and religious officials, said, "This child is the way the world must be." Even the people who worked to make him into a religion never paid attention to those particular words.

§

There are no creeds, no doctrines; few religious or civil laws notice our young ones. And if it comes to it, they do not get a majority when a vote is taken.

Since children don't vote, few politicians put their needs on the list. A worldwide attitude seems to be that there is little benefit investing in babies once they are born. But I contend

that we are accountable for children whether we have young ones in our own home or not.

In New York's Hell's Kitchen,1873, a 10-year-old's plight first came to the attention of the authorities. It was by way of a kind neighbor, who reported that Mary Ellen McCormack was being routinely injured by her adoptive mother. There were no laws to protect children, the April 10, 1874, New York Times coverage ("Inhuman Treatment of a Little Waif") of her court testimony reported. They used, instead, rules written by the American Society for the Prevention of Cruelty to Animals.

Another hundred years went by before Congress passed the Child Abuse Prevention and Treatment Act in 1974. This, finally, was due to the cumulative efforts by specific states.

Traveling away from the United States in an extended sojourn after retiring from 32 years as a United Methodist pastor in Northern California, I found that attitudes in the six countries I visited didn't seem to differ that much from our own with regard to child protection. My journey ended with two months in Paris, however, and there I found one interesting variation.

This discovery was thanks to an American visitor who is currently a kindergarten teacher. Wendy has taught fourth grade, as well, and spends many of her hours every week on playgrounds.

We heard children playing as we crossed squares where they chased each other in tag, chanted slogans across a divide, or, in passing the local elementary school during lunch and recess. One day, she offered, "These kids have a different sound."

Really? How's that?

"Well, they're, um, having fun. It's in their yelling and shouting I hear the difference they're full of...all I can think of is 'fun.' More joy."

You mean, compared with American children.

She nodded thoughtfully as if agreeing with herself as well as with me.

"I hear these notes in their voices, not the language, but the tone."

In quizzing her about the difference in children's playground sounds, she surmised that there was more aggression in the voices of American children: Winning ranks higher than fun.

Can it be that kids in the States have succumbed to adult messages meaning our culture rewards winners and steps on losers?

Oh sure, we pump kids up with what we call 'self esteem' but too often it's hot air, giving prizes for little and demanding discipline only on the sports field in order to be first, while self-control is not necessarily required at home. Mutual respect and appreciation for authority are in short supply.

Our children crave structure, not empty praise. To truly care for them, of course, acknowledgement counts, but they know when they're being glorified for nothing.

The young need someone to look up to. I remind adults that however smart or armed with tech knowledge at early ages our offspring may be, they are not equipped to be in charge of the household, their education, or even their own bedtime.

Engaging young ones in real conversations; learning together to value the oral tradition that transmits ethics, compassion and respect from one generation to another, enhances our humanity. It is another essential way to care for and protect our children. We pass along what gives us pleasure in our lives as well as the cautions of the long-view: the wisdom of age.

Every child does have a life, but it's up to us to keep that flame bright until they are mature enough to do it for themselves.

Most satisfying, is that the fun, the playfulness of the well-tended child enhances the wisdom of elders. They encourage us to ease up and enjoy our years as we grow together.

One afternoon on the number 87 bus which cuts across Paris from Le Marais to the Champs du Mars, a grandmother, cane in hand, carefully boarded with a loquacious five year old. They were seated just ahead of me, juxtaposed so that I could see the woman's face as she quizzed him on his kindergarten class that morning. He recited with ease regarding letters, numbers and

city landmarks they were learning. With each correct answer, she met my eyes, smiling and justifiably proud.

My enjoyment, however, was not just in the bright answers of an alert child but in her awareness that every moment is one in which we have an opportunity not only to observe what is in our environment but to enrich another through exchange. She was trading energies with this little boy; teaching him the life he was living as well as enhancing her own interest in being here, now. "Way to go!" I wanted to say.

So what did the rabbi mean? How is a child the way the world must be? I've heard people say it's that joy factor, but I don't think that's all it is.

Rather, if we pay attention to creating a world that's fit for children we will also enjoy living there. It requires, first, building a home that practices ethics, talks about and requires respect, honesty, faithful kindness (even when angry), and forgiveness. Then, learning to live by this moral compass in our families, neighborhoods, and schools.

Without a long pause or making a grand gesture of meditation, we are given opportunities to consider small wonders—or simply to wonder—all through the day: At the traffic light, waiting for our exit on the Metro, walking to and from the bus stop.

Always, alert to how we can make the world a vital, compassionate place for little ones.

ACKNOWLEDGEMENTS

Cover Image, "Greek and Armenian refugee children in the sea near Marathon, Greece, c. 1915." Public Domain.

"Dust" by **Mary Pan** was first published in *intima: a journey of narrative medicine*, Spring 2016.

"Until We Have Loved" by **Jeanine Pfeiffer** was a Finalist/Honorable Mention in *Hippocampus Magazine*'s 2015 Remember in November Contest for Creative Nonfiction.

"Desert Castles" by **J. A. Bernstein** was first published in *Chariton Review*, Vol. 40, No. 1. Summer, 2017.

"36°C Below Zero — Braving the Freezing Cold Arctic Circle with the Nenets Reindeer Herders of Siberia" by **Christine Amour-Levar** was first published in *The HuffPost*, January 14, 2016.

"A Poetics of Ghosting," an interview of **Rodrigo Toscano** by **Aaron Beasley** was first published in the *Boston Review*, 12 April 2018.

"Close Call with Siberian Kickboxers" by **Robert Cowan** was first published in *Mayday 8*, Summer 2014.

"Haynaku: For the white feminist professor who told me I was 'ghettoizing' myself by studying Asian American Literature" by **Melinda Luisa de Jesús** was first published in *Rigorous*, Volume One, Issue 3.

"Composting Civilization's Grief: Life, Love, and Learning in a Time of Eco-Apocalypse" by **S. Lily Mendoza** was originally given as a keynote address at the Third International Babaylan Conference held in the Unceded Coast Salish Territories, in Vancouver, Canada in September 2016.

"Waiting for Jonathan Koshy" by **Murzban F. Shroff** was published by Independent Thinkers in 2015.

"On Shame" by **Marthe Reed** and **Laura Mullen** was first published in *afteriwas dead.*

"The Arduity of Poetry," an interview of **Eileen R. Tabios** by **John Bloomberg-Rissman** was first published in *Arduity.*

ABOUT THE CONTRIBUTORS

Of French, Swiss and Filipino descent, **Christine Amour-Levar** is a Social Entrepreneur, Environmental Advocate, Marketing Consultant and Author currently based in Singapore, where she lives with her husband and four children. Through Women On A Mission, the non-profit organisation she co-founded in 2012, she has led teams on challenging expeditions to the Arctic, the Middle East, Africa and the Himalayas to raise awareness

and funds for women survivors of war and to empower and support women who have been subjected to violence and abuse. An avid believer in women as Gamechangers with unique knowledge and solutions to move the needle on sustainability, Christine recently launched #HERplanetearth, a global women's advocacy movement that promotes gender equality and the integrity of the environment.

Daniel Atkinson received his PhD in ethnomusicology from the University of Washington, Seattle in 2011. His research focus is on Afro-American vernacular expression and its interaction with the global landscape. His dissertation research was conducted at the former slave plantation turned world's largest prison, Angola State Penitentiary in Louisiana. The research was designed to serve as a platform to discuss issues of economic disparity and institutional racism as products of the 13th, 14th and 15th Amendments to the Constitution as well as to preserve some of the remaining a cappella gospel tradition at the prison. That research

is now featured at the Smithsonian's National Museum of African American History and Culture. He is currently working on the first historical biography of Vaudevillian and founding father of the Harlem Renaissance, George W. "Nash" Walker (1872-1911) and is the curator of the Global Rhythms concert series at Town Hall, Seattle.

Aaron Beasley currently lives in Salt Lake City. He studies in the English department at the University of Utah & interns for the Eclipse digital archive for small-press writing (eclipsearchive.org). He is co-author with artist Jeremy Kennedy of *NOTE TO SEA* (Rebel Hands Press, 2017).

J. A. Bernstein's forthcoming novel, *RACHEL'S TOMB* (New Issues, 2019), won the AWP Award Series, Hackney, and Knut House Prizes. His forthcoming story collection, *STICK-LIGHT* (Eyewear, 2018), was a finalist for the Robert C. Jones and Beverly Prizes. His work has appeared in *Shenandoah*, *Kenyon Review Online*, *Tampa Review*, *Tin House* (web), *World Literature Today*, and other journals. A Chicago-native, he studied Middle Eastern History and Arabic at Brown University and in Jordan on a Fulbright Scholarship. He later completed a Ph.D. in the Creative Writing & Literature Program at the University of Southern California, where he held the Middleton Fellowship. A husband and father of three, he teaches at the University of Southern Mississippi and is the fiction editor of Tikkun.

Cynthia Buiza is the Executive Director of the California Immigrant Policy Center. She moved to the United States 13 years ago and is now based in Los Angeles, California. Prior to that, she worked with various international organizations, including the United Nations High Commissioner for Refugees, the Open Society Institute-Burma Education Project in Thailand, and the Jesuit Refugee Service. She earned a Masters in International Affairs from the Fletcher School at Tufts University, with a concentration on human security studies. Her poetry and prose have appeared in various anthologies in the Philippines and the U.S. She is also the co-author of *Anywhere But War*, about the armed conflict and internal displacement in the Indonesian Province of Aceh.

John Bloomberg-Rissman is a left coast mashup ethnographer and editor, responsible for what has become a life-work, Zeitgeist Spam. The first three sections (*No Sounds of My Own Making; Flux, Clot & Froth; In the House of the Hangman*) have been published, and the fourth, *With the Noose Around My Neck*, begun the day of Trump's election, is well underway. Among the books he has edited or is in process of editing are (with Jerome Rothenberg) *Barbaric Vast & Wild: A Gathering of Outside & Subterranean Poetry from Origins to Present: Poems for the Millennium 5*, and (with Richard Lopez and T.C. Marshall) *The End of the World Project*. He posts stuff at www.johnbr.com.

Renato Redentor Constantino
manages the Constantino
Foundation and the Manila-based
international group Institute for
Climate and Sustainable Cities,
which published the award-
winning *Agam: Filipino Narratives
on Climate Change and Uncertainty*,
composed of 26 images and 24
narratives in verse and prose
written in eight languages. His
bicycle is named Wyatt Earp.

Rio Constantino is a Filipino
high school student who wants to
be a biologist someday. Like many
others his age, he constantly
searches for sleep, alcohol, and an
internet connection, in that order.

Robert Cowan is a literature
professor and dean at the City
University of New York. He's also
the author of *The Indo-German
Identification: Reconciling South
Asian Origins and European
Destinies, 1765-1885* (Camden
House, 2010) and *Teaching Double
Negatives: Disadvantage and
Dissent at Community College*
(Peter Lang, 2018). He has
published poetry, short fiction, and
creative nonfiction

in *Bayou, Entropy, Flatbush Review, Green Spot Blue, Here Comes
Everyone, Mayday, Skidrow Penthouse* and *Word Riot*.

Melinda Luisa de Jesús is Chair and Associate Professor of Diversity Studies at California College of the Arts. She writes and teaches about Filipinx/American cultural production, girl culture, monsters, and race/ethnicity in the United States. She edited *Pinay Power: Peminist Critical Theory*, the first anthology of Filipina/American Feminisms (Routledge 2005). Her writing has appeared in *Mothering in East Asian Communities: Politics and Practices*; *Completely Mixed Up: Mixed Heritage Asian North American Writing and Art*; *Approaches to Teaching Multicultural Comics*; *Ethnic Literary Traditions in Children's Literature*; *Challenging Homophobia*; *Radical Teacher*; *The Lion and the Unicorn*; *Ano Ba Magazine*; *Rigorous*; *Konch Magazine*; *Rabbit and Rose*; *MELUS*; *Meridians*; *The Journal of Asian American Studies*, and *Delinquents and Debutantes: Twentieth-Century American Girls' Cultures*. She is also a poet and her chapbooks, *Humpty Drumpfty and Other Poems*, *Petty Poetry for SCROTUS Girls' with poems for Elizabeth Warren and Michelle Obama, Defying Trumplandia, Adios Trumplandia, James Brown's Wig and Other Poems*, and *Vagenda of Manicide and Other Poems* were published by Locofo Chaps/Moria Poetry in 2017. Her first collection of poetry, *peminology*, was recently published by Paloma Press (March 2018). She is a mezzo-soprano, a mom, an Aquarian, and admits an obsession with Hello Kitty. More info: http://peminist.com

Gabriela Igloria is a Filipino-American poet. She is currently the editor-in-chief of Granby High School's literature & arts magazine, *The Cupola*, and is a student at the Muse Writers Center. She has been published in Rattle's *Young Poet's Anthology* and in *Whurk Magazine*.

S. Lily Mendoza is a native of San Fernando, Pampanga in Central Luzon, Philippines and is a fluent speaker of Kapampangan and Tagalog. She is Associate Professor of Culture and Communication at Oakland University in Rochester, Michigan. She is the author of *Between the Homeland and the Diaspora: Theorizing Filipino and Filipino American Identities* (Routledge, 2002; Philippine revised edition by University of Santo Tomas Publishing, 2006) and lead editor of *Back from the Crocodile's Belly: Philippine Babaylan Studies and the Struggle for Indigenous Memory* (Center for Babaylan Studies, 2013; Philippine edition by UST, 2015). She has published widely around questions of identity and belonging, cultural politics in national, post- and trans- national contexts, discourses of indigenization, race and ethnicity, and, more recently, modernity and industrial civilization and what it means to be a human being in the face of climate change and eco-systems collapse. She is currently the Director of the Center for Babaylan Studies.

Laura Mullen is the author of eight books: *Complicated Grief, Enduring Freedom: A Little Book of Mechanical Brides, The Surface, After I Was Dead, Subject, Dark Archive, The Tales of Horror,* and *Murmur.* Recognitions for her poetry include Ironwood's Stanford Prize, a National Endowment for the Arts Fellowship and a Rona Jaffe Award. Her work has been widely anthologized, and recent poems have been published in *The Nation, Conjunctions,* and *Lana* *Turner.* Her translation of Veronique Pittolo's *Hero* is forthcoming from Black Square in 2018.

Mary Pan is a writer and family medicine physician with training in global health and narrative medicine. Her work has been published in several print and online publications including *Intima*, *Blood and Thunder*, *Hektoen International* and *Pulse*, among others. She lives in Seattle with her husband and three young children. More at marypanwriter.com

Jeanine Pfeiffer is an ethnoecologist exploring biocultural diversity: the connections between nature and culture. A Fulbright scholar, University of California Pacific Rim researcher, and National Science Foundation/National Institutes of Health grantee, Dr. Pfeiffer has worked in over thirty countries. Based in Northern California, she teaches environmental studies at San José State University. Her scientific articles are curated on ResearchGate.net and Academia.edu and her Pushcart-nominated prose can be found in the *Bellevue Literary Review*, *Proximity*, Hippocampus, *Lowestoft Chronicles*, *Langscape*, *Between the Lines*, and *Nowhere*. More at www.jeaninepfeiffer.com

Marthe Reed is the author of *Nights Reading* (Lavender Ink, 2014); *Pleth*, with j hastain (Unlikely Books, 2013); *(em)bodied bliss* (Moria Books, 2013); *Gaze* (Black Radish Books, 2010); and *Tender Box, A Wunderkammer* (Lavender Ink, 2007). A sixth collection, *ARK HIVE*, will be published by The Operating System (2019). Her poetry has been published in *BAX2014, New American Writing, Golden Handcuffs Review, Entropy, New Orleans Review, Jacket@,* *Fairy Tale Review, Exquisite Corpse, The Volta,* and *The Offending Adam*, among others. *Counter-Desecration: A Glossary for Writing in the Anthropocene*, co-edited with Linda Russo, will be published by Wesleyan University Press in 2018. Reed was co-publisher and managing editor for Black Radish Books and lived in Syracuse, NY.

Karen Bryant Shipp is a singer, organist, and choral director who works as Minister of Music at Oakhurst Baptist Church in Decatur, GA, a progressive Baptist church where she is given the freedom to explore not only all kinds of music, but other religions and ideas. Karen was ordained at Oakhurst in November 2010.

Murzban F. Shroff has published his stories with over 60 literary journals in the U.S. and UK. His fiction has appeared in journals like *The Gettysburg Review*, *The Minnesota Review*, *The Saturday Evening Post*, *Chicago Tribune*, and *World Literature Today*. His non-fiction has appeared in *India Abroad, The New Engagement,* and *The American Scholar*. Shroff is the winner of the John Gilgun Fiction Award and has garnered six Pushcart Prize nominations. His short story collection, *Breathless in Bombay*, was shortlisted for the Commonwealth Writers' Prize in the best debut category from Europe and South Asia, and rated by the Guardian as among the ten best Mumbai books. His novel, *Waiting For Jonathan Koshy*, was a finalist for the Horatio Nelson Fiction Prize. Shroff represented Mumbai at the London Short Story Festival and was invited to speak about his work at the Gandhi Memorial Center in Maryland, University of California Los Angeles, California State University Monterey Bay, the Institute for South Asia Studies at UC Berkeley, and the Annenberg School for Communications & Journalism at the University of Southern California.

Leny Mendoza Strobel is Professor of American Multicultural Studies at Sonoma State University. She is also one of the Founding Directors of the Center for Babaylan Studies. Her books, journal articles, online media presence reflects her decades-long study and reflections on the process of decolonization and healing of colonial trauma through the lens of indigenous perspectives. She is a grandmother to Noah and she tends a garden and chickens with Cal in Northern California.

Rodrigo Toscano's newest book of poetry is *Explosion Rocks Springfield* (Fence Books, 2016) Previous books include *Deck of Deeds, Collapsible Poetics Theater* (a National Poetry Series selection), *To Leveling Swerve, Platform, Partisans,* and *The Disparities*. He works for the Labor Institute in conjunction with the United Steelworkers, the National Institute for Environmental Health Science, Communication Workers of America, and National Day Laborers Organizing Network,

working on educational / training projects that involve environmental and labor justice, health & safety culture transformation, and immigrant worker rights.

Audrey Ward is an author (*Hidden Biscuits*, Wipf & Stock, 2015), writer and poet; an ordained clergywoman in the United Methodist Church, and the mother of two daughters and a son, grandmother of four granddaughters and two grandsons. However, the importance of the above roles are, here, in reverse: She considers the last, that of parent and grandparent to be her number one all-pervasive education and worthwhile endeavor of her lifetime, a source of great pride and exasperation.

ABOUT THE EDITOR

Eileen R. Tabios loves books and has released over 50 collections of poetry, fiction, essays, and experiental biographies from publishers in nine countries and cyberspace. Publications include three Selected Poems projects, *YOUR FATHER IS BALD: Selected Hay(na)ku Poems, INVENT(ST)ORY: Selected Catalog Poems & New 1996-2015* and *THE THORN ROSARY: Selected Prose Poems & New 1998-2010*; the first book-length haybun collection, *147 MILLION ORPHANS (MMXI-MML)*; a collected novels, *SILK EGG*; an experimental autobiography *AGAINST MISANTHROPY*; and two bilingual editions, the English/Romanian *I FORGOT ARS POETICA / AM UITAT ARTA POETICA* and the English/Spanish *ONE, TWO, THREE: Hay(na)ku / UNO DOS TRES: Hay(na)ku*. Her award-winning body of work includes invention of the hay(na)ku poetic form (whose 15th year anniversary is celebrated in 2018 with exhibitions, readings and a book launch at the San Francisco Public Library) as well as a first poetry book, *BEYOND LIFE SENTENCES* (1998), which received the Philippines' National Book Award for Poetry (Manila Critics Circle). Her poems have been translated into eight languages as well as computer-generated hybrid languages, paintings, video, drawings, visual poetry, mixed media collages, Kali martial arts, music, modern dance, sculpture and a sweat shirt. Additionally, she has edited or conceptualized 15 anthologies of poetry, fiction and essays; founded and edits the online journals *GALATEA RESURRECTS (A Poetry Engagement)* and *The Halo-Halo Review*; founded and manages the literary arts press Meritage Press; and has exhibited visual art and visual poetry in the United States and Asia. More information at https://eileenrtabios.com

Paloma Press

Poetry+Prose
Est. 2016

Established in 2016, **PALOMA PRESS** is a San Francisco Bay Area-based independent literary press publishing poetry, prose, and limited edition books. Titles include *BLUE* by Wesley St. Jo & Remé Grefalda (officially launched at The Library of Congress in September 2017), and *MANHATTAN: An Archaeology* by Eileen R. Tabios (which debuted at the 4th Filipino American International Book Festival at the San Francisco Public Library).

Paloma Press believes in the power of the literary arts, how it can create empathy, bridge divides, change the world. To this end, Paloma has released fundraising chapbooks such as *MARAWI*, in support of relief efforts in the Southern Philippines; and *AFTER IRMA AFTER HARVEY*, in support of hurricane-displaced animals in Texas, Florida and Puerto Rico. As part of the San Francisco Litquake Festival, Paloma proudly curated the wildly successful literary reading, "THREE SHEETS TO THE WIND," and raised money for the Napa Valley Community Disaster Relief Fund.